TEXAS
THEN & NOW

TEXT AND CONTEMPORARY REPHOTOGRAPHY BY
RICHARD REYNOLDS

FOREWORD BY
ROY FLUKINGER

WESTCLIFFE PUBLISHERS
westcliffepublishers.com

CONTENTS

In 1998, John Fielder, publisher, photographer, and avid conservationist, contacted me about a project involving rephotographing Texas landscape images from the same vantage points that were used, in some cases, over 100 years ago. Fielder was using the same technique in his own book, *Colorado 1870-2000*, following the footsteps of 19th century photographer William Henry Jackson. Jackson had created a significant body of work in the western and southwestern U.S., and Fielder was rephotographing some of Jackson's Colorado images within a few feet and sometimes within inches of the original angle and location. I decided to research the project, and I set out in search of the "William Henry Jackson" of Texas.

I went to the Center for American History (CAH) at the University of Texas at Austin. The CAH has an extensive collection of vintage Texas photographs, many from the 1800s. I spent a day looking through hundreds of images, but did not find a substantial amount of landscape work from any one photographer. After spending another day of searching through books on the history and geography of Texas at the Austin Public Library, I concluded that a body of landscape photography representing one photographer's work didn't exist, and decided a book like this could not be done in Texas.

Six years later, Westcliffe Publishers asked me to reconsider the *Texas: Then & Now* project (as it came to be known); only this time, they proposed that I do it using work from as many different photographers as necessary to present a broad photographic portrait of historic Texas. This method was successfully used in some of their most recent "then-and-now" books. After thinking about this new approach for a day or so, I thought that it may indeed work. I knew from my preliminary research six years earlier that there had been a number of photographers who worked in specific regions of the state in the late 1800s and early 1900s, and by combining their work, I might be able to come up with enough photos for a substantial book.

The first person I contacted was Roy Flukinger, Curator of Photography at the Harry Ransom Center (HRC) at The University of Texas at Austin. Roy oversees a collection of three million photographs. My wife, Nancy, and I went to visit Roy to get his thoughts on the project and to see what vintage landscape photos HRC had in its collection. He told us about the work of W.D. Smithers, the first professional photographer to work in the Big Bend region of West Texas in the early 1900s, and whose entire collection was now in HRC's archives. He also suggested a number of other collections around the state that might have some good vintage images, and brought to my attention a book published in the late 1980s that detailed the major photo collections in Texas. With this information in hand, I went to work on *Texas: Then & Now*.

Early on, I realized that not only wasn't there an extensive collection of Texas landscapes by any one photographer, but there wasn't a comprehensive collection of Texas landscapes in general. Aside from West Texas, I had trouble finding very many good landscape photos from most of the other regions of the state.

I have made a career of photographing the diversity of the Texas landscape: Gulf Coast beaches, High Plains canyons, East Texas forests, Trans-Pecos mountains, South Texas thornscrub, and Hill Country wildflowers. West Texas is a land of beauty and majesty, and is no doubt the most photographed part of the state. The Hill Country, while not as dramatic as the Big Bend, also is very scenic. The other regions can be more problematic: the South Texas Plains and the High Plains are, as their names suggest, rather flat and require a little more work to produce strong landscape images. The East Texas Piney Woods are beautiful—lots of greenery and lakes—but the relative "plainness" of Texas' landscape and the "shortage" of magnificent scenery is one of the reasons why so little landscape photography was done in Texas during its formative years.

In my research, I found far more images of people than I did landscapes. W.D. Smithers, some of whose landscape

photos are represented in this book, had far more images of the U.S. Army soldiers and residents of the Big Bend country than he did of its scenic charms. In fairness, he was contracted to work for the U.S. Army as a photographer for most of the years he was in the Big Bend area. In all the collections I visited, I found many more cityscapes, photographs of architecture, bridges, and buildings, than pure landscapes. But many of those, while not strictly scenic photos, showed a substantial amount of the environment around them, such as in panoramas and skyline views.

Repeat photography is a tool used to gauge changes in the geography or ecology of the land. Precise technical rephotography utilizes mathematical triangulation and the necessity to match not only the time of year but also the precise time of day. For each rephotograph, I tried whenever possible to find and use the original photographer's vantage point. There were a number of exceptions, however. In some instances, the original vantage point is no longer accessible. Frequently, a tree or other obstruction was in the way; I simply stepped aside to get a clearer view. A lot of the old-time photographers made images of downtown scenes while standing in the middle of the street. In the days of horse and buggy or Model T automobiles, this was not too dangerous. In the interest of living another day and finishing this book, I elected to shoot from a vantage point closer to the curb. For the Congress Avenue shot in downtown Austin, I used a handheld camera and darted to the middle of the street between green lights, snapped a photo, and ran back to the curb as quickly as possible to avoid cars that seemed to speed up rather than slow down when their drivers saw me. There were also a few generic shots, such as the cattle crossing the Concho River, that were impossible or impractical to locate definitively, but that I felt compelled to use because they are such strong and beautiful images of a Texas that doesn't exist anymore.

I tried to use historical photos that were professionally crafted images with good technical qualities—those with good

Photographer Richard Reynolds

composition, sharpness, and correct exposure. In addition to images by W.D. Smithers, this book includes the work of other notable professional photographers: Robert Runyon, who documented the Rio Grande Valley; Charles E. Arnold, who left behind a wonderful record of Dallas; Frank Schlueter, who worked in the Houston and upper Gulf Coast region; and Nick Mersfelder, who captured many stunning images of the Fort Davis area in the late 19th century.

The oldest photo in this book was made in Houston in 1856, and I tried to choose the oldest photos in every case. For some locations, however, the oldest photographs I could find were from the 1940s. It was also important to have a broad representation of as much of the state as I could find in the 15 months I had to work on this project. I looked for photographs of recognizable landmarks that many people could identify. I chose some photographs that I knew would show a great deal of change, such as the Dallas and Houston skylines and some that would show little change, such as shots of Big Bend National Park.

When researching photos, I took photocopies of the images into the field to determine if the scene could be duplicated. If it could, I drew two diagonal lines connecting the corners of each image (making a large "X") to determine the exact center point of each scene.

I would then select the lens I thought would come closest to reproducing the old view, then compose the scene on the ground glass (the viewfinder) of my 4"x5" camera, positioning the camera until the center point of the scene was at the exact center of my viewfinder. It was helpful to know the type of camera and lens the original photographer used because today's lenses for the most part do not exactly match the focal lengths that were in use in the late 1800s and early 1900s. The focal length determines the angle of view your lens takes in—whether you are getting a wide view or one that zooms in on a smaller area.

The resulting "now" image was cropped when necessary to match the borders of the old photo. In a few cases, I included more of a scene than the original photo did, such as the Alpine panorama or Concho Avenue in San Angelo, or I changed the framing of the shot. This was to show significant architectural features that had come into play in subsequent years, or to illustrate the amount of growth or change better than a strict duplication of the field of view.

Finding the locations of the old photos was the most demanding—but also the most enjoyable—part of this project. Sometimes, I immediately knew where the picture had been taken because of familiarity with the landmarks. In others, such as some of the Big Bend photos, it took the better part of a day to locate and photograph the exact spot. Occasionally, I would have to go back another day to get better light. In a few photos, where boulders or other permanent landmarks are in the foreground, I was able to match the original vantage point within a few feet.

One way I determined the vantage point of some of the landscapes was to note the position of peaks, rock outcrops, and other prominent landmarks. I then noted their locations relative to other features that were nearer or farther away, such as distant ridges or mountains. The farther away the subject was, the more challenging it was to locate the vantage point precisely. By wandering around the area, I would eventually arrive at the correct location. On more than a few occasions, I could tell that people who had been watching me were wondering if I was lost, or perhaps inebriated.

As you page through the photos, you will see many degrees of change. Sadly, some of the most beautiful, innovative, and exotic architectural treasures, particularly courthouses from the 19th and early 20th centuries, are not around anymore. Some burned, some were torn down to build "better" or more "modern" glass and concrete structures, but a few, thankfully, remain.

I was happy to see that many places I rephotographed for this book were largely unchanged: Big Bend, Enchanted Rock, Palo Duro Canyon, and the Guadalupe River, to name a few. Of course, not displaying *visible* change doesn't mean the places haven't changed in other ways, such as the air quality in Big Bend or the water quality of the Guadalupe River. In the case of the first three places, the lack of major change is largely the result of concerned Texans' campaigning to protect them under the umbrella of the state or national park systems. Other views, such as those of Austin from Mount Bonnell, Alpine, and South Padre Island, show substantial development since the first photos were made.

It's easy to look at these remarkable old photos and think, "Boy, those were the good old days." I look at them side by side with the current views and, in most cases, I like what I see in the vintage photo better. If you live in a fast-growing major city in Texas, such as Austin or San Antonio, you can see significant change in the landscape on the cities' outskirts on a daily basis. Fifteen years ago, I only had to go about 10 miles west from the center of downtown Austin to get away from the development. Today, I have to drive at least 30 miles to leave it behind. Scenic views once devoid of buildings and telephone poles are now chock-full of luxury homes and shopping malls. But then I have to remind myself that my home was built on once-wild land that was outside the city limits not that long ago, and residents back then probably complained about the "runaway development," too.

This collection of images is by no means a definitive portrait of historic Texas. Although I looked through tens of thousands of vintage photographs from more than 20 different collections, there are probably a hundred images I didn't see for every one that I did.

As I crisscrossed the state over the past 15 months, I accumulated almost 30,000 miles on Texas' highways, farm-to-market roads, and dusty county roads. While researching and collecting vintage photographs and rephotographing scenes, I was constantly reminded of Texas' vastness, its remarkable heritage, and the responsibility I took on when I agreed to capture the past and present views of the Lone Star State. I hope the scenes represented in this book challenge you to learn more about the history of Texas and to appreciate the splendor and diversity of a state rich in history and natural resources.

—*Richard Reynolds*

3

To the list of pioneers and dreamers who shaped and built modern Texas—the ranchers, farmers, cattlemen, housewives, city planners, contractors, businesspeople, plainsmen, teamsters, politicians, and, of course, cowboys—we must add photographers as well.

Not that this profession was ever a dominant one at any time during Texas history. Certainly, many in these other groups had much more to do with shaping the growth and economy of the Lone Star State. We must clearly acknowledge that the plains were tamed and the urban centers grew thanks in large part to the roles these other sizable groups played. Nobody can claim that photographers—who never came close to numbering more than a few thousand individuals at any point in the Texas saga—ever exceeded one of the other major professions that have and do continue to dominate the state's history and present ascendance.

Rather, it is photography's role—as opposed to any corresponding socioeconomic balance sheet—that adds weight to the individuals who practiced this profession for the last two centuries. Texas was certainly not the first U.S. state or territory to see the growth of photography; that honor clearly belongs with the Eastern Seaboard states where the continent's industrial revolution first took hold. Indeed, we cannot even name the first photographer in Texas. For the present, we can only acknowledge that the early practitioners of this craft must have arrived in the territory, coincidentally along with our new statehood, sometime in the mid-1840s.

Early photographers practiced their profession along the same, safe lines as their Eastern predecessors—by founding commercial, largely portrait businesses within the established and growing towns and cities that began to arise throughout the state. Granted, there may have been a small number of committed peripatetic photographers roaming between the villages and a scattered few forgotten amateurs who may have pointed their lenses at the odd landscape or townscape. The bulk of practitioners, however, found their markets in such popular mediums as portraiture or such commercially successful formats as stereographs throughout the remaining decades of the 19th century.

The question we often catch ourselves asking is why Texas had no major 19th-century landscape artists to match the expeditionary photographers of the Western United States and their territories. Where was the Timothy O'Sullivan or the Andrew J. Russell of the Big Bend or the Pecos Basin? Why were there no mammoth-plate landscapists like William Henry Jackson or Carleton Watkins at work in the Great Plains or among the many rolling rock outcroppings of the state? Did it all just come down to the fact that the Far West featured tremendous mountain ranges and Texas did not? (Every time one gets to thinking about how all-fired important a mountain may be, it is wise to recall the old Texas adage: "The best way to be remembered is to have a song written about you; the surest way to be forgotten is to get a mountain named after you.")

Geography has always seemed to be just too simple an excuse for such a disparity. Texas is not shabby when it comes to the numbers. Its total land and water area is, after all, some 266,807 square miles—meaning that it makes up more than

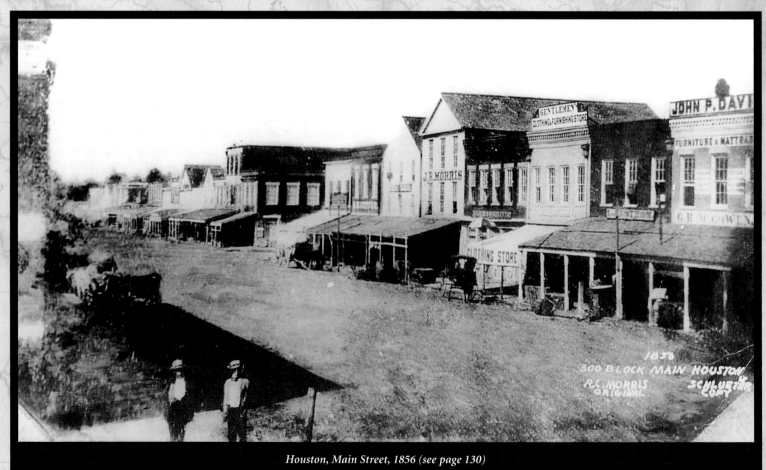

Houston, Main Street, 1856 (see page 130)

7 percent of the total land area of the entire United States. Within that quantity of land, there is great diversity and variety, including 350 miles of coastline, more than 90 mountain peaks one mile or more above sea level, and rocks from every geological area. Meteorologists brag about our 10 climatic zones while geologists point to the fact that Texas encompasses five of the seven major North American physiographic provinces. Clearly, the raw materials have always been here.

What is different is the growth and development of the state. While it was a frontier that needed taming, it was a much different frontier than that of the Far West. While the Western states were often spoken of as needing to be conquered, Texas, despite its own War of Independence and years as a free republic, followed the model of the majority of Eastern and Central states that were viewed as territories that needed to be settled. A Jackson or a Watkins was dispatched into the West to reveal to the remainder of the isolated United States the wild, romantic wilderness that was owned but largely unsettled during the nation's second period of Manifest Destiny following the Civil War. The Western expeditionary photographers—largely inspired and financed by governmental surveys or private capitalistic enterprises—were initially dispatched to show the commitment required and challenges faced throughout these relatively new and unexplored lands. Thus, the roots of American landscape photography lay in the promise of the land rather than the desire of the photographers to create the vision.

So it would also evolve that the question of "place" in early Texas photography becomes a very elusive one. Clearly, it was never defined by any single visionary photographer or by any group of dedicated practitioners of the art. From early on, Texans came to recognize and experience place as more than just a physical location or geographical feature of the terrain. The concept was shaped unknowingly by these new Texans and, as more people began to traverse and inhabit the wide-ranging lands of the state, a sense of Texas place began to be defined by the cultural and physical locations where the people chose to conduct their lives upon the land itself.

Therefore, for most Texans, as for the vast majority of Americans in this era, land became a significant part of the ongoing arc of civilization and culture. In the 19th century, as colonization evolved into more farms, ranches, and towns, the trails opened up into roads that joined the entire patchwork of settlements throughout the state. During this era, there were no true landscape or cityscape photographers among the commercial photographers, although a few attempted to bring their cameras out into their surrounding communities. Of these, we are most mindful of Louis de Planque of Corpus Christi, Hamilton Briscoe Hillyer and William James Oliphant of Austin, McArthur Cullen Ragsdale who roamed Central Texas, and the little-known Henry Stark, clearly the most talented of the state's earliest photodocumentarians.

A new period of transformation began at the start of the 20th century when agriculture and ranching were joined by the newly launched oil industry. Villages and towns began the not-so-quiet transformation into cities, while industrialization led to profound changes throughout many areas of the state. As populations and city limits grew, so too did the demand for photographers. The portrait studios expanded to fill the commercial and documentary needs of each community and, as darkroom technologies became less complicated and less cumbersome, the cameras became more flexible and capable of leaving the studio behind, turning to meet the needs of many different and expanding markets.

It is important to remember, however, that landscape and cityscape photography per se did not develop into established singular disciplines in Texas until the latter half of the 20th century. Up to this point, commercial firms largely incorporated views of buildings, city blocks, singular homes, and surrounding lands as a part of their commercial stock-in-trade. Views still could be produced for a particular customer or purpose but, because of the easily replicable nature of the photographic process, multiple prints could be generated and sold to a wide variety of buyers for an even wider variety of purposes. Please,

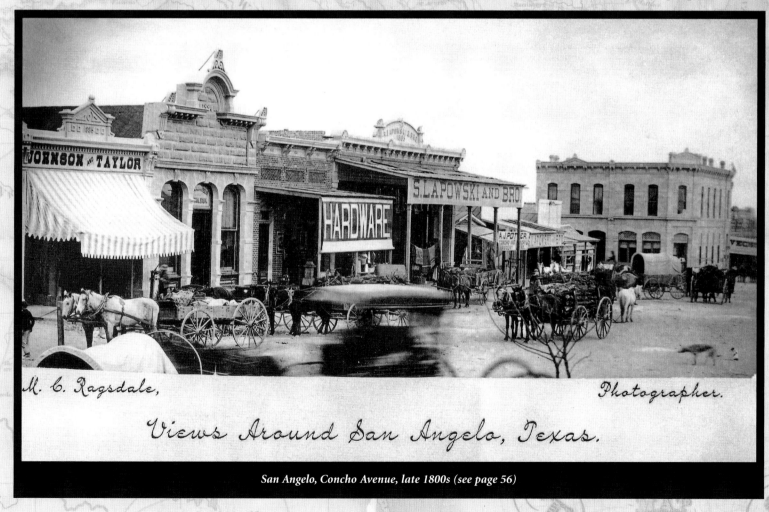

M. C. Ragsdale, *Photographer.*

Views Around San Angelo, Texas.

San Angelo, Concho Avenue, late 1800s (see page 56)

always remember this point as you view the "then" images in this book—they are drawn from a rich breadth of many of Texas's historical archives and represent many different photographers who reflect an equally broad range of individual intentions for the original creation of their images. The quantities, techniques, styles, and applications would certainly change with each generation, but the photographers of this half-century encompass a wide variety of backgrounds and intentions.

For example, we find throughout this era—not really surprisingly—a few working cowboy-photographers such as Ray Rector of Stamford, Frank Duncan in West Texas, and Erwin E. Smith. A number of others began in specific sites and expanded outward to document whole regions—particularly Wilfred D. Smithers in the Trans-Pecos region, Robert Runyon in the Lower Rio Grande Valley, Frank J. Schlueter around Houston and its coastal environs, the independent firm of Harvey and Julius Patteson of San Antonio, and E.O. Goldbeck, who also began in San Antonio and ended up "covering the whole world…and then some." Finally, there were those who, as in the preceding era, stayed on in one place and became the photodocumentarians of their particular city or town: Fred A. Gildersleeve of Waco, Jack Specht of San Antonio, Dr. John F. "Doc" McGregor of Corpus Christi, John P. Trlica of Granger, Charles Arnold of Dallas, and Milton Lawless and Joe D. Litterst of Houston are a few who come immediately to mind.

Langtry, Judge Roy Bean, circa 1900

Two new changes came along in the 1960s to dramatically alter the status of photography in Texas. The first was a worldwide transformation: the acceptance of photography as a major art form. What the public became newly aware of—but what photographers had recognized since the birth of the medium—was that the photograph was not merely an image of great objective detail but also one that had the potential to express lasting beauty and almost infinite emotional depth. Individual creativity began to be recognized and celebrated, not only for what the photograph could depict or describe but even more so by the feelings and emotions it could articulate and imply. The newest generations were capable of devoting their entire lives and careers to the art of the photograph and did not have to spend the bulk of their time and energy in the portrait studio or processing lab. And, perhaps not so surprising, the vast majority of these photographers came out of the state's larger urban centers and directed their cameras at the cities or towns from which they grew. Among the numerous photographers to emerge from this period are such critical figures as Russell Lee, Frank Goelke, Carlotta Corpron, Garry Winogrand, Geoff Winningham, Alan Pogue, Keith Carter, Reagan Bradshaw, April Rapier, O. Rufus Lovett, Bill Wright, Will van Overbeek, Michael O'Brien, and Tammy Cromer-Campbell.

The other significant change of this era was the emergence, at last, of a number of artists dedicated primarily to landscape photography. The earliest artist of this modern school was probably Jim Bones. One of Russell Lee's first students, Bones made the examination and interpretation of the wide variety of Texas earth surfaces his own. His landscapes—ranging from detailed black-and-white abstractions to eloquent color transformations—came to celebrate all areas of the state and were always touched by a sympathy for and commitment to the land that was undoubtedly shaped by the humanism of the photographer and his former teacher. Thus, by the 1970s, Bones had opened the floodgates and other landscape photographers quickly emerged to complement and learn from his work.

In the process of observing this important transformation of the landscape (and, in complementary juxtaposition, the cityscape) in contemporary photography, it is startling to see how the past and present generations of photographers have challenged and enriched the discipline. When you see the

work of these current pioneers—including individuals such as Frank Armstrong, David H. Gibson, Arthur Meyerson, Luther Smith, Todd Jagger, Dennis Fagan, James H. Evans, Steve Goff, Kenny Braun, Scott Campbell, Bill Wright yet again, and Charles Kruvand—you get the feeling that the state has finally spawned a group of photographers who are, at last, up to the potential of its land. It is now finally evident that the spirit of conquest that seemed so prevalent in the work of the Far West expeditionary workers of the 19th century is at last being matched here in Texas at the beginning of the 21st century. Throughout the work of these present visionaries, we now can fully experience a rediscovery of Texas place in photographic imagery that is at once majestic and lyrical, eloquent and dramatic. And dramatic in the sense J. Frank Dobie once used to describe the artistry of Charles M. Russell: "the drama of potentiality, of shadowing destiny, of something coming, of something left behind."

Of these present groups of Texas artists, let it be said that they do more than know Texas—they also feel it.

To this group must surely be added our present artist, Richard Reynolds. Reynolds is among the most masterful of our contemporary photographers. His landscapes have graced—and often bettered—publications for the last three decades or more, while his individual prints distinguish the walls of many private and public institutions. In particular, his vibrant color vision is equaled by only a very few and it is constantly amazing to experience the rich variety of hues and tonalities he always discovers and coaxes out of the sky, rocks, water, and light itself. His compositions are faithful in spirit and challenging in conception, and thus always a revelation to the mind as well as the eye. You will find in his explorations of land and city a sense of style and an outgrowth of humanism that make him a direct and worthy successor to that singular vision of Jim Bones.

We must, therefore, applaud his artistic courage to undertake such a rephotographic challenge as the present volume dictates. Rephotography, though not in itself new, is never an easy task. From the outset, it involves the artist in a certain limitation of point of view and location to produce a current perspective based upon a much older photograph. The challenge, while mindful of the passage of time and the effect of history, can also be overwhelming for some. The creativity of Reynolds, happily, recognizes no such limiting factor and he utilizes his endless palette of other creative elements—including exposure, light, color saturation, and point of view—to enhance his own interpretations of these perspectives. The resulting pairings in this book are therefore rendered as far more than "then and now" images—they also are preconceived notions about change and its effects upon history, experience, and human memory. Reynolds consistently honors the photographers of the Texas past while asking each of us to enjoy the present and consider the possibilities of the future.

With such an homage to the past as our future, we should feel justified for including the Texas photographers among the other significant pioneers of our state's past and future. In no way do we suggest that the person with the camera can possibly eclipse the cowboy and his peers. Rather, let it be said that both groups share many of the common positive characteristics that help make Texas great. The Texas historian, Walter Prescott Webb, once asked the question of what made the American West romantic and spectacular. He concluded that the Westerner appeared so because of the Easterner—who was largely destined to witness the outward appearances of a different world while not being a part of it. I believe the photographer does us one better. He or she may well experience a world that we do not, but always leaves us with a photograph of some aspect of that world which, in turn, will always give us at least the opportunity to share in that experience.

—*Roy Flukinger*
Research Curator of Photography
Harry Ransom Humanities Research Center
The University of Texas at Austin

San Antonio, Mission San Juan Capistrano, circa 1900 (see page 108)

WEST TEXAS

El Paso ☆ Socorro ☆ Guadalupe Mountains ☆ Pecos ☆ Fort Davis ☆ Alpine
Marfa ☆ Marathon ☆ Sanderson ☆ Lajitas ☆ Terlingua ☆ Big Bend

> "I must say as to what I have seen of Texas, it is the garden spot of
> the world, the best land and the best prospects for health I ever saw."
> —Davy Crockett

El Paso Rim Road, circa 1940s

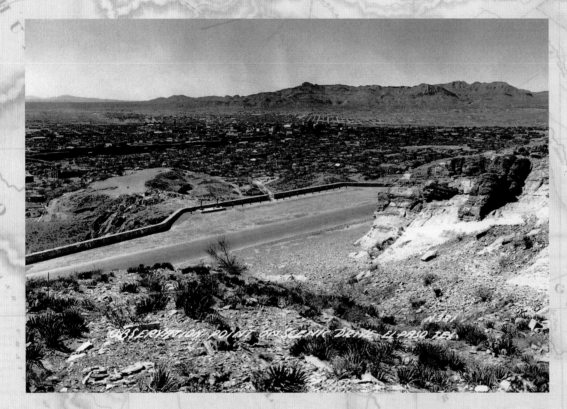

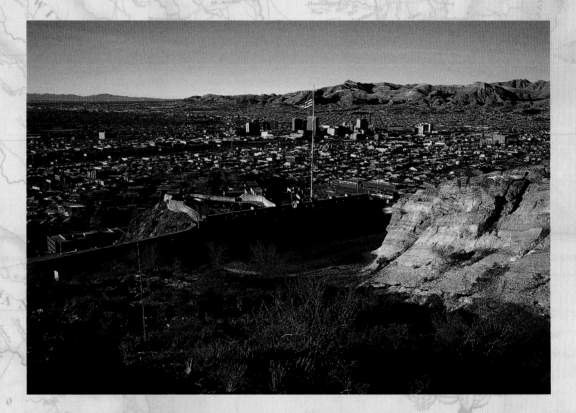

From El Paso's earliest days, city leaders knew that the slopes of Mount Franklin would provide a spectacular panoramic view of the area. Mayor Charles Davis (1917–1923) approved construction of a scenic drive for automobiles, and the 1.8-mile route was completed in October 1920. It immediately became one of El Paso's most popular attractions. The road reaches a high point of 4,222 feet, 500 feet above the Rio Grande, which is less than a mile away. In 1932, the city endeavored to widen and pave the road, and two years later a Civilian Conservation Corps company from Fort Bliss carried out additional culvert work.

The scenic drive continues to attract visitors who want to get a bird's-eye view of the far western tip of Texas. From this overlook, you can get a 240-degree view encompassing most of the city of El Paso, Fort Bliss, the Rio Grande, Ciudad Juárez in Mexico, and the surrounding Chihuahuan Desert. The first time I went to photograph this view, spring winds were gusting up to 70 mph and I could barely stand up, much less set up my camera. I went back the next morning when the winds had somewhat subsided and shot this picture.

El Paso View from Mesa Garden, 1882

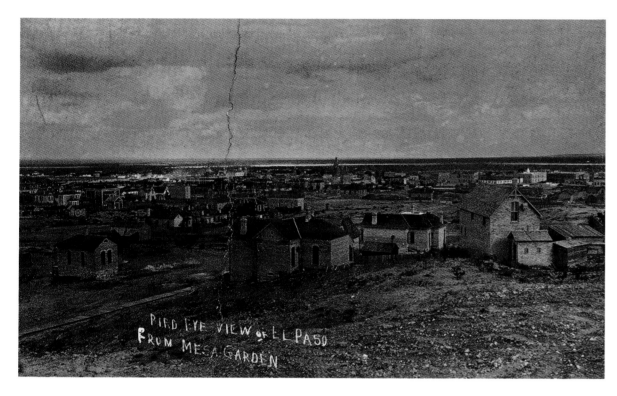

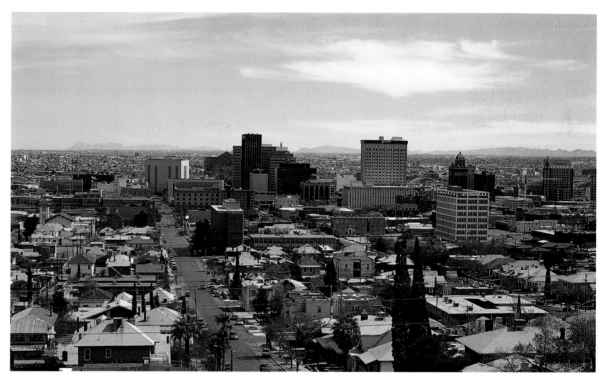

El Paso was named after the deep gap between the two mountain ranges rising out of the desert. The earliest settlements dated back to 1598, when an expedition led by Juan de Oñate of Spain came through the region. By the middle of the 18th century, about 5,000 people inhabited the area. Local aristocrat Juan María Ponce de León received a land grant in what is now downtown El Paso, and from the kernel of a colony named Franklin, the city grew. A military post, Fort Bliss, was established in 1854, and the Butterfield Overland Mail arrived in 1858. A year later, pioneer Anson Mills completed his plan for the town of El Paso.

After 1900, El Paso began to evolve into a metropolitan city and emerge from its Old West persona as it developed into a hub for various industries and transportation activity. Today, it is the largest U.S. city on the Mexican border. Together with its sister city of Ciudad Juárez, on the other side of the Rio Grande, the combined population is over 2 million.

El Paso Mesa Street, 1907

In the 1880s, the railroad's arrival diversified the city's population, bringing the honest as well as the scandalous. Madam Etta Clark capitalized on the city's booming population and "introduced" it to the sex trade. Utah Street, now Mesa Street, was teeming with parlors used to distract the adventurers who'd left their wives back east. Clark's girls became popular thanks to her business savvy, which included placing an ad in the 1901 city directory as "owner of furnished rooms."

El Paso has grown from a railroad border town into an urban city with a blending of cultures and languages unlike anywhere else in the state. With an average of more than 300 sunny days a year, El Paso has earned its nickname, the "Sun City." Thanks to its sunshine-filled days and low cost of living, El Paso is currently the fourth-largest city in Texas.

Corpus Christi de la Ysleta Mission early 1900s

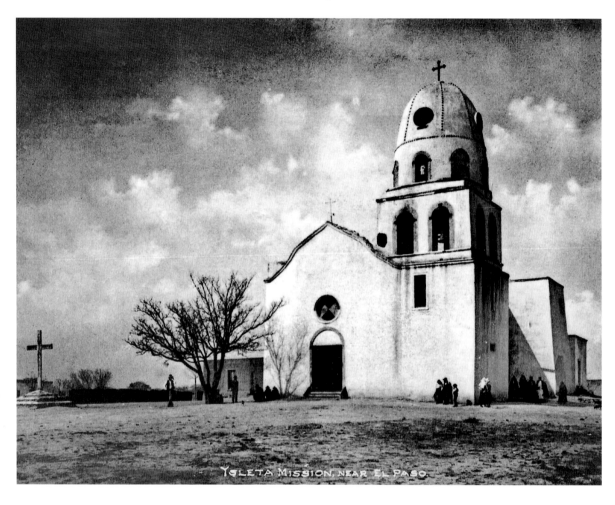

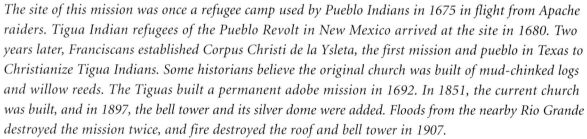

The site of this mission was once a refugee camp used by Pueblo Indians in 1675 in flight from Apache raiders. Tigua Indian refugees of the Pueblo Revolt in New Mexico arrived at the site in 1680. Two years later, Franciscans established Corpus Christi de la Ysleta, the first mission and pueblo in Texas to Christianize Tigua Indians. Some historians believe the original church was built of mud-chinked logs and willow reeds. The Tiguas built a permanent adobe mission in 1692. In 1851, the current church was built, and in 1897, the bell tower and its silver dome were added. Floods from the nearby Rio Grande destroyed the mission twice, and fire destroyed the roof and bell tower in 1907.

The Tigua tribe, historically a farming culture, lost its agricultural land to the encroaching urban environment. El Paso annexed Ysleta in 1955, much to the objection of its 40,000 residents. The Texas legislature recognized the Tiguas as an Indian tribe in 1967, and a year later President Lyndon B. Johnson transferred responsibility for Ysleta to the State of Texas. Since then, the Tiguas have established a residential district and a number of business enterprises on their reservation in the oldest part of Ysleta. The mission has been documented by the Historic American Buildings Survey and is on the National Register of Historic Places.

La Purísima Concepción del Socorro 1930

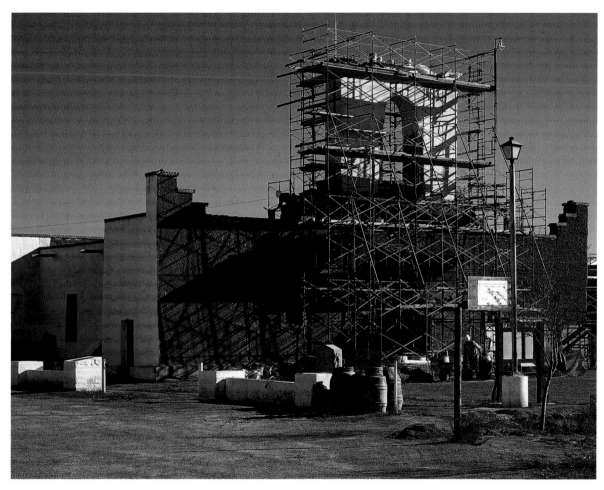

Nuestra Señora de Limpia Concepción de Los Piros de Socorro del Sur (Our Lady of the Immaculate Conception of the Piros of Socorro of the South) was established in 1682 for the Piro, Thano, and Jemez Indians who sought refuge in the El Paso area after the Pueblo Revolt in New Mexico. Its name was later shortened to La Purísima Concepción del Socorro. The permanent mission, completed in 1691, was destroyed by flood in 1740, and its replacement was destroyed by another flood in 1829. In 1843, the central section of the present structure was built just northwest of its previous site. The adobe building was nearly identical to its predecessor, with the original hand-carved beams or vigas to support the roof. Additions to the building between 1873 and 1915 included right and left transepts, a new sacristy, and large European-style arched windows and doors.

In 1985, the Mission Heritage Association, with a $50,000 gift from the Texas Historical Commission, was able to save the adobe edifice from collapse. In 1998, La Purísima Restoration Committee made an assessment of Socorro Mission's condition and determined that a full restoration would cost $2 million. After two years of fund raising, three years of preservation work was begun. An effort to raise additional funds to complete the project and to landscape the surrounding area is currently underway.

Guadalupe Mountains Area circa 1940s

Guadalupe Mountains National Park

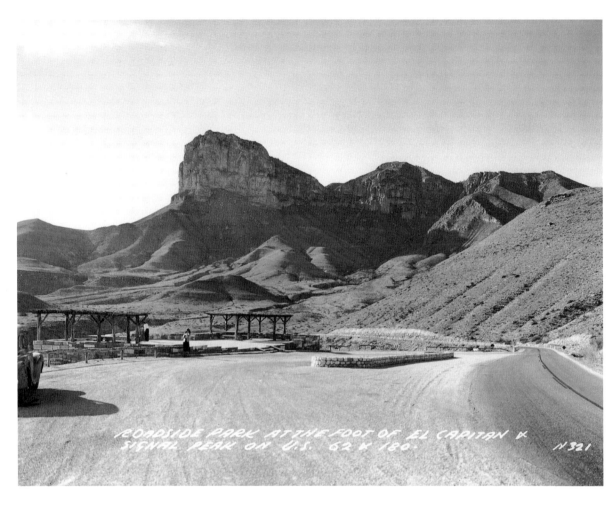

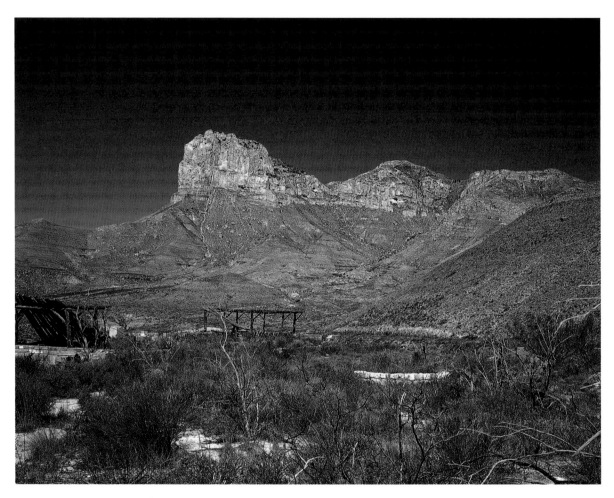

Guadalupe Mountains National Park, established in 1972, preserves some of the exposed remnants of the Capitan Reef, one of the world's finest examples of ancient barrier reefs. The flora and fauna in the park represent species native to Mexico and the Rocky Mountains. The park includes a portion of the Chihuahuan Desert and protects some local desert species, including prickly pear and cholla cacti, lechuguilla (a type of agave that grows in no other desert), kangaroo rats, and coyotes. This view shows two of the park's highest peaks, El Capitan on the left and Guadalupe Peak (formerly Signal Peak) on the right. The latter, at 8,749 feet, is not only the highest peak in the Guadalupes—it's also the highest point in Texas.

When I first saw the vintage view of this scene, I assumed it was taken at the current roadside park on US 62/180 near the base of El Capitan. When my wife, Nancy, and I arrived there, however, I realized it wasn't. Continuing north through Guadalupe Pass, we were soon able to determine the rough location by comparing the juxtaposition of the peaks in the picture. There was not, however, an area off the highway big enough to have held the roadside park. At that point, we realized that the decrepit old structure we had seen perched at the top of a nearby hill must be part of the remains of the old park. After making the short but steep climb up the hill, I confirmed that this was the right place, and realized that the original road followed a steeper, rougher route than the current one.

Pecos High Bridge early 1900s

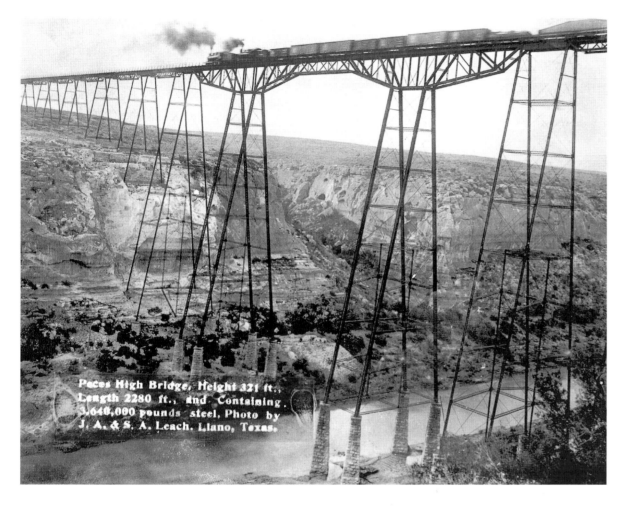

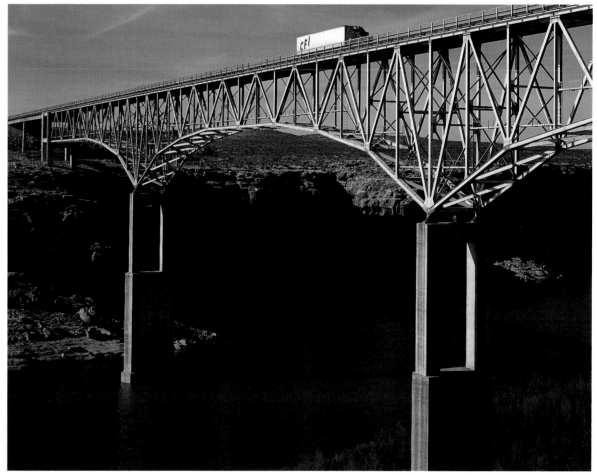

Trains on the Sunset Route of the Southern Pacific lines have crossed the Pecos River on three different bridges, completed in 1883, 1892, and 1944 respectively. The most famous was the 1892 Pecos High Bridge, for many years the highest railroad bridge in North America and the third highest in the world. Judge Roy Bean of nearby Langtry served as coroner for workers killed during bridge construction. The 1892 bridge was 2,280 feet long and stood 321 feet above the river. In 1909 and 1910, the trestle was significantly reinforced, the four-leg central towers were converted to six-leg towers, and the length was reduced to 1,516 feet. Further reinforcement was added in 1929. Finally, with increased rail traffic during World War II, it became clear that a new, heavier structure was needed.

Construction on the new Pecos High Bridge, started in August 1943 at a site 440 feet downstream from the 1892 bridge. Modjeski and Masters of Harrisburg, Pennsylvania, designed the new bridge in the continuous cantilever-truss style. It was 1,390 feet long and its rails were 322 feet above the river. The Sunset Limited was the first train to cross the bridge when it opened on December 21, 1944. The 1944 Pecos High Bridge is still in use, but the rails now stand only about 265 feet above the Pecos River due to the increase in the level of Amistad Reservoir, created in 1968. The 1892 bridge was dismantled in 1949.

Portions of these captions were reprinted with permission from the Handbook of Texas Online, copyright Texas State Historical Association.

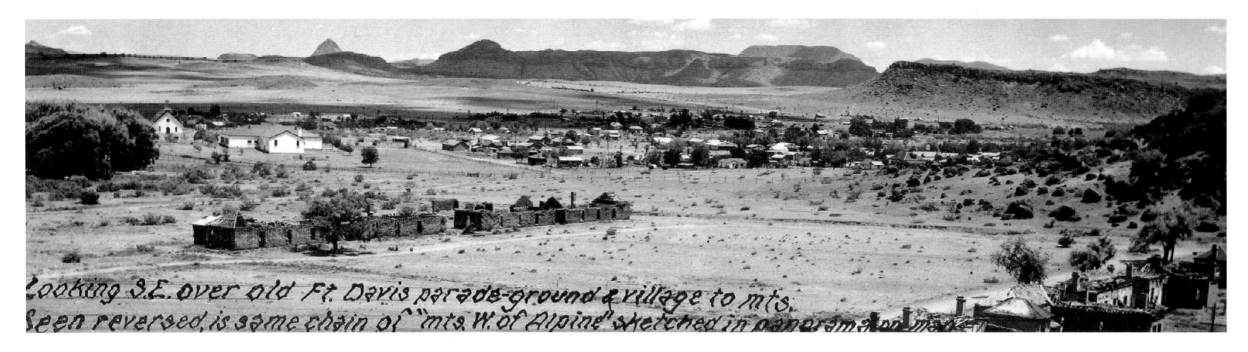

In 1854, Secretary of War (and later president of the Confederacy) Jefferson Davis established Fort Davis in response to the need for a route with water through the Southwest. The post, the key link in a line of forts reaching from San Antonio to El Paso, played a significant role in the defense and development of West Texas. In September 1879, Apache chief Victorio and his Mescalero Apache warriors began a series of attacks on white settlements in the area west of Fort Davis. Col. Benjamin H. Grierson led troops from Fort Davis and other posts in several battles with the Apaches. Victorio retreated to Mexico and was killed in a fight with Mexican troops in October 1880. After the Victorio campaign, life at Fort Davis calmed down. By 1891, the military usefulness of Fort Davis had passed and the post was abandoned.

Fort Davis National Historic Site

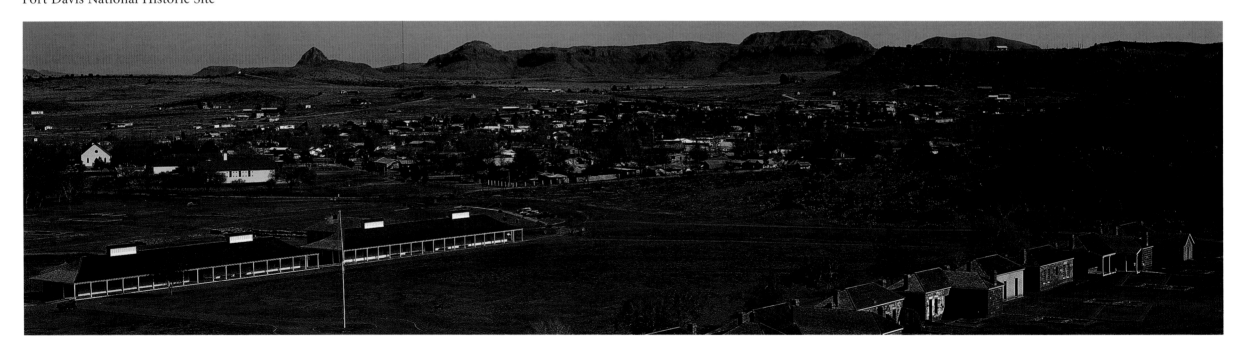

Today, 24 roofed buildings and more than 100 ruins and foundations can be seen at Fort Davis National Historic Site. Five of the historic buildings have been refurnished in 1880s decor. Visitors can take self-guided tours of the furnished buildings and ruins, hike on designated nature trails that connect with trails of adjacent Davis Mountains State Park, or have a picnic under a grove of shady cottonwood trees. Bugle calls and a representation of an 1875 dress retreat parade take place on the grounds. Interpreters dressed in period clothing are stationed at some of these structures during the summer months.

Fort Davis 1900

Fort Davis National Historic Site

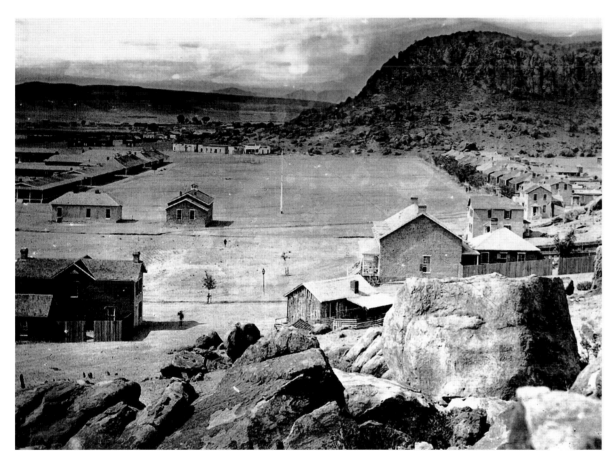

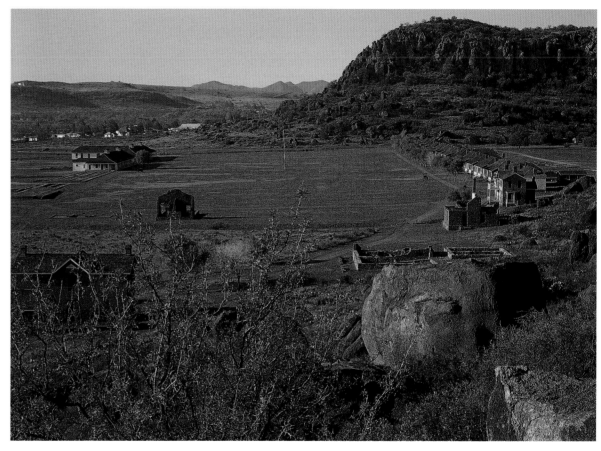

The town of Fort Davis began as a settlement known as Chihuahua, which sprang up southwest of the military post of Fort Davis after it was established in 1854. The earliest Anglo-American explorers of this area called it Painted Comanche Camp. By virtue of its position at the crossroads of two important trails and its status as a base for travelers and hunters, the town of Fort Davis became the most important town in the Trans-Pecos country. In the 1880s, Fort Davis became a ranching center as ambitious cattle-men poured into the Trans-Pecos, many of them seeking to escape the Texas Fever epidemic raging in other parts of the state. By this time, the town had an estimated 2,000 inhabitants and a weekly newspaper called the Apache Rocket.

In September 1961, Fort Davis National Historic Site was established; its formal dedication was in April 1966. A few years later the Chihuahuan Desert Research Institute, headquartered in Alpine, opened an arboretum on a 300-acre tract of land on CO 118 just southeast of Fort Davis. Both of these attractions, as well as the nearby Davis Mountains State Park and the University of Texas McDonald Observatory, have helped make Fort Davis a popular tourist destination.

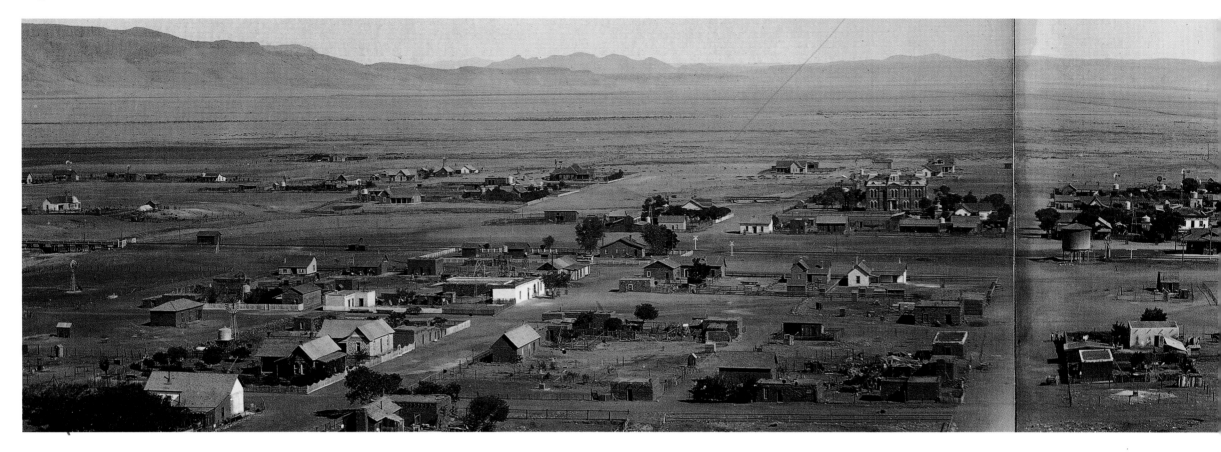

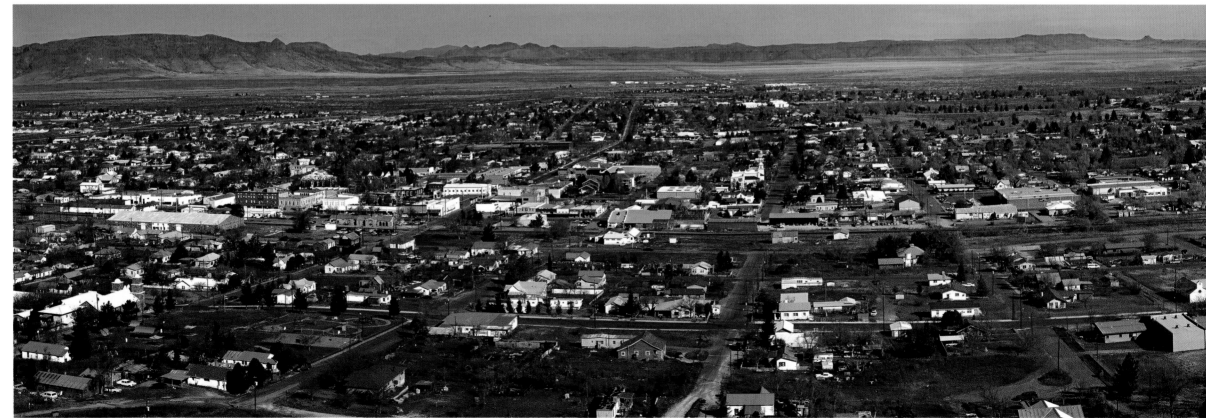

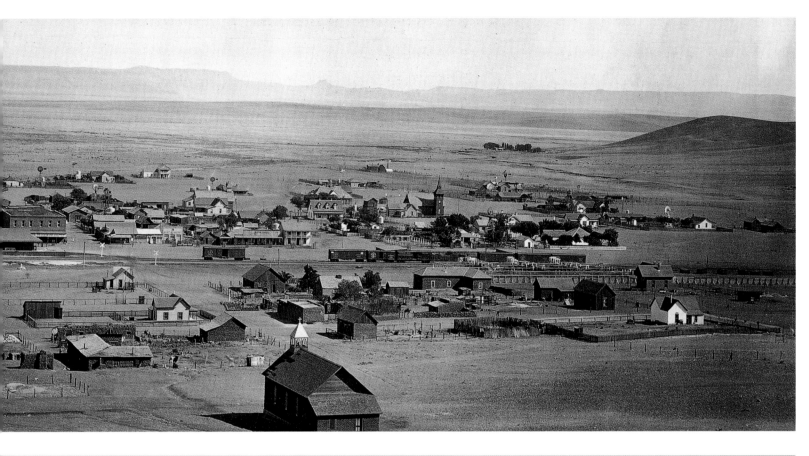

This photograph dates back to 1904, when Alpine was about 25 years old. The town's origins date back to the 1880s, when it was known as Murphyville, after area landowners and brothers Daniel and Thomas Murphy. Alpine expanded from an encampment of railroad workers who made their homes at the foot of present-day "A" Mountain, where this photograph was taken. The town was renamed the more exotic "Alpine" in 1888. Early on it supported the usual businesses found in small towns: drinking and lodging establishments, a general store, a butcher shop, and a farrier. In 1921, Sul Ross Normal College (now Sul Ross State University) was established. Ranching and the transcontinental railroad made Alpine an important center of commerce in West Texas. With the establishment of Big Bend National Park in 1944, Alpine became one of the park's several gateways, and from that time tourism was an increasingly vital part of the town's economy.

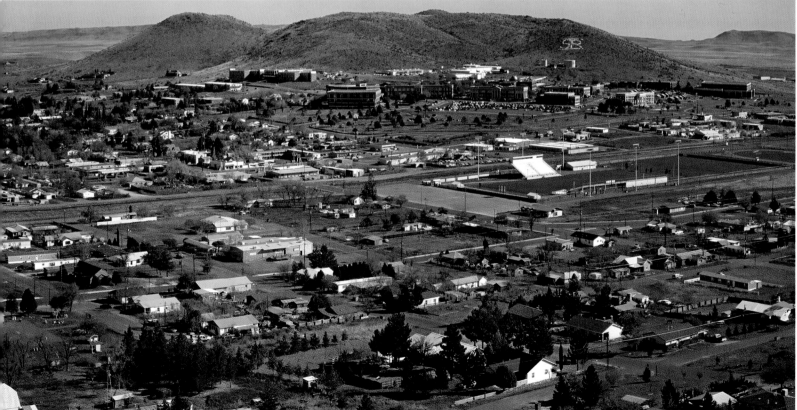

I thought finding the location of this photo would be a cinch. It was a short hike up to the summit of "A" Mountain, but once there, I had trouble finding visual cues to locate the original vantage point. The only building I could verify as being in both old and new scenes was the courthouse, but as it didn't line up with the mountain in the distance, I realized I was too far east. The hilltop behind Sul Ross State University added to my confusion, for it still jutted up above the horizon even though I was at the summit of "A" Mountain—an indication that I was not as high up as the original photographer. In the end, the fierce winds dictated where this shot would be taken—just below the summit of the mountain, where the road cut provided enough of a windbreak to allow me to set up my camera.

19

Marfa Presidio County Courthouse, 1890

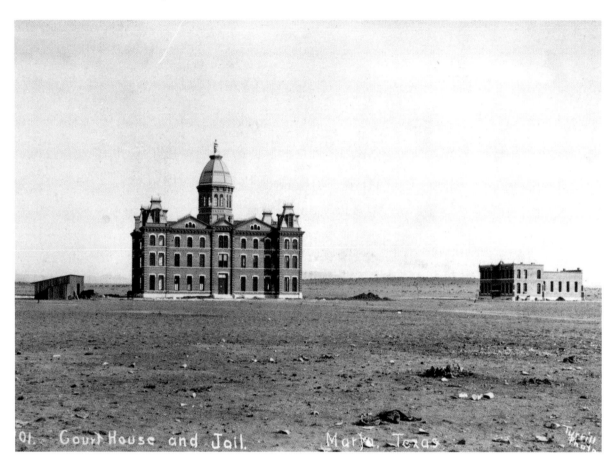

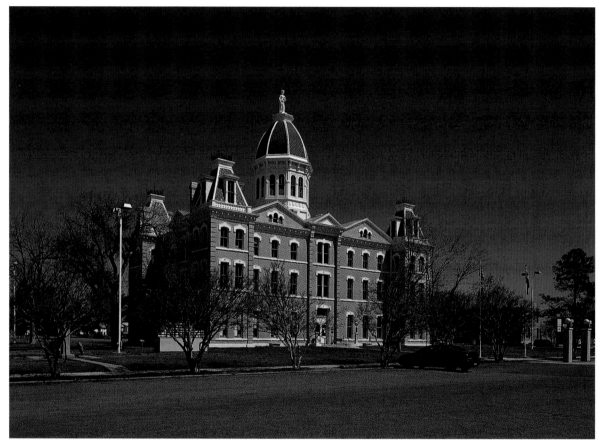

Marfa was established in 1883 as a water stop and freight headquarters for the Galveston, Harrisburg, and San Antonio Railway. It is named after a character in the Dostoevsky novel, The Brothers Karamazov. *By 1885, Marfa had a saloon, a hotel, and a general store. A year later, this three-story Renaissance Revival courthouse, designed by Alfred Giles, was built for $60,000. The U.S. government sent cavalry troops to Marfa during the Mexican Revolution and also built canvas hangars there from which biplanes flew reconnaissance missions. The military presence in Marfa and Presidio County was continued and enlarged by the establishment of Camp Albert. The town and surrounding area have been featured in several Hollywood movies, including* Giant *(1956) and* The Andromeda Strain *(1971).*

Marfa has enjoyed a growing arts community since the establishment of the Chinati Foundation in the late 1970s. Its tourism industry has also boomed due in part to it being widely known as one of the coolest places in the state to visit during the summer. Ideal thermals in the area brought in gliders in 1963. Marfa eventually hosted two national soaring competition meets, an international meet, several regional meets, and a number of annual soaring camps. The original Presidio County Courthouse, the centerpiece of downtown Marfa, underwent a complete restoration in 2001.

Marathon Camp Peña Colorado, circa 1930

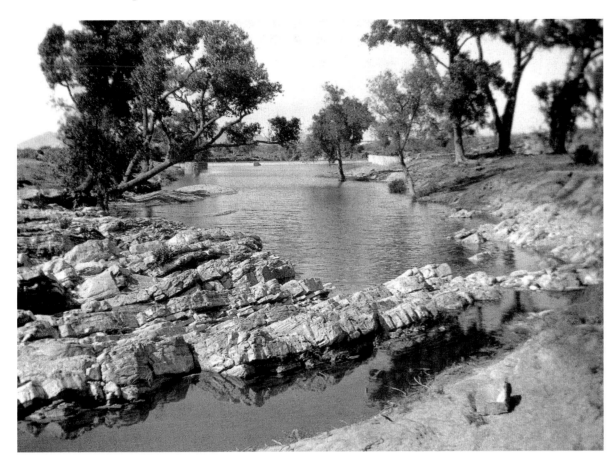

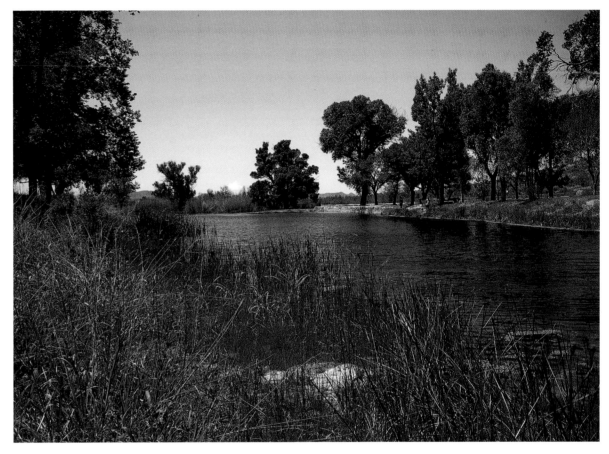

For nearly 15 years, the U.S. Army used Camp Peña Colorado for a post during the late 1800s. It was located about 4 miles southwest of the site of present-day Marathon. The post was built near a large spring on Peña Colorada Creek, for which the creek, and the post were named. Indians occupied the area for thousands of years before the U.S. Army moved two companies of the Twenty-fifth U.S. Infantry Regiment here from Fort Stockton in 1879. The regiment's primary purpose was to increase pressure on the Apaches of the Trans-Pecos region, who were still forcefully resisting white settlement. Secondary duties included escorting and protecting settlers in the region, building roads, and pursuing bandits and horse thieves. The post was abandoned in January 1893 when the Indian threat diminished and the need for U.S. Army troops in the Big Bend shifted closer to the border.

The site of the old camp, now known as Post Park among locals, is about 5 miles south of Marathon. In 1935, David St. Clair Combs, an early trail driver and prominent Texas rancher, donated the land around Peña Colorada Springs for a park. A historical marker now designates the former outpost. The park is still enjoyed by residents of the area who have picnics around a spring-fed water hole surrounded by cottonwood trees.

Sanderson 1913

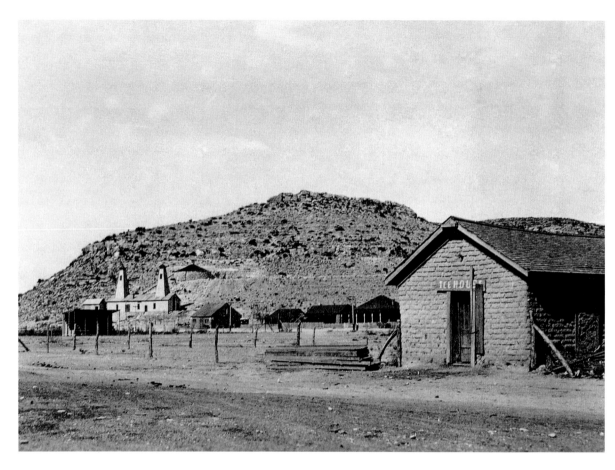

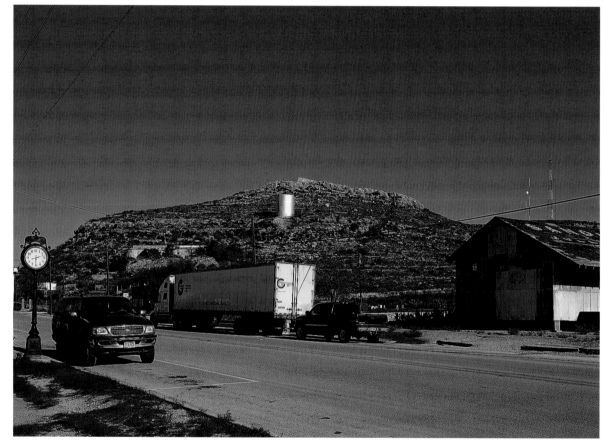

Sanderson lies in a sparsely populated area of West Texas that was known as Strawbridge when the site served as a division point for the Southern Pacific Railroad. In 1882, the town was renamed after Thomas P. Sanderson, a railroad engineer. In its early years, Sanderson was a rowdy frontier town. Roy Bean operated a saloon there for a short time and Charlie Wilson's Cottage Bar was a favorite spot for railroad workers, cowboys, and local ranchers. On June 11, 1965, Sanderson was devastated by a flash flood that roared down Sanderson Canyon into the town, destroying numerous homes and businesses and killing 24 people. To prevent further catastrophes, the town built 11 flood-control dams.

Today, Sanderson calls itself "The Cactus Capital of Texas." A drive through the town in early to mid-spring gives the nickname justification, with dozens of species of the spiny plants in bloom. The town is on historic US 90, approximately midway between San Antonio and El Paso. Its geographic location and altitude of about 3,000 feet give Sanderson a relatively mild climate. Many of the old adobe and stucco buildings, the century-old depot, railroad buildings, and cattle pens from its frontier days are still standing.

Lajitas 1916

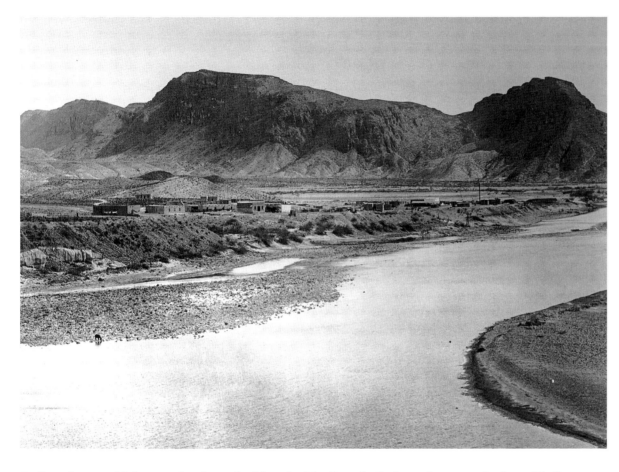

Lajitas sits on a high, steep bank overlooking the Rio Grande. In its early years, the fate of Lajitas was closely tied to the quicksilver (mercury) market in nearby Terlingua. The boom years brought many people into the area during the late 1800s and early 1900s. Ranching in northern Mexico increased traffic across the Rio Grande as well. Pancho Villa's attacks along the border prompted the U.S. Army to establish a cavalry post there in 1916 under the command of Gen. John Pershing. After the quicksilver business went bust in the 1940s, only four people remained in Lajitas.

Still a small town on the western edge of Big Bend National Park, Lajitas has been growing as a resort town ever since. Houston entrepreneur Walter M. Mischer first undertook its redevelopment in 1976. Three motels, a hotel, a restaurant, a golf course, a swimming pool, an RV park, and an airstrip were built by the mid-1980s. Hollywood soon discovered Lajitas and several movies were filmed in the area during the 1980s and 1990s. "Lajitas, The Ultimate Hideout" is the newest resort in the area, offering elegant accommodations, private club, golf course, spa, tennis center, and several fine restaurants.

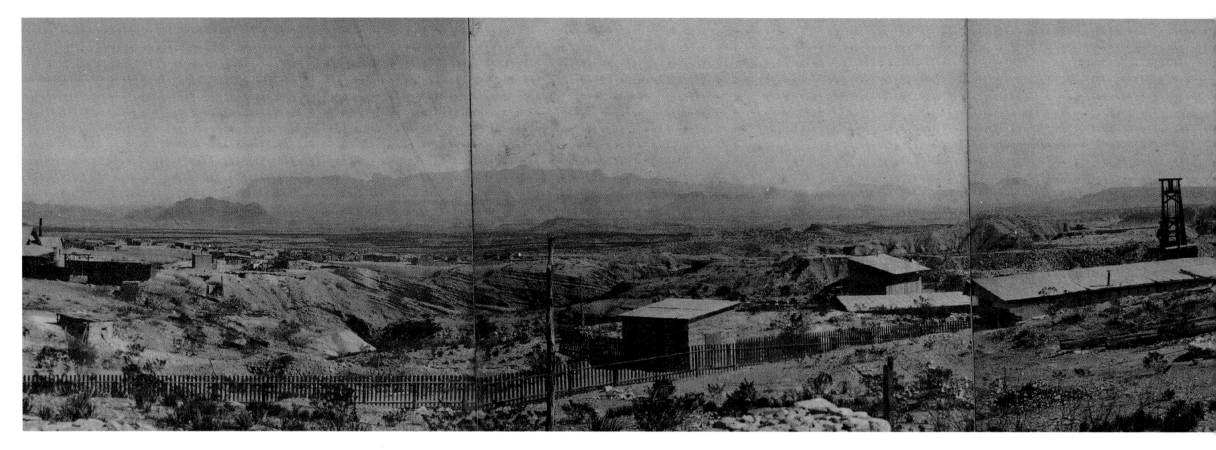

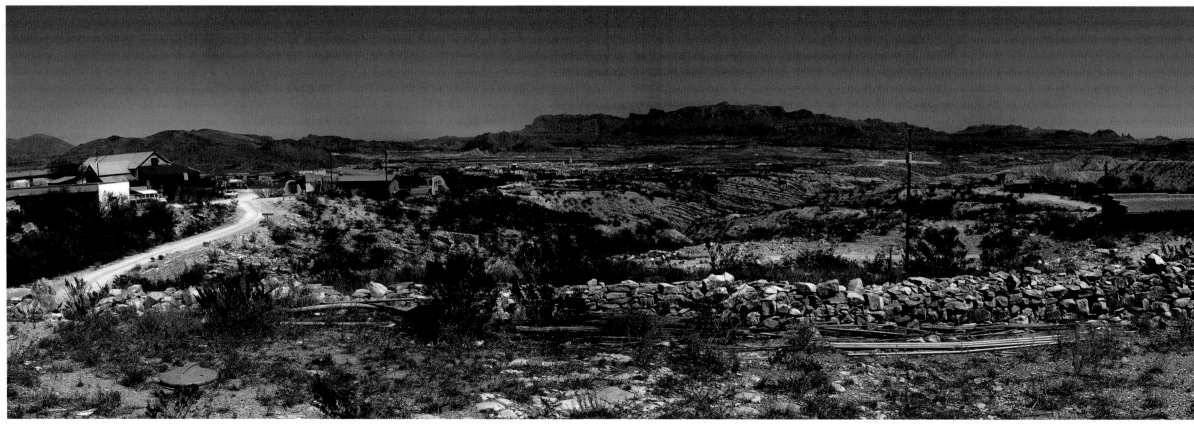

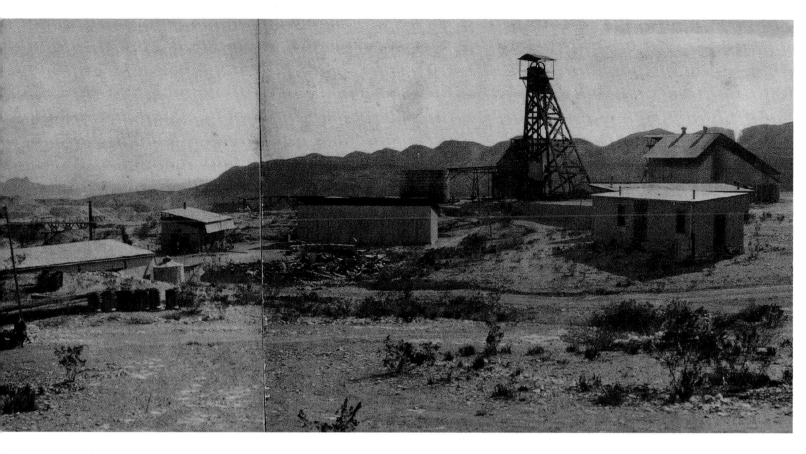

Terlingua, an arid desert town nestled in the badlands west of Big Bend National Park, was once a thriving quicksilver (mercury) mining town. The name is derived from the Spanish "tres linguas," meaning three languages, referring to the multicultural flavor of the area: Mexican, Native American, and Anglo.

It didn't take long to find the vantage point for this 100-year-old panorama from the Terlingua mining district west of Big Bend National Park. It was taken in the heart of Old Terlingua at the Perry Mansion, which was built by town founder Howard E. Perry during the boom years of the Chisos Mining Company. The structure was unused for many years but when my wife and I went to photograph the scene, a Terlingua musician who goes by the name "Uh Clem" was living there. Clem was very cordial and not only agreed to let us photograph the scene, he figured out the vantage point and filled us in on Terlingua history in the process.

Terlingua Post Office, early 1900s

Starlight Theatre

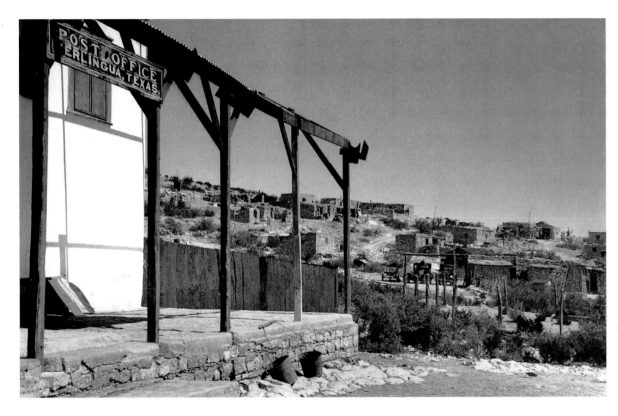

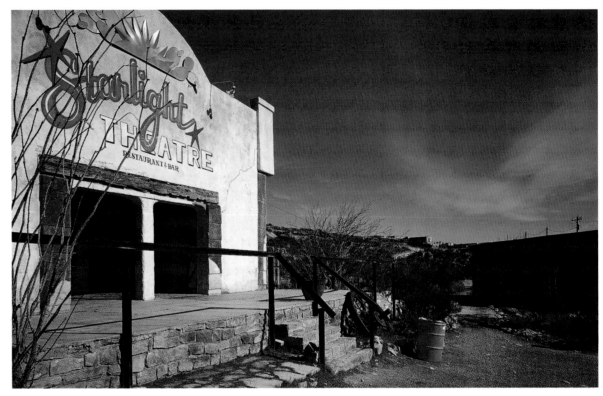

The Terlingua Post Office was established in 1899, and by 1902, in addition to the mine complex, Terlingua consisted of a number of temporary structures occupied by some 200 to 300 laborers. That same year, Howard E. Perry established the Chisos Mining Company to mine quicksilver for use in thermometers and as a primer to detonate gunpowder in cartridges and shells. By the end of World War I, Terlingua quicksilver dominated the industry in the United States, but by 1942 Perry declared bankruptcy and Terlingua became a ghost town. After World War II, mining in the area ended and area ranchers were struggling. The establishment of Big Bend National Park in 1944 marked the beginning of a new industry for the region—tourism.

Today, Terlingua is a town of sharp contrasts: crumbling, roofless adobe buildings, and rusty old cars and machinery juxtaposed with new motels and cafes. Significant changes have taken place in the past 25 years. A new community has developed, part of it catering to tourists, the other part acting as home to a growing number of artists and refugees from big cities. Talented musicians abound and live music can be heard year-round in such local establishments as the Starlight Theatre. The one-time Terlingua Post Office and former movie theater has been converted into one of the best-known bars and eateries in the area, patronized by locals and visitors alike. River rafting on the Rio Grande has become such a popular tourist activity that there are now four outfitters in the area.

Big Bend Area CCC Basin Camp, 1934

Big Bend National Park

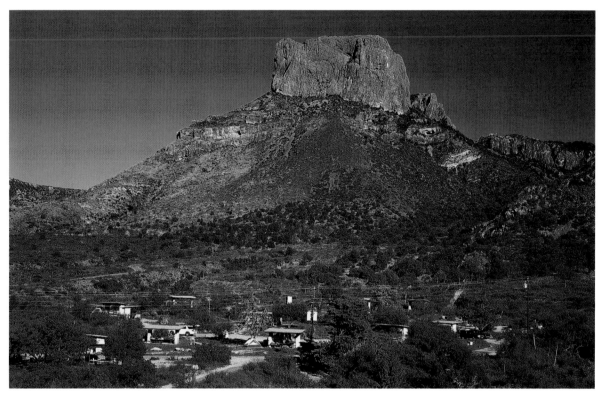

Franklin D. Roosevelt's New Deal played an important role in the development of Big Bend National Park. The discovery of water in the Chisos Basin in the early 1930s led to the establishment of the Civilian Conservation Corps (CCC) camp pictured here. CCC crews began working on roads, campsites, and trails to prepare the park to receive visitors. To ease their stay in the rugged surroundings, workers were provided with a number of amenities, including access to woodworking facilities and photographic darkrooms. Later, CCC crews built additional mountain trails, a general store, and stone cottages still in use today. The CCC program ended in 1942, but today's visitors to Big Bend still enjoy the results of its efforts.

High-tech nylon tents and an assortment of pickup campers and motorized recreational vehicles have replaced the old canvas CCC tents. A modern facility with paved roads, covered shelters, and running water has supplanted the old campground. As of this writing, a private vendor was scheduled to take over management of the campground. A "controlled burn" fire set in March 1999 by the National Park Service consumed the northern and western slopes of Casa Grande, the large flat-topped mountain pictured here. In the five years since, the remarkable recovery is apparent, particularly the native grasses that quickly filled in available spaces after the fire.

Big Bend Area Lost Mine Trail, 1930

Big Bend National Park

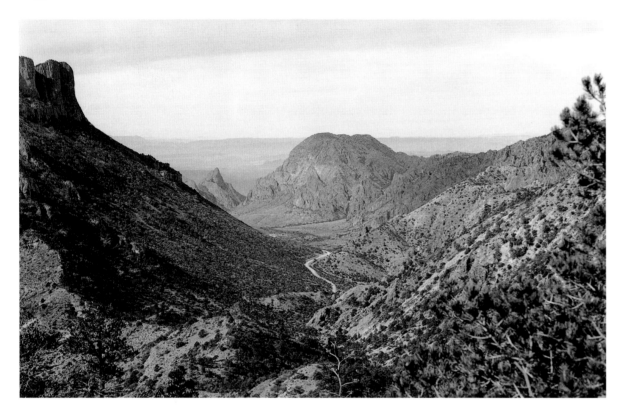

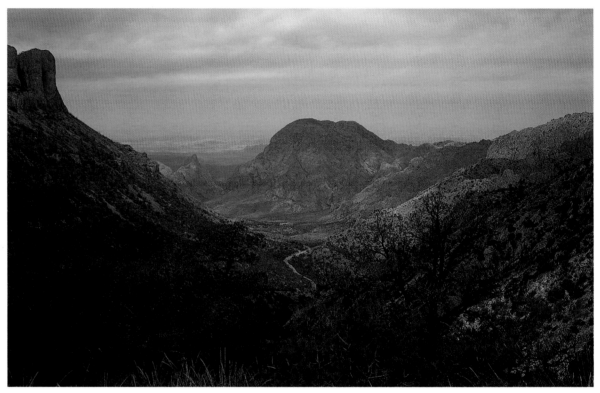

Wilfred Dudley "W.D." Smithers, a photographer and writer who produced the first significant body of photography on the Big Bend region between 1915 and 1940, made this photograph before Big Bend was established as a national park. Smithers hiked to this spot several years before the Civilian Conservation Corps blazed a trail that is still used today. Some of the colorful rocks across the valley below hinted of hidden mineral wealth to early explorers. There are stories of a rich seam of gold being discovered in this area by Spanish settlers, knowledge of which was supposedly lost when the settlers were killed by Native Americans. No trace of such a mine in this area has ever been found, but the story floated around long enough to provide the "Lost Mine" moniker that is still used today.

The 5.2-mile Lost Mine Trail begins at mile marker 5, just below Panther Pass on the Basin Road. The hike provides one of the best views in the park. The trail starts at an elevation of 5,600 feet and climbs over the lower slopes of Casa Grande on the north-facing side of Green Gulch, a relatively sheltered valley with pine, juniper, and fir trees. It steadily climbs to the top of a 6,850-foot promontory overlooking Pine and Juniper Canyons. In this view from the ridge at the end of the trail that divides the two canyons, little has changed since Smithers made his photograph more than 70 years ago. Beyond the Window (the V-shaped cut in the middle of the picture), the Chihuahuan Desert and the Mesa de Anguila are visible in the distance to the west.

Big Bend Area Western flank of the Chisos, 1930

Big Bend National Park

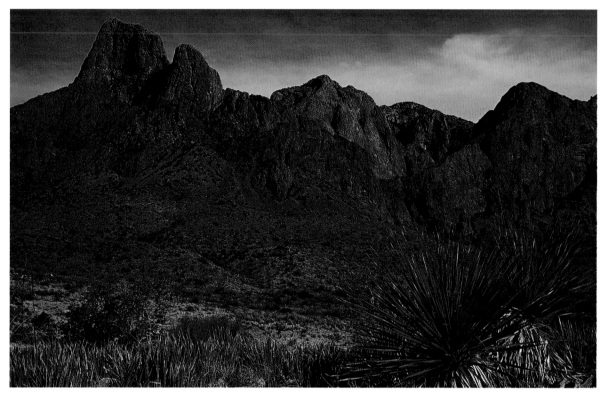

In 1929, Homer Wilson, a mining and petroleum engineer from Del Rio, arrived in Brewster County and began buying grazing land west of the Chisos Mountains. He eventually acquired 44 sections, including most of the old G4 ranch, a massive tract of land owned in the 1880s by the son of a former Confederate general. Wilson established his headquarters at Oak Spring, one of the two creeks that drain the Chisos Basin, where he became the first large-scale sheep and goat rancher in the Big Bend area, introducing various ranching and water-conservation innovations. He remained in business until the mid-1940s, when the Park Service took over much of the land that had belonged to the old G4 with the establishment of Big Bend National Park.

When Ross Maxwell became Big Bend National Park's first superintendent in July 1944, he faced several serious problems, not the least of which was the presence of ranchers who remained on the land. There were still about 50 active ranchers in the park, running about 25,000 cattle, 30,000 sheep, and 2,000 horses. Faced with the difficulties of moving people and stock, the Park Service did not get all the stray livestock out of the park for five more years. The scars of overgrazing are still apparent 55 years later. Native grasses have returned in some areas, but in most, desert vegetation such as the lechuguillas pictured here still dominate the landscape.

Big Bend Area Green Gulch, 1930

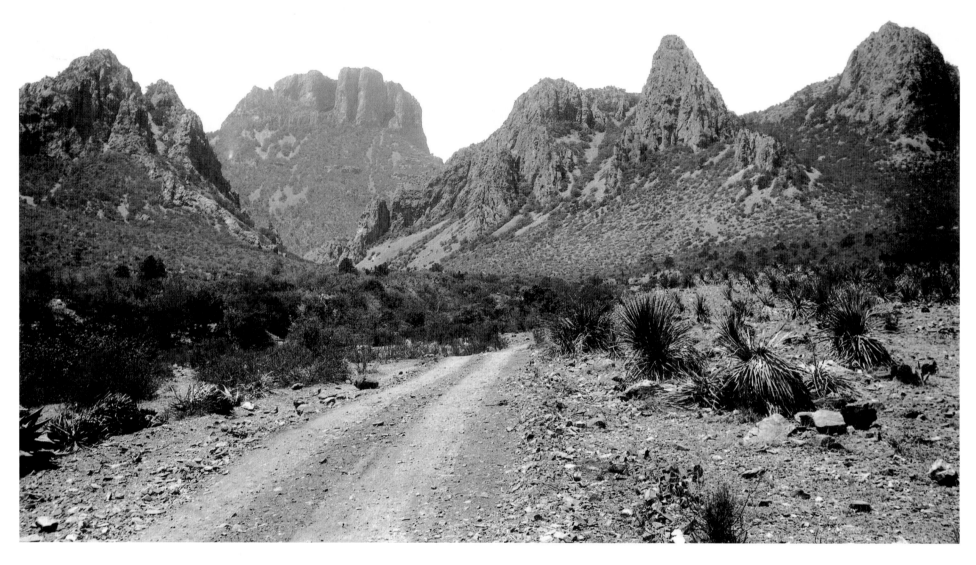

The Civilian Conservation Corps (CCC) was one of President Franklin D. Roosevelt's New Deal programs designed to reduce unemployment while conserving natural resources. The CCC changed the lives of several million people across the country, including hundreds who worked in Big Bend National Park in the 1930s and 1940s. Just a few years after Wilfred Dudley "W.D." Smithers made this picture, the CCC built an all-weather access road into the Chisos Basin. The CCC crew surveyed and built a 7-mile road using only picks, shovels, rakes, and a dump truck, which it loaded by hand. The crew members scraped, dug, and blasted 10,000 truckloads of earth and rock and constructed 17 stone culverts that are still in use today along the Basin Road. Nicknamed "Roosevelt's Tree Army," the CCC operated through the cooperative efforts of four agencies: the Departments of Labor, Interior, and Agriculture, and the U.S. Army.

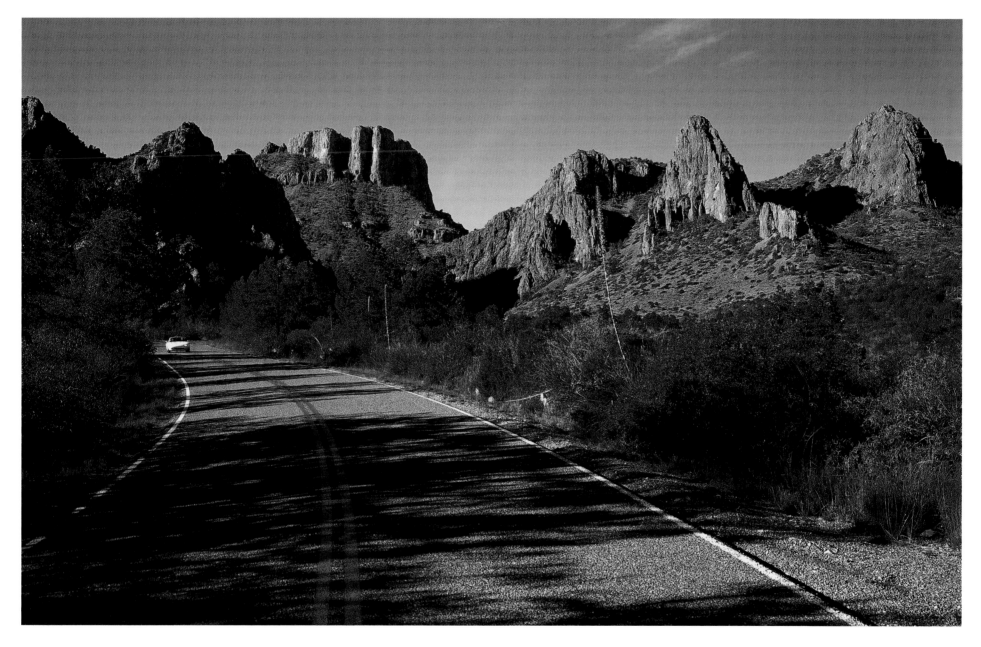

Today, the road into the Chisos Basin is one of the best scenic drives in the park, winding through the sprawling meadows of Green Gulch, offering views of the towering Chisos Mountains all around. The road climbs steadily for 7 miles and reaches its summit at Panther Pass before descending into the Chisos Basin through a series of sharp, winding curves. Mountain lions, black bears, and javelinas may occasionally be seen crossing the road.

Big Bend Area Santa Elena Canyon, 1930

Big Bend National Park

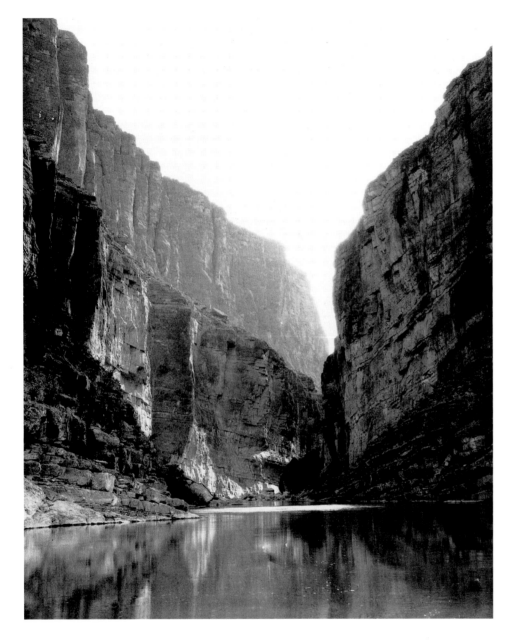

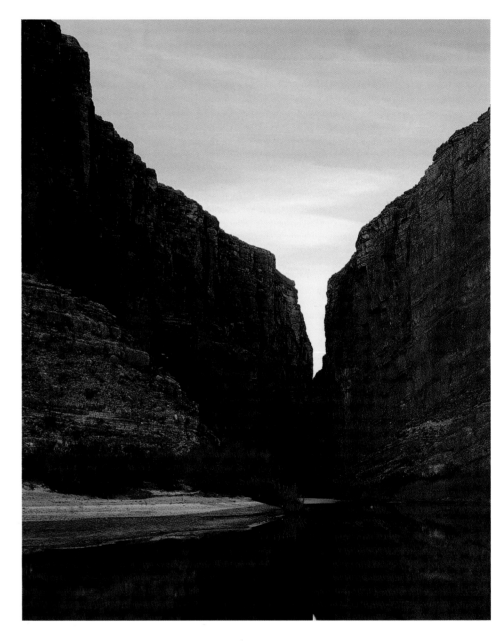

The Rio Grande has sliced through 100 million-year-old limestone to create three magnificent canyons: Boquillas, Mariscal, and Santa Elena. The latter is perhaps the most spectacular, and definitely the most difficult to navigate, whether by canoe, raft, or boat. Many have ventured into the canyon confident of their navigational skills, only to be stymied by the Rock Slide—a jumble of huge boulders stacked more than 200 feet high with the river spilling through. The mouth of the canyon is also spectacular, but is decidedly calmer and much easier to get to. The river passes through 1,500-foot-high sheer canyon walls separating Texas from Mexico, meets up with Terlingua Creek, takes a right turn, and continues on to Mariscal Canyon.

In 2003, after a 10-year drought, the river stopped running in several places for the first time in the park's 59-year history. Bountiful summer rains later that year and in 2004 helped get the river running again and eased the drought, but the Rio Grande continues to run at historically low levels. The mouth of Santa Elena Canyon is accessible by a short trail leading from a parking lot off the main road. The trail continues into the canyon for about another half mile, when Terlingua Creek is not too high.

THE PANHANDLE

Palo Duro Canyon ☆ Higgins ☆ Canadian River ☆ Canadian ☆ Old Mobeetie ☆ Tascosa
Amarillo ☆ Randall County ☆ Mineral Wells ☆ Plainview ☆ Lubbock ☆ Fort Concho ☆ San Angelo

> "Texas will again lift its head and stand among the nations. It ought to do so, for no country upon the globe can compare with it in natural advantages."
> —Sam Houston, War Hero

Palo Duro Canyon The Lighthouse, 1930

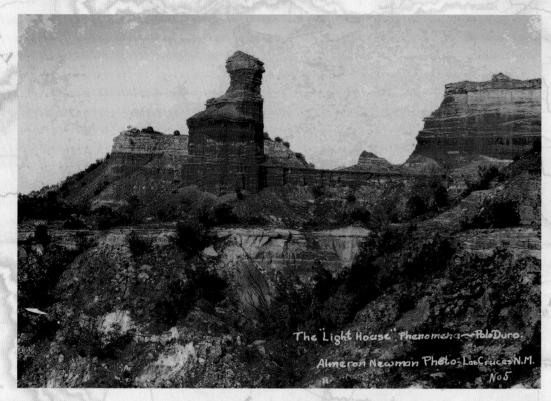

The "Light House" Phenomena—Palo Duro.
Almeron Newman Photo—Las Cruces N.M.
No 5

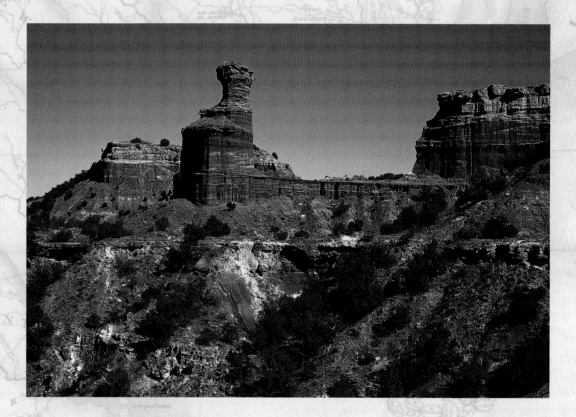

The canyon's first explorers no doubt came across the Lighthouse formation, a 300-foot-high shale-and-sandstone pinnacle carved from a ridge by erosion. The Apaches were some of the first occupants of Palo Duro Canyon. Comanches and Kiowas arrived sometime during the 18th century. Although the members of Coronado's expedition may have been the first Europeans to see the canyon in 1541, the first Anglo-Americans to explore Palo Duro were members of Capt. Randolph B. Marcy's 1852 expedition, who came in search of the Red River's source. The first scientific expedition into the canyon came in 1876. Almeron Newman, a photographer from Santa Fe, made this fine photograph around 1930.

The Lighthouse is still the best-known formation in Palo Duro Canyon State Park, and has been designated a National Natural Landmark by the National Park Service, a designation recognizing the best examples of biological and geological features in both public and private ownership. A number of the park's multiuse trails lead to the Lighthouse. The primary hiking trail is a moderate, mostly level hike until a short but steep climb at the end leads directly to the base of the formation. While no major change in the surrounding landscape is apparent, some minor weathering of relatively soft formations can be seen.

Palo Duro Canyon 1930

Palo Duro Canyon is the signature landscape feature of the Texas Panhandle. The canyon gets its name, Palo Duro, from the Spanish words for "hard wood." It is 800 feet deep and up to 12 miles wide, although the average width is 6 miles. The kaleidoscope of colors in the canyon walls tells the story of four different geologic periods. The vegetation in the park includes many native grasses, prickly pear cacti as well as juniper, willow, cottonwood, and mesquite trees. In wet years, the canyon explodes with wildflowers in mid- to late spring.

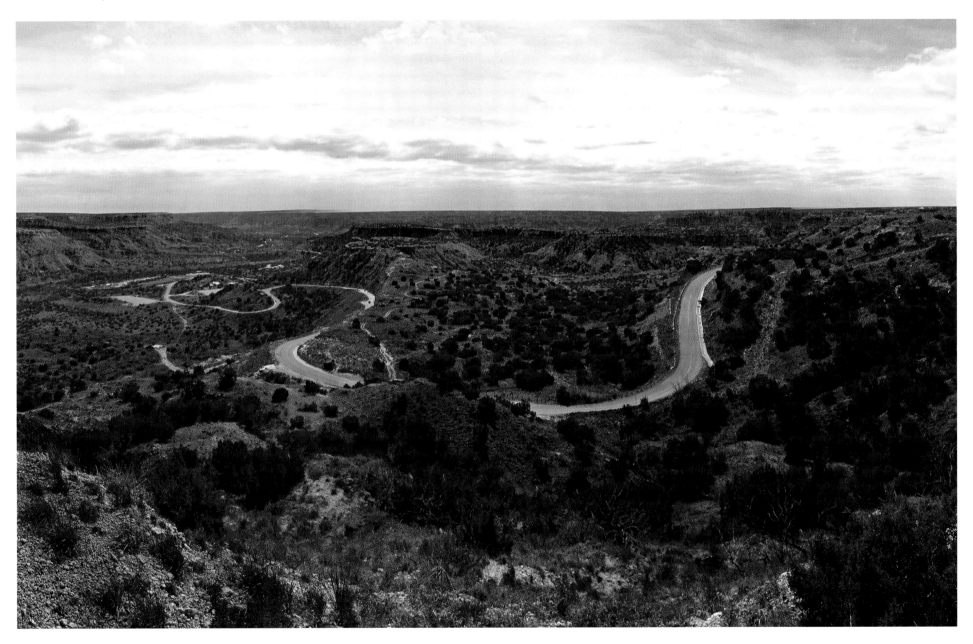

While the canyon was used for cattle ranching for decades, it also became a favorite spot for the locals to picnic and camp. In 1933, the state of Texas purchased land in the upper canyon to establish Palo Duro Canyon State Park, which overlaps Armstrong and Randall Counties. Today, more than 500,000 visitors see the canyon every year. The 8-mile drive into the canyon traces Charles Goodnight's route when he established his Old Home Ranch here in 1876. The Texas Parks and Wildlife Department keeps a small herd of longhorn cattle, descendants of the original state herd at Fort Griffin, on the canyon rim.

Palo Duro Canyon Devil's Tombstone, early 1930s

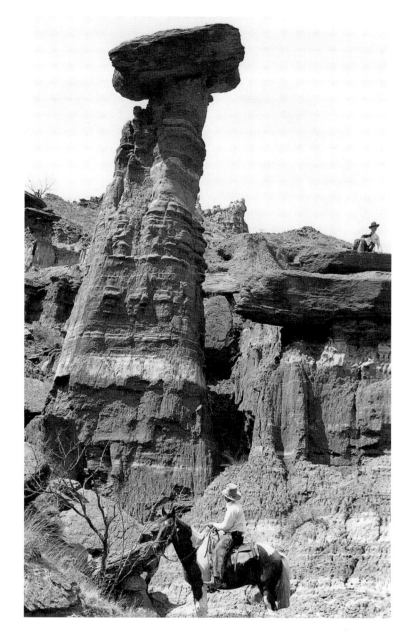

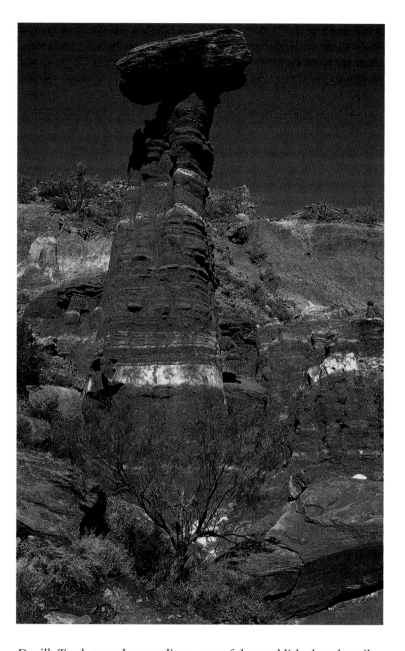

Palo Duro Canyon extends 60 miles, spanning from near the town of Canyon to Silverton. It was formed primarily by water erosion from the Prairie Dog Town Fork of the Red River. The canyon walls reveal four distinct rock layers dating back 240 million years: Cloud Chief Gypsum, Quartermaster, Tecovas, and Ogallala. The first three are readily apparent in the canyon formations known as the Spanish Skirts. The Ogallala layer is composed of sand, silt, clay, and limestone—the same ingredients in the cap rock that underlies the entire Texas Panhandle. Devil's Tombstone, pictured here in the early 1930s, is one of the more distinctive formations standing within the state park.

Devil's Tombstone does not lie on any of the established park trails; and I discovered it accidentally while hiking to the Lighthouse. Towering 50 feet or so above the canyon floor, it is relatively small when viewed from the half mile or so it stands away from the Lighthouse trail. The giveaway is the flat boulder adorning the top of the shale and sandstone pedestal. Its unmistakable lopsided appearance is visible even from a distance. After traversing through a number of arroyos and dense prickly pear thickets, I discovered that the formations in this scene had indeed changed noticeably in the 70 years or so since the first photo was made—several large boulders had been dislodged by erosion.

Palo Duro Canyon El Coronado Lodge, circa 1930s

Palo Duro Canyon State Park Interpretive Center

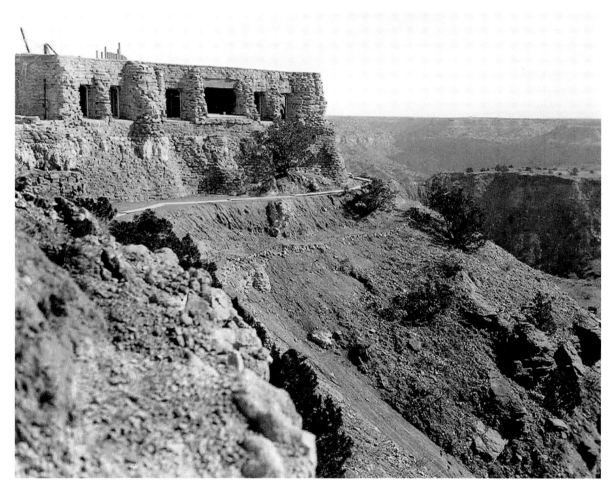

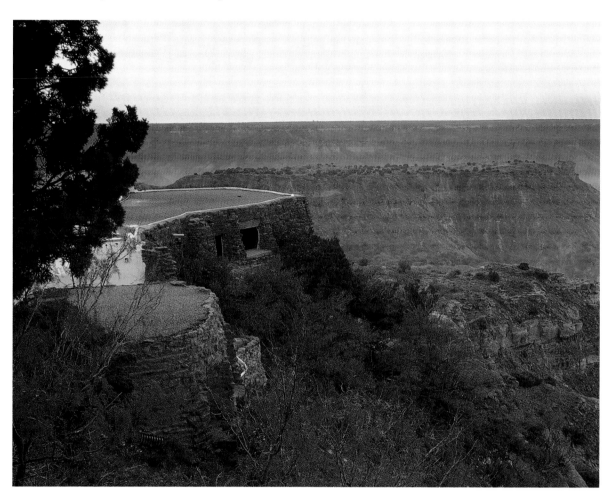

In the early 1930s, President Franklin D. Roosevelt authorized the creation of four Civilian Conservation Corps (CCC) camps to work in Palo Duro Canyon for a period of five months. The crews built El Coronado Lodge and six other cabins on the park's rim; the cabins are still in use today. Guy A. Carlander, an Amarillo architect and one of the park's leading proponents, designed them (and took this photograph). The CCC also built several bridges and concrete river crossings, created a water system, and worked on a number of roadways and trails in the park. Palo Duro Canyon State Park officially opened on July 4, 1934.

Today, the old El Coronado Lodge has been converted into an interpretive center for the state park that details the canyon's colorful history and geology. Large picture windows present stunning panoramas of the canyon below, along with numerous mesas, buttes, and other geological formations.

Higgins 1905

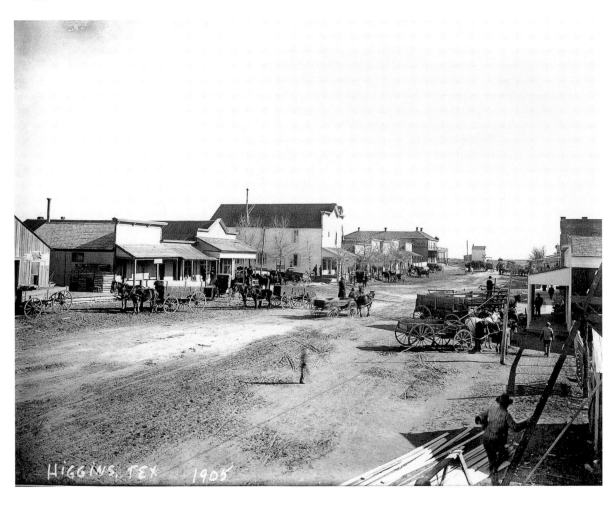

Higgins is a small town in the grasslands of the eastern Panhandle, only 2 miles from the Oklahoma border. It was settled in 1886 when surveyors from the Santa Fe Railroad were in the area looking to extend the railroad's Panhandle branch line. The following year, B.H. Eldridge and E.B. Purcell laid out the town, which they named for G.H. Higgins of Massachusetts, a wealthy stockholder in the Santa Fe Railroad. The railroad was instrumental in the town's rapid growth, and ranching soon became a major industry in Higgins.

Today, the town is a grain and livestock marketing center and has had oil wells since 1956. The local newspaper, the Higgins News, has been in operation since 1897. In 1898, 19-year-old Will Rogers came to Higgins and worked for a time on the Ewing family's Little Robe Ranch. In 1962, the town began an annual observance of Will Rogers Day.

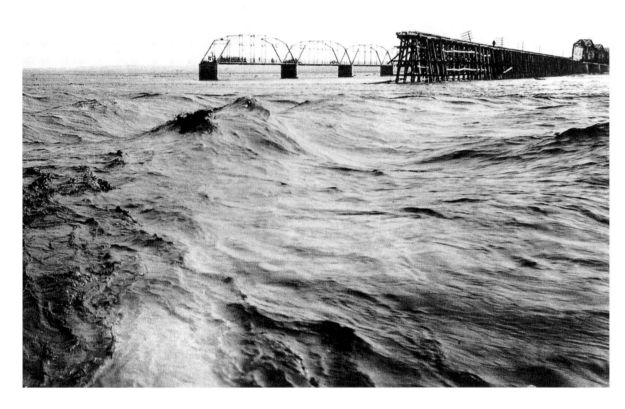

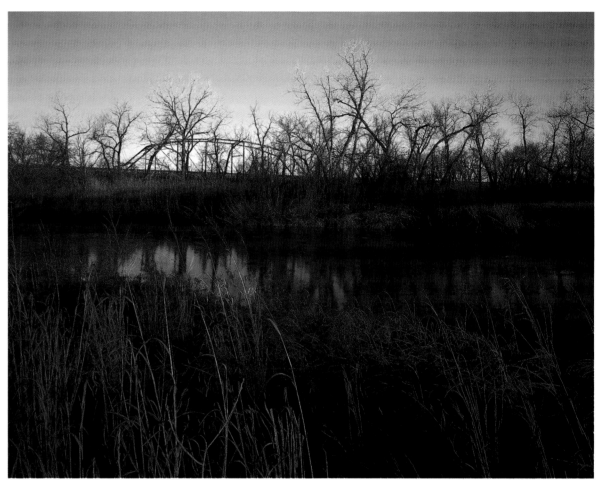

The Canadian River originates south of Raton Pass, snakes across northeastern New Mexico, and then winds through the Texas Panhandle for almost 200 miles. Early explorers erroneously thought the river went through Canada, hence its name. The Canadian has carved a gorge as much as 800 feet deep during its run through Texas. The 2,635-foot-long Canadian River Wagon Bridge was completed just north of the town of Canadian in 1916. A flood in October 1923 cut a gaping 600-foot-wide channel around the northern end of the eight-year-old bridge, rendering it unusable. Civic leaders wasted no time in fixing the problem. With the financial assistance of the Texas Highway Department, four new spans were added to the bridge to extend it across the new channel. The work was completed less than a year after the flood.

Four additional spans brought the bridge's total length to 3,255 feet. The bridge is still considered to be one of the best examples of a multiple overhead truss design in Texas. The original Canadian River Wagon Bridge still stands parallel to the US 60/83 bridge just a few miles north of the town of Canadian. Since 1953, when the new concrete bridge was constructed, the old wagon bridge was restricted to supporting a natural gas pipeline across the river. Today, the old bridge is open to foot traffic only.

Canadian 1900

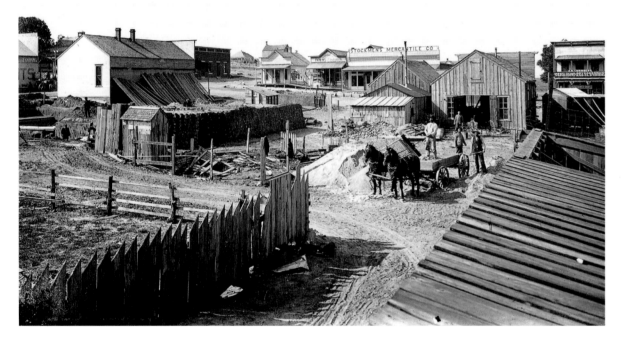

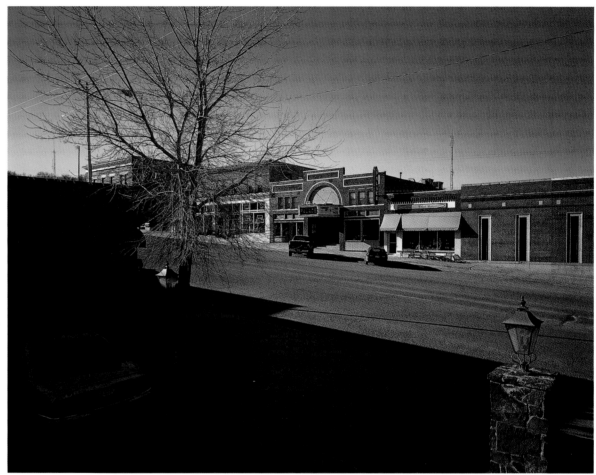

In 1887, the town of Canadian was founded on the south bank of the Canadian River in the eastern Texas Panhandle. When a bridge across the Canadian River was completed that same year, the residents of nearby Hogtown moved their homes and businesses to Canadian. As the town attracted more settlers and businesses, Canadian added a hotel and a post office. Canadian's reputation as a rodeo town began the following year when the annual Cowboys' Reunion staged a commercial rodeo, one of the first in Texas. The event has been an annual custom ever since.

In the early 1950s, Canadian lost its railroad roundhouses and division headquarters as a result of reorganization by the Santa Fe Railroad. Nevertheless, it continued to thrive on ranching and farming, as well as oil and gas production. In addition to the annual rodeo, the annual Midsummer Music Festival in August and the Autumn Foliage Tour in October attract visitors to Canadian. The Pioneer Museum is housed in the old Moody Hotel, which dates from 1906.

Old Mobeetie Post Office, 1878

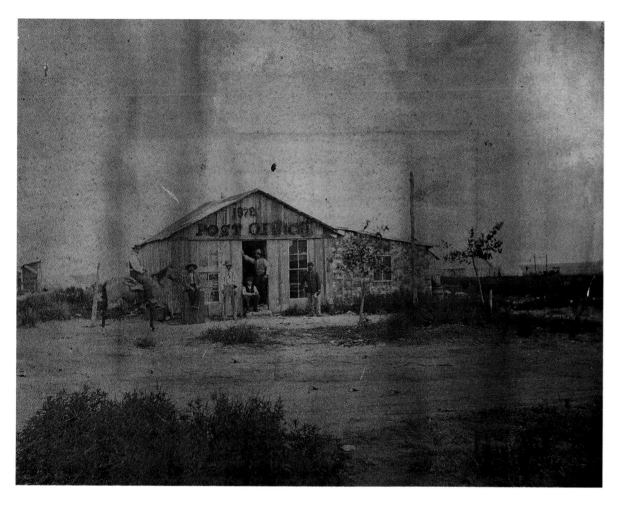

Mobeetie was the first town in the Texas Panhandle. Its name comes from a Comanche word meaning "sweet water." The community originally wanted to be called Sweetwater, but had to select another upon discovering the name was already taken. For a time during the late 1800s, Mobeetie was the center of commerce in the Panhandle region. It was a trading post for nearby Fort Elliot and for buffalo hunters who plied their trade in the area. The town's fortunes declined when Fort Elliot was closed in 1890 and a destructive tornado hit in 1898.

Only a handful of residents remain in this one time "mother city" of the Panhandle. When the railroad lines bypassed the town in 1929, most of the residents and businesses moved to form the new community of New Mobeetie, two miles away. On my first visit to Old Mobeetie, I was surprised how many shady trees were on the grounds and how peaceful it was. The old jail, the fort's original flagpole, and a few buildings are all that remain at the site. There is an RV park, although I didn't see any campers there during my two visits.

Old Mobeetie Jail, circa 1880s

Old Mobeetie Museum

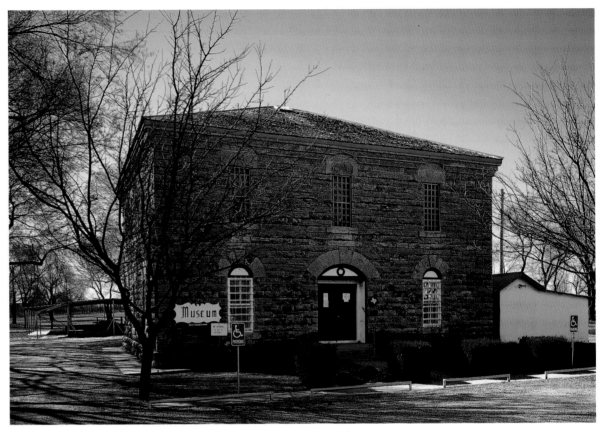

Mobeetie was a typical raucous frontier town that attracted a number of famed Old West characters in its heyday. Some of its legendary visitors included Bat Masterson, Pat Garrett, and Poker Alice. In the early 1880s, Capt. George W. Arrington and his company of Texas Rangers arrived to restore law and order to the town. Arrington was so successful that he was elected sheriff in 1882, and he promptly made the old jail his new home.

The old jail is now a museum commemorating Old Mobeetie's frontier heritage. Among its holdings are an original hanging device, a buffalo-horned Comanche war bonnet, old photographs, and an impressive collection of antique bottles that were recovered from Fort Elliot.

Tascosa Courthouse, 1911

Julian Bivins Museum

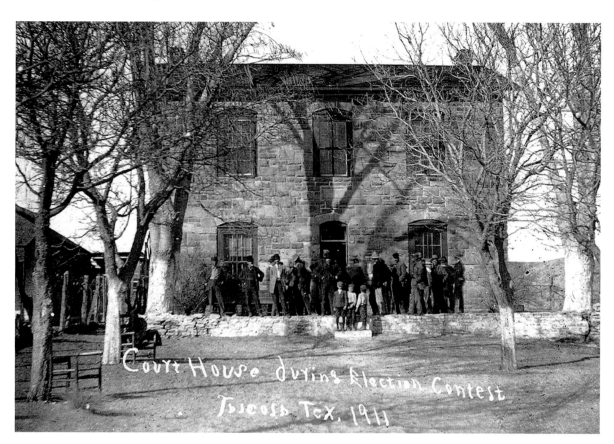

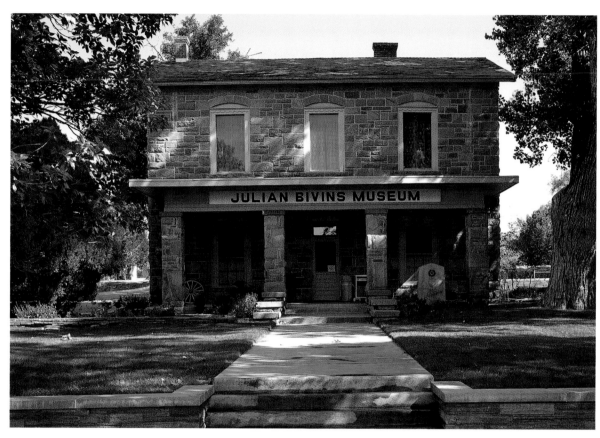

Tascosa's beginnings date back to the days when cattle drives came through the Panhandle on the way to Dodge City. Tascosa's location on the Canadian River was at the site of an easy ford for cattle and freight. After 1875, large ranches dominated the area, and Tascosa supported them as a shipping and supply center. Tascosa was named the Oldham County seat in 1880, and a stone courthouse was built. As the "Cowboy Capital of the Plains," Tascosa had its share of gunfights. Famous outlaws such as Henry "Billy the Kid" McCarty and Dave Rudabaugh, as well as lawmen Pat Garrett and Charles A. Siringo, settled their scores at one time or another in Tascosa. As other Panhandle towns grew, Tascosa entered into a period of steady decline. Tascosa lost its county seat to Vega after an election in 1915, then lost most of its population. Frenchy McCormick, widow of the town's first saloon owner, was the last resident of old Tascosa by 1939.

In June 1939, Cal Farley, a former professional wrestler and Amarillo businessman, established his Maverick Boys Ranch at the site of old Tascosa, offering a home and training opportunities to underprivileged boys. The ranch opened in March 1939 with five boys housed in the old county courthouse, which also served as the first headquarters of the institution. The courthouse, donated by former property owner Julian Bivins, continued to be used as a dormitory until 1963. At that time, it was converted into a house museum and opened as the Julian Bivins Museum.

Tascosa Schoolhouse, 1922

The old schoolhouse was built in 1885 using adobe bricks, over which plaster was later applied on the exterior to reduce weathering. Between 1910 and 1920, it was clad in wood siding for further protection. Melba Brown was a teacher at the original Tascosa school when Cal Farley founded Maverick Boys Ranch in 1939. For the next 50 years, she taught in this schoolhouse and another one in Tascosa. The county deeded the schoolhouse to Ms. Brown upon her retirement in 1989, and she in turn deeded it to the Boys Ranch. It was gradually restored over the next eight years. Ms. Brown moved to Guymon, Oklahoma, where she was still living as of this writing.

Today, the schoolhouse is a museum with an old piano, desks, and other antique furniture. It is occasionally used for public relations work, and as a music hall for fiddlers and other musicians to get together and jam.

Amarillo Magnolia Petroleum, late 1920s

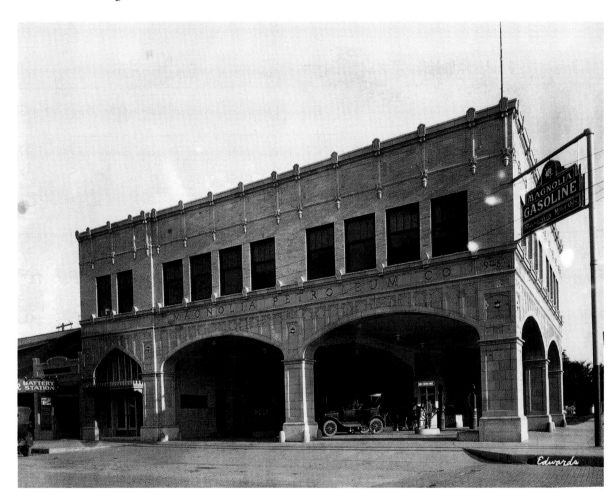

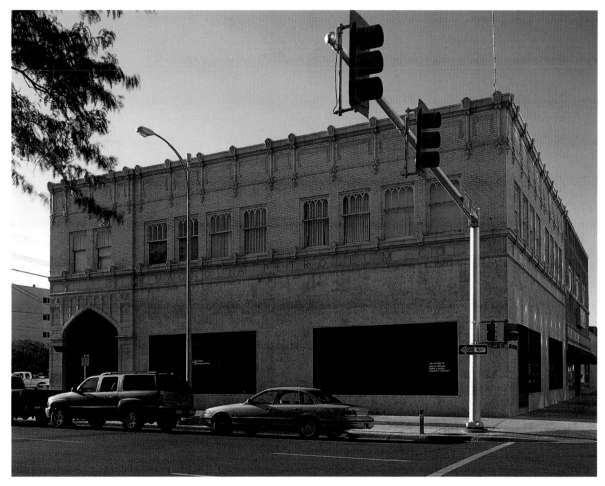

Thanks to the famous Spindletop discovery, Texas oil quickly became big business. Hundreds of oil companies sprang up all over the state. The Magnolia Petroleum Company, founded in 1911, was a consolidation of several of these. More fortunate than most, Magnolia Petroleum became increasingly important in the southwestern states, and Standard Oil Company of New York soon began acquiring some of its stock. In December 1925, all of the Magnolia stock was exchanged for Standard Oil Company of New York stock. Over the next 34 years, expanding operations and industry consolidation transformed Magnolia Petroleum into the modern Mobil Oil.

Today, the Magnolia Petroleum building houses a law firm. As this photo illustrates, there have been modifications to the original structure, most notably in the loss of the elegant arched doorways. However, the building remains a cornerstone on the streets of Amarillo, as well as a reminder of the oil industry impact on Texas.

Amarillo Polk Street, 1910

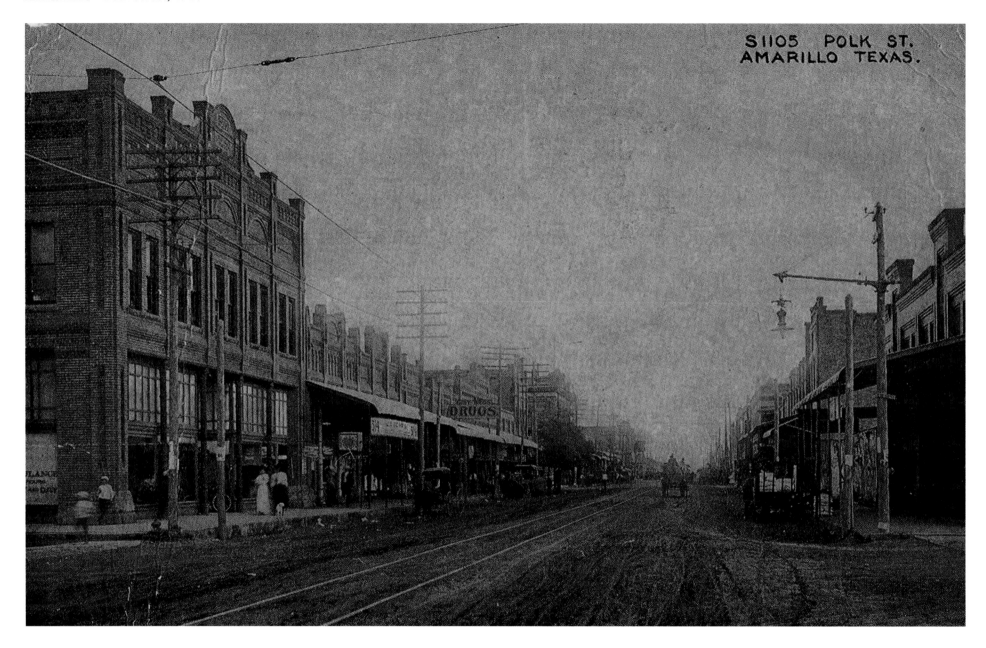

Amarillo's beginnings trace back to the Fort Worth and Denver City (FW&DC) Railway Company's construction of the first railroad into the Texas Panhandle. When the Santa Fe Railroad was completed in 1898, the point at which it crossed the FW&DC became the site of what would become the Panhandle's premier city. The railroads paved the way for settlers into the Panhandle of Texas and the region grew quickly. Amarillo's economy was based on ranching and it became one of the largest cattle shipping points in the world. The city was incorporated in 1899, and by 1910, it had telephone service, water, gas, and electric systems. Churches, schools, and libraries soon followed, as well as a streetcar system and three new railroad depots.

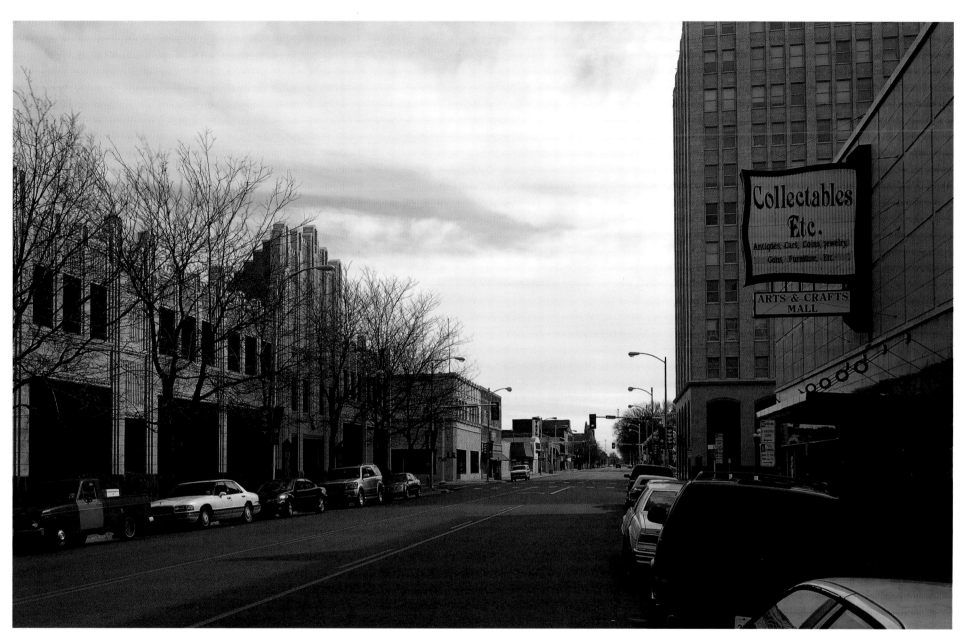

The 1970s saw the establishment of the Amarillo Art Center, ASARCO copper refinery, and the Donald D. Harrington Discovery Center, which housed the first computer-controlled planetarium in the nation. By the 1980s, the Santa Fe and Burlington National railroads provided freight service and Amarillo International Airport served five major airlines. The completion of Interstates 40 and 27 through the city encouraged new housing developments and shopping centers. Today, Amarillo's economy is anchored by the gas, petroleum, agriculture, and cattle industries.

Amarillo Post Office, circa 1920s

Coble Building

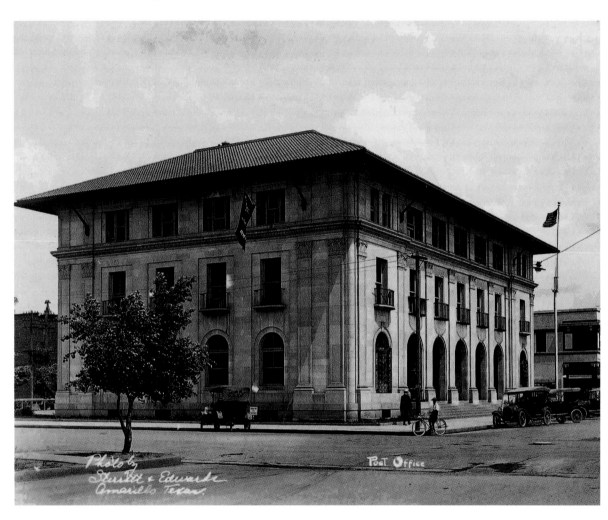

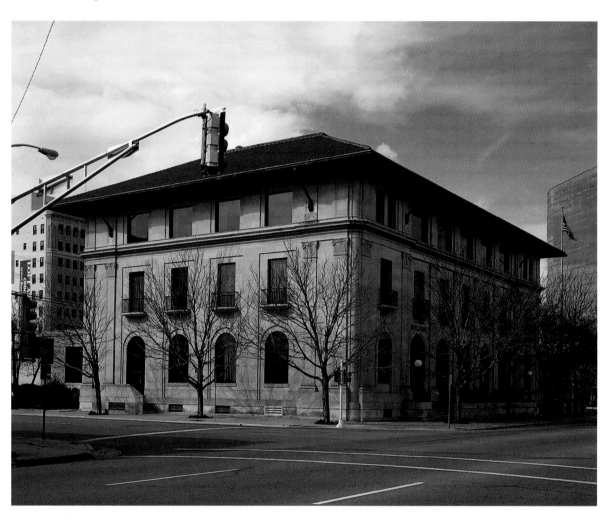

The Amarillo Post Office was built in 1916 on Taylor Street downtown. It was a creation of architect Oscar Wenderoth. Wenderoth, the son of a portrait painter and one time Supervising Architect of the U.S. Treasury, designed many other federal buildings around the country.

The Coble Building is named after William Thomas Coble (1875–1958); a once prominent Amarillo oilman and rancher. Coble was president of both Coble–Heywood Oil Co. and the Southwestern Cattle Raisers Association. The Coble Building now houses the First Bank of Texas along with an architectural and engineering firm. Unlike so many other vintage structures put to other uses around the state, the Coble Building has been modified very little.

Randall County Courthouse 1910

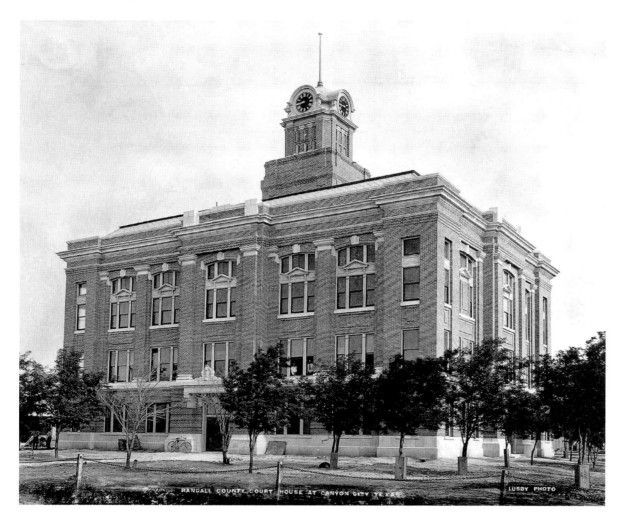

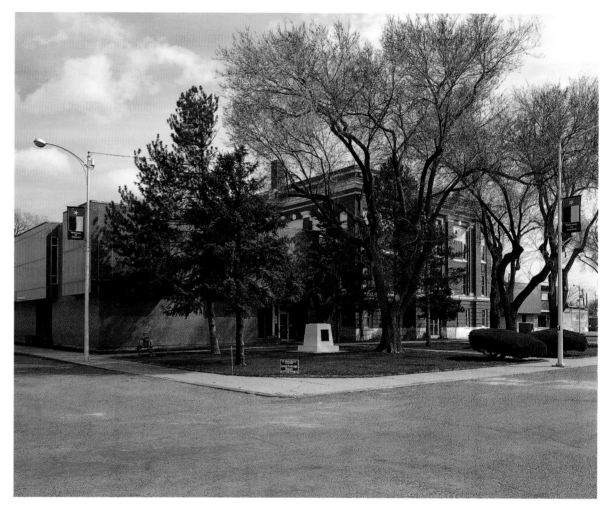

The Randall County Courthouse was designed by architect Robert G. Kirsch and was completed in 1909. It was built in Texas Renaissance style and was finished on the eve of the opening of West Texas State University, now known as West Texas A&M University. The brick building was the second courthouse for Randall County; the first had a wooden frame structure and a tin roof where citizens of Canyon reportedly held dances. The 1909 structure was built on the site of the first school in the county. The tower visible in this photo was removed during remodeling in 1945 and its current annex was built in 1957.

The courthouse has fallen into a state of disuse over the last several years because of lack of maintenance. Efforts are currently underway to fully restore the old courthouse and transform it again into a functioning judicial building. There are proposals to replace the clock tower and renovate the interior to include offices for a justice of the peace, county judge, and even a spacious new courtroom.

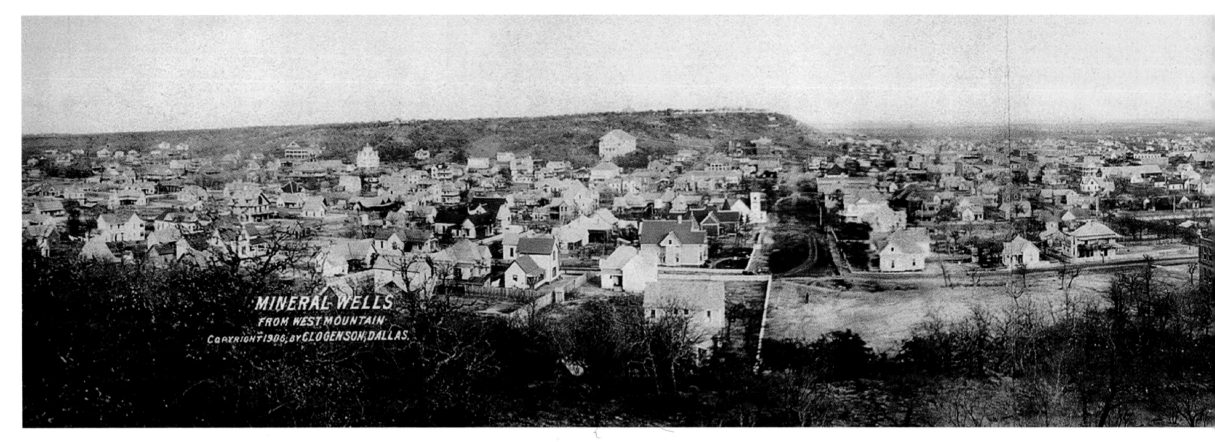

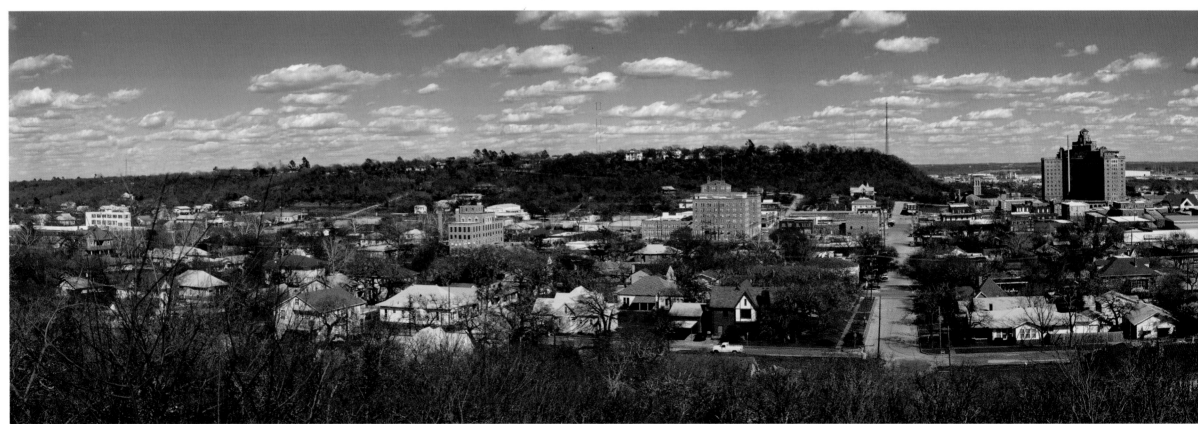

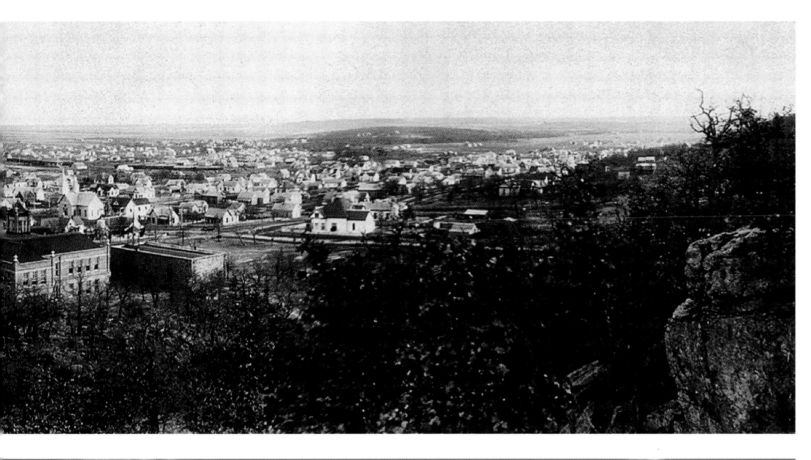

Mineral Wells got its name from local well water, which in 1885 reportedly cured the rheumatism of J.A. Lynch, the town's founder. The water was dubbed "Crazy Water" and was thought to cure a long list of maladies, including several mental disorders. Word of the town's miraculous water spread quickly and before long, Mineral Wells was a thriving health resort. By 1920, the city had at least 400 mineral wells and its population had grown from only a few hundred in 1890 to almost 8,000. The Famous Mineral Water Company, founded in 1904, is still in operation today and visitors can sample the water that made Mineral Wells famous.

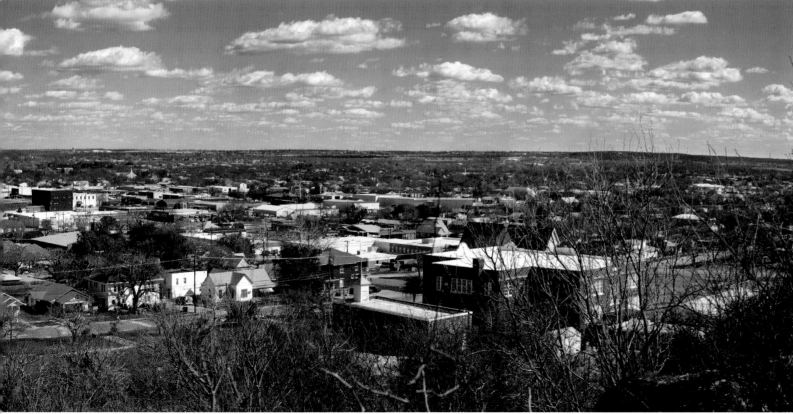

The large building near the center of this photo is the 452-room Baker Hotel, built in 1929 in the style of the Arlington Hotel in Hot Springs, Arkansas. Among the famous people who stayed at the Baker were Judy Garland, Clark Gable, the Three Stooges, Roy Rogers, and Dale Evans. The hotel closed in 1972. The Crazy Water Hotel located at 401 N. Oak was finished in 1912, but was destroyed by fire in 1925. It was rebuilt in 1927 and is today being used as a retirement home. A historical marker at the intersection of US 281 and US 180 identifies the site of the first mineral water well in the county. Today, Mineral Wells is a manufacturing center for clay pipe, aircraft systems, plastics, electronic products, bricks, feed, and clothing.

Plainview 1890

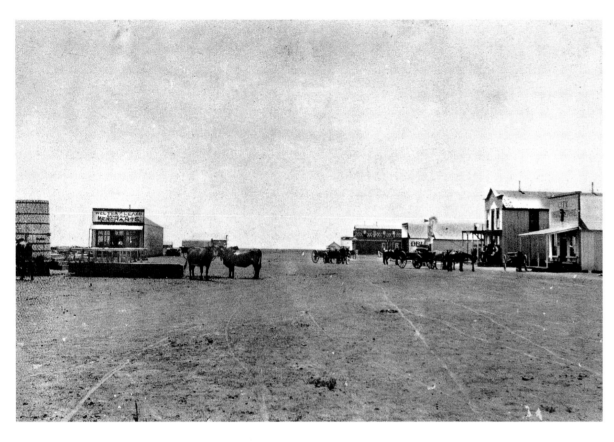

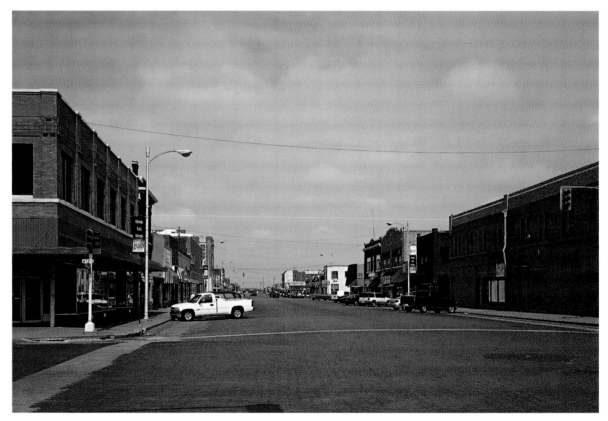

Plainview's name came from the flat, treeless landscape that surrounds it. It was founded in 1888 by Z.T. Maxwell and Edwin Lowe. Located on a cattle trail, the town's abundant water and good ranchland were instrumental in its success. Only four years later, Plainview had a courthouse, several churches and hotels, a post office, a newspaper, and stagecoach service. With the arrival of the railroad in 1906, Plainview blossomed. Previously, the area had only been used for grazing, but its rich soil ensured a thriving agricultural industry. Cotton, corn, maize, sorghum, millet, alfalfa, various vegetables, and wheat were grown successfully and contributed significantly to Plainview's economy.

Most people associate Plainview with sausage king and Plainview native Jimmy Dean. In 1969, the country singer opened his Jimmy Dean Meat Company, which later relocated. In 1971, Missouri Beef Packers opened a large beef-processing plant near Plainview. Today, Plainview's successful agricultural industry still provides the underpinnings of its economy. The Hale County Historical Commission was founded in Plainview in 1963, and the Llano Estacado Museum was opened on the campus of Wayland Baptist University in 1976. The museum's primary focus was to continue the examination of the South Plains of Texas.

Lubbock 1909

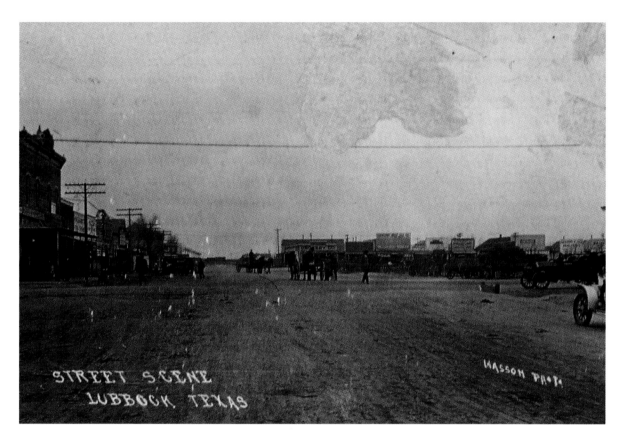

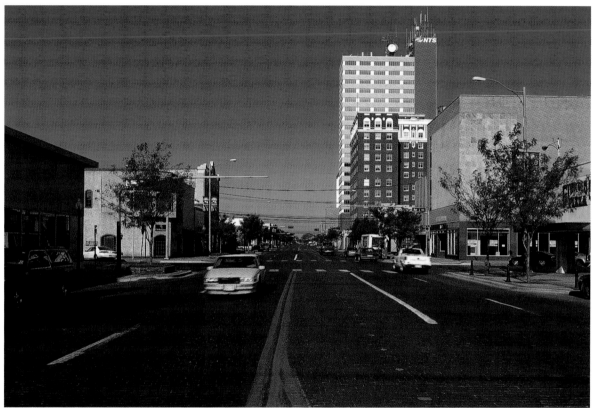

Lubbock County was founded in 1876. It was named after Thomas S. Lubbock, a former Texas Ranger and the brother of Francis R. Lubbock, the governor of Texas during the Civil War. The present-day city of Lubbock was not formed until late 1890, when two settlements in the county, Old Lubbock and Monterey, were combined to form the settlement of Lubbock. Once rail service was established in Lubbock and its agricultural industry continued to grow, it became the marketing center of the region and earned the name "Hub of the Plains."

On May 11, 1970, the city was devastated by a tornado that killed 26 people and caused more than $135 million in damage. However, the city rebounded quickly and built a civic center, a library, and other replacements. Lubbock's population has grown to about 200,000, thanks to thriving agricultural commerce, as well as a variety of manufacturing facilities.

Lubbock Texas Technological College Dairy Barn, 1925

Texas Tech University Dairy Barn

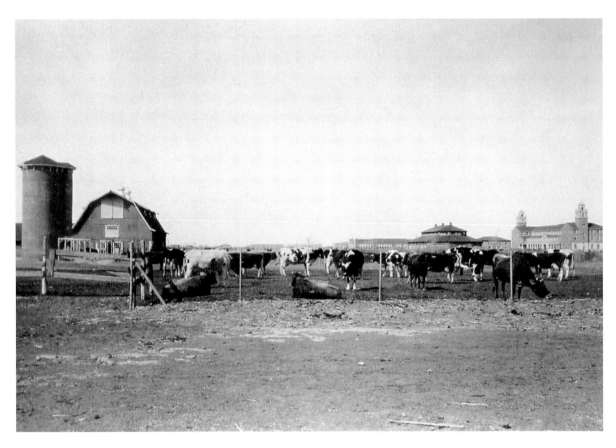

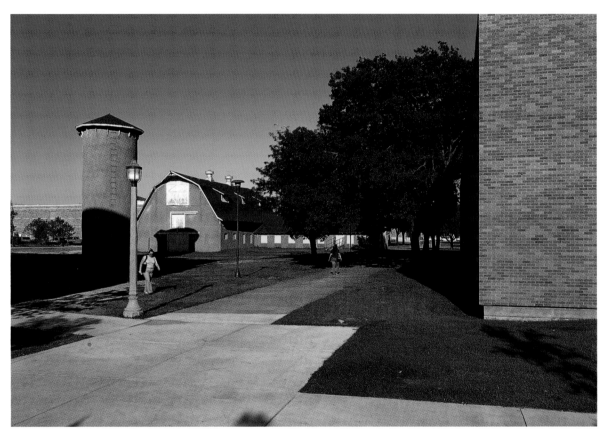

Texas Technological College was founded on February 10, 1923, to educate West Texans in technological, manufacturing, and agricultural pursuits. The Dairy Barn and silo were built on the Texas Tech campus in 1926–1927 as a teaching facility. The barn was designed by Fort Worth architect W.C. Hedrick. Up until 1935, students brought their own cows to campus. The Student Dairy Association first marketed milk products at the University. After 1927, the Dairy Manufacturers Department furnished milk and ice cream to the Lubbock community and the school cafeteria.

The barn was abandoned in 1964 when dairy operations moved to another location. By 1992, a successful fund raising effort ensured stabilization and the preservation of the barn as a symbol of Texas Tech's agricultural heritage. Today, it is included on the National Register of Historic Places.

San Angelo Fort Concho, 1880s

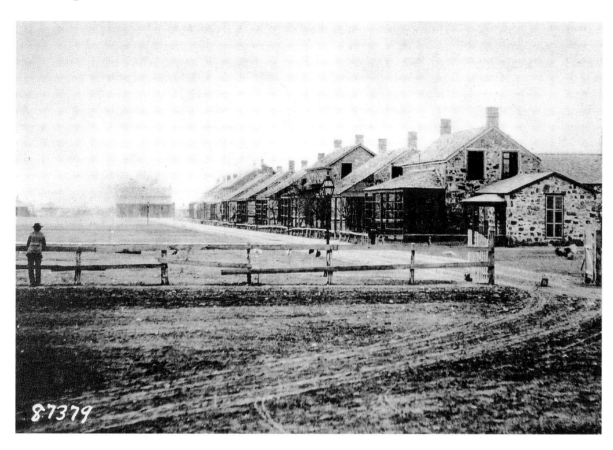

Fort Concho National Historic Landmark

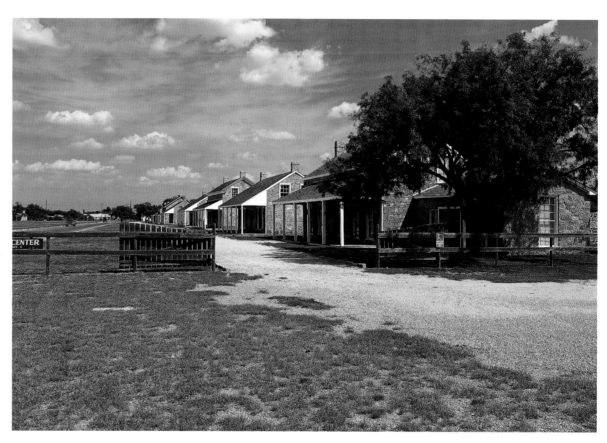

Fort Concho was established in 1867 by the U.S. Army to defend settlers and protect U.S. interests in West Texas after the Civil War. The post was named after the Middle and North Concho Rivers, which converge in San Angelo. By 1879, Fort Concho boasted 40 structures built of locally quarried limestone. Among the services Fort Concho soldiers performed were scouting and mapping parts of West Texas, building roads and telegraph lines, escorting stagecoaches and cattle drives, and generally serving as a police force for the area. The fort was not the site of any major Indian conflicts, but it furnished personnel and supplies for three others between 1872 and 1880.

With the establishment of the nearby town of San Angelo, civilian law enforcement improved and Fort Concho's usefulness as a military post declined. The army abandoned the fort on June 20, 1889, but most of its buildings were converted to other uses. In 1929, Ginevra Wood Carson moved her West Texas Museum into the former Fort Concho headquarters building and changed the name to Fort Concho Museum. By the mid-1950s, the city had acquired the museum and some other fort properties and had rebuilt four others from ruins. The fort was designated a National Historic Landmark in 1961. Today, it encompasses most of the former army post and includes 23 restored structures.

San Angelo Concho Avenue, late 1800s

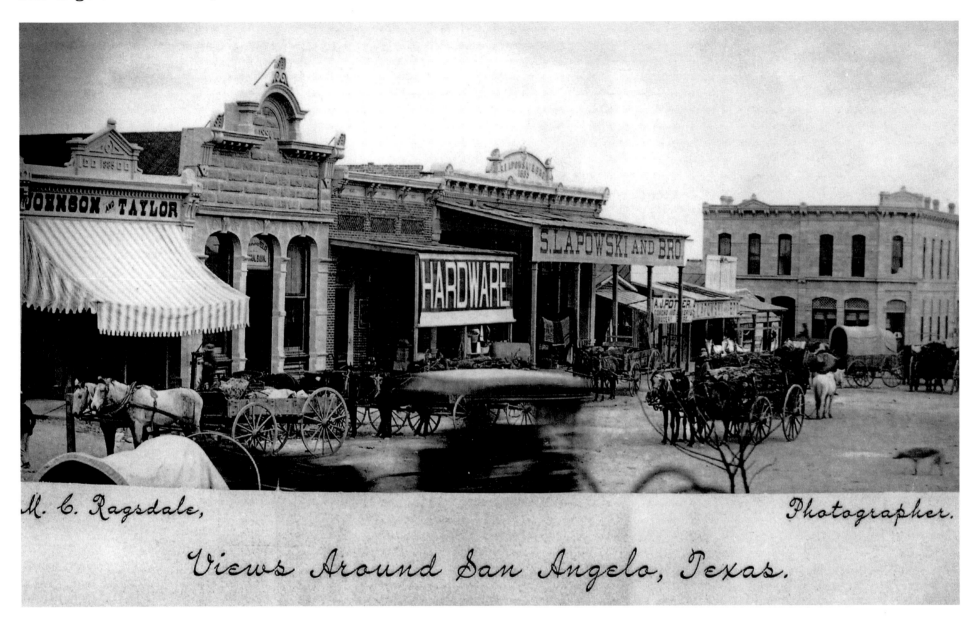

In the late 1800s, San Angelo was a rowdy frontier town with a colorful cast of characters. Its development was closely tied to nearby Fort Concho, which was established by the U.S. Army in 1867 to protect settlers. Santa Angela, as it was initially named, had its share of saloons, gamblers, and prostitutes, and its reputation was such that even soldiers from the fort were afraid to venture into the town at night. Oscar Ruffini, an architect who designed and supervised the construction of the new county courthouse in 1882, also designed about 40 other buildings in the downtown area, many of which are still in use.

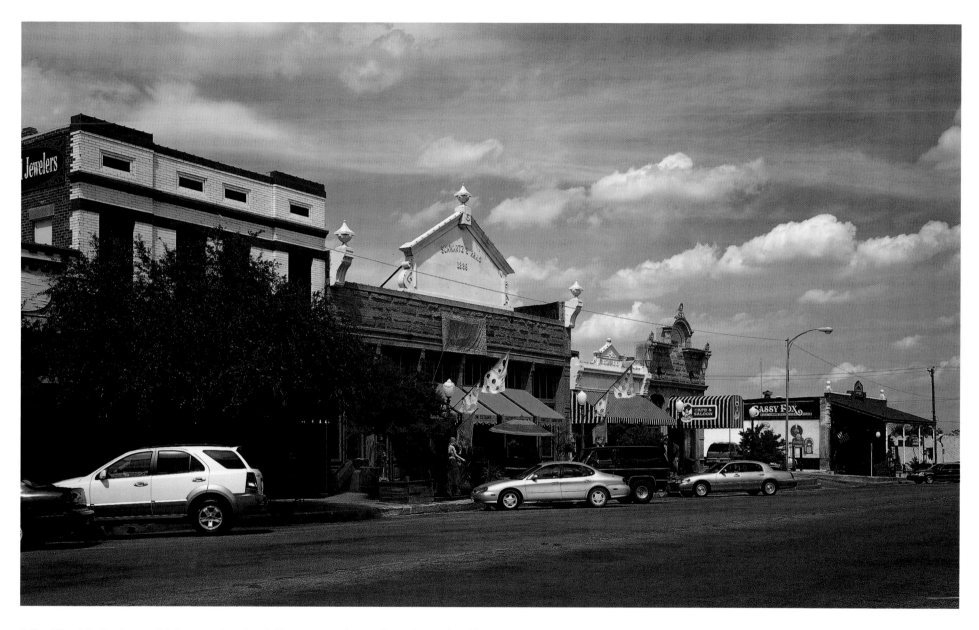

Miss Hattie's Parlor and Museum is a bordello museum located on the city's oldest and most historic street, Concho Avenue. At one time, Concho Avenue had more than 35 saloons and bordellos. Today, it houses a number of specialty shops, including a country store, antique and brass shops, a saddle maker, several restaurants, and designer fashion shops.

San Angelo Concho River, circa 1870s

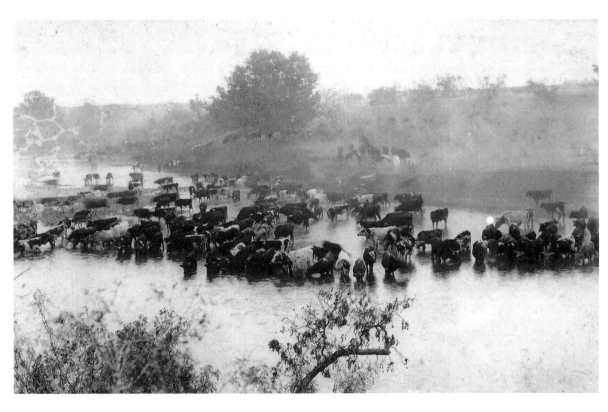

San Angelo's location at the juncture of the North, South, and Middle Concho Rivers made it very favorable for farming and ranching. The three branches of the Concho watered and fed countless herds of Texas longhorns on their way to market during the cattle boom years of the 1870s. With the arrival of the railroads in the latter part of the 19th century, San Angelo became one of the leading cattle markets in Texas.

With a population of 88,000, San Angelo is one of the fastest growing cities in West Texas. It has one of the most diverse industrial bases in the state, producing a wide variety of products, including surgical sutures, denim jeans, iron and steel, and electronic and oil field equipment. It has a nationally recognized museum of fine arts, a growing technology sector, a beautiful riverwalk, and a growing tourism industry. This recently completed Visitor Center on the banks of the Concho River greets travelers coming into the city on US 87.

Junction ☆ Brady ☆ Waco ☆ Enchanted Rock ☆ Llano ☆ Austin
Fredericksburg ☆ Marble Falls ☆ Guadalupe River ☆ Bandera

"Honor the Texas flag; I pledge allegiance to thee, Texas, one and indivisible."
—Texas Pledge of Allegiance

Junction Highway, circa 1940s

Junction is named for its location at the confluence of the North and South Llano Rivers. It was founded in 1876, and by 1879 had a drugstore, livery stable, sawmill, post office, and several general stores. In order to provide power and water to the city, as well as irrigation to the surrounding lands, a dam was built on the South Llano River in 1896. Between the years of 1910 and 1920, automobiles became a presence in the town. By the 1920s, graveled streets and electric streetlights were also introduced to Junction.

Junction is in a very scenic and sparsely populated part of the Texas Hill Country. With many streams and rivers flowing through the area, camping, fishing, hunting, tubing, and canoeing are popular activities. South Llano River State Park, a wooded 507-acre area with abundant wildlife, lies along the winding South Llano River south of town. Junction continues to be the shipping and marketing center for Kimble County's livestock, wool, mohair, pecan, cedar-oil, and grain industries.

Brady McCulloch County Courthouse, 1905

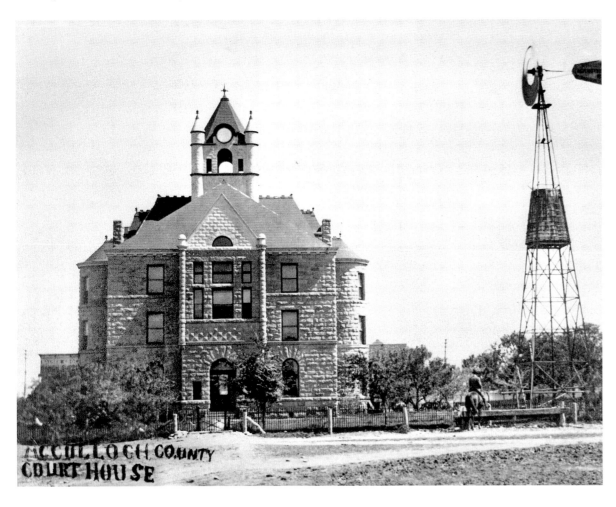

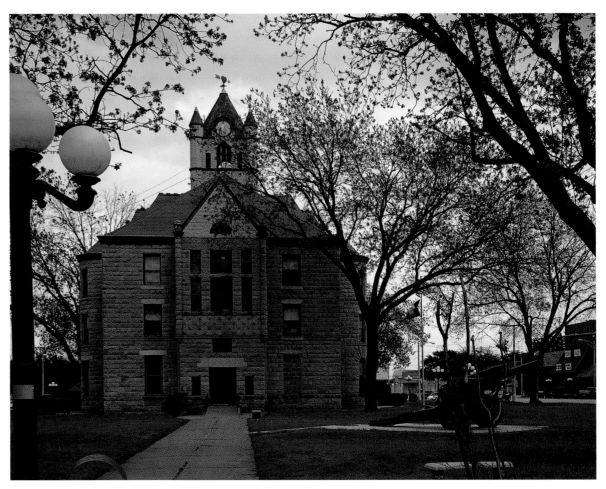

The McCulloch County Courthouse was built in 1899 of native stone from two area quarries. Architects William Martin and Peter Moodie designed the Romanesque Revival structure. One unusual feature of the courthouse is that its clock tower has no clocks—merely four round spaces. The county was named after Ben McCulloch, a veteran of Sam Houston's San Jacinto campaign in 1836 as well as the Mexican War. McCulloch later served as a U.S. Marshall in Texas around the time the county was created in 1856. Brady lies on the northwest edge of the Hill Country on the former Dodge Cattle Trail.

The old courthouse is still in use today. A monument on the grounds describes Brady as being in the heart of Texas, a reference to its location at the geographical center of the state. A survey done by the Texas Association of Professional Surveyors in 1997 found the true center to be about 20 miles northeast of town.

Waco Suspension Bridge, circa 1910s

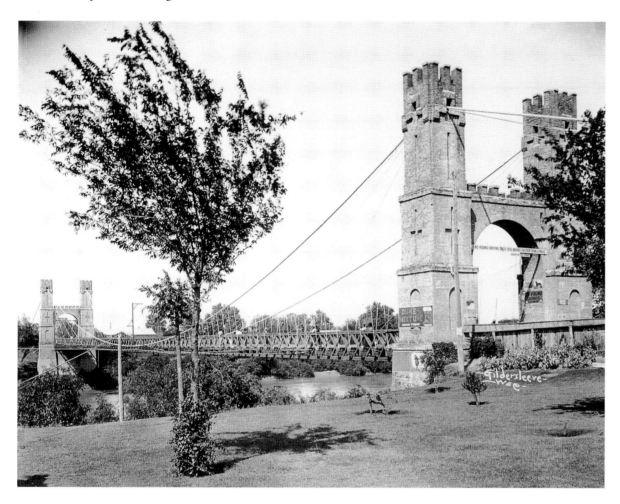

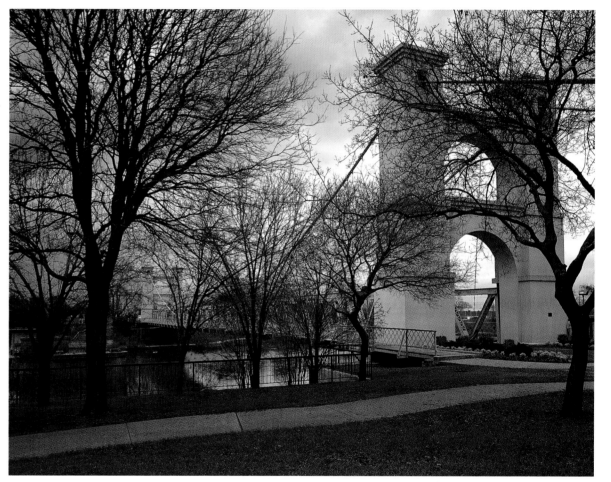

City leaders established a private company in 1866 that secured a state charter to begin working on a suspension bridge for Waco. The renowned New York firm of John A. Roebling (which later designed and built New York's Brooklyn Bridge) was hired to design this 475-foot bridge. Construction began in January 1869. Using a number of specialized materials and nearly three million bricks, the Waco Suspension Bridge was a spectacular engineering feat for its time. Completed just one year later, it became the first single-span suspension bridge west of the Mississippi. The bridge provided the only wagon-size passage over the Brazos River, bringing the Texas section of the Chisholm Trail straight through Waco in the process.

Located between Franklin Avenue and Washington Avenue, the Waco Suspension Bridge was used by vehicular traffic until 1971, when it was retired to serve as a historical monument. Today, it is open for pedestrian traffic in a park just east of the Waco central business district near the site of the original Waco Springs. The Waco Suspension Bridge is on the National Register of Historic Places and has a Texas Historical Medallion from the Texas Historical Commission.

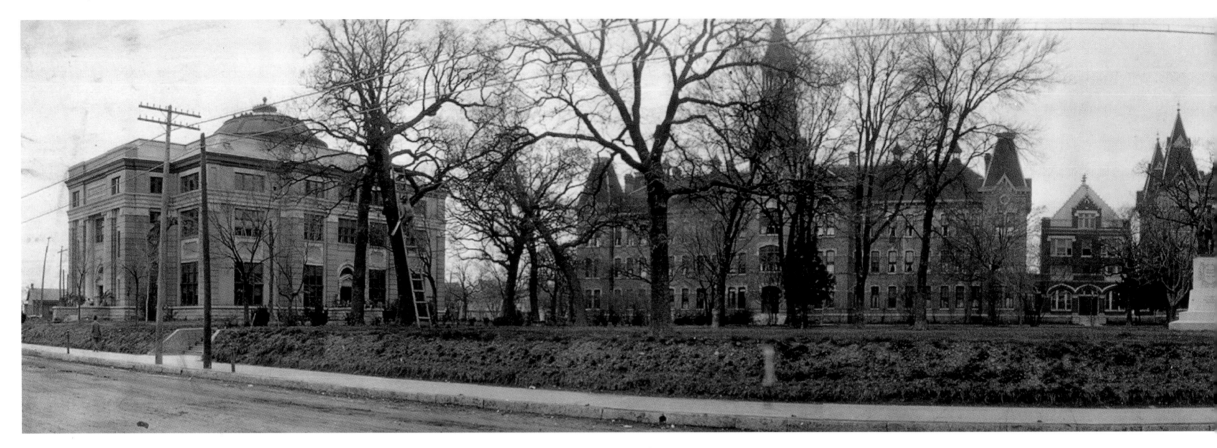

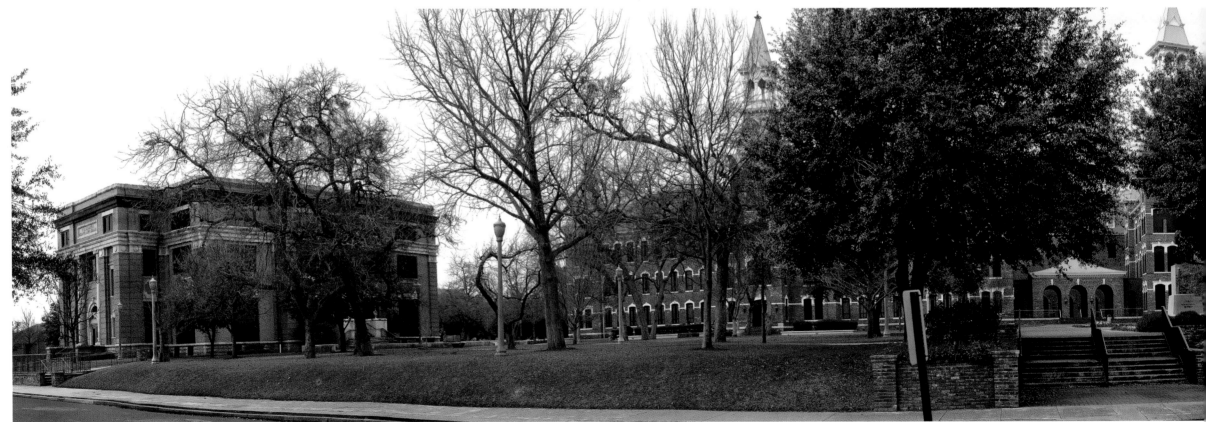

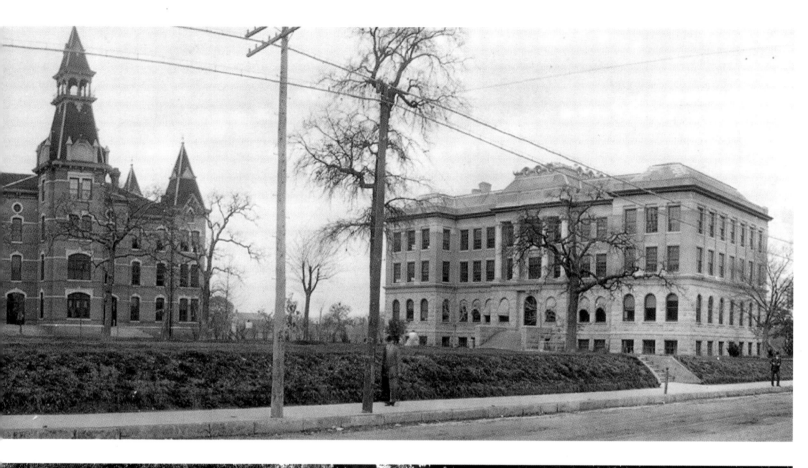

The Republic of Texas chartered Baylor University on February 1, 1845, and opened it in the town of Independence in 1846. The university granted its first degree in 1854. Under the control of the Baptist General Convention, Baylor was established on the Waco campus in 1887. Samuel Palmer Brooks served as president from 1902 until his death in 1931. Brooks added new departments and organized the schools of education, law, business, and music. During the Brooks administration, the campus grew rapidly and Baylor was admitted to membership in various college and university associations.

Baylor is the oldest institution of higher learning in the state and the largest Baptist university in the world. It has more than 14,000 students, and it offers 147 baccalaureate degree programs at the undergraduate level, 23 masters degrees with 75 programs of study, and 21 doctoral degree programs. It also has a law school and a theological seminary. The 735-acre campus is located near the Brazos River in Waco.

Portions of these captions were reprinted with permission from the Handbook of Texas Online, copyright Texas State Historical Society

Enchanted Rock Area 1924

Enchanted Rock State Natural Area

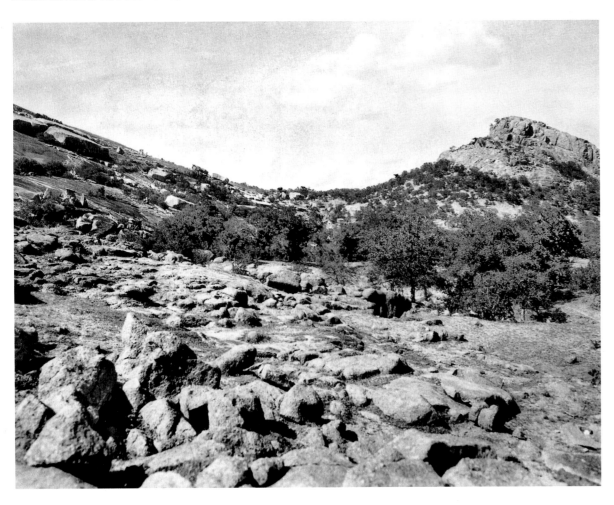

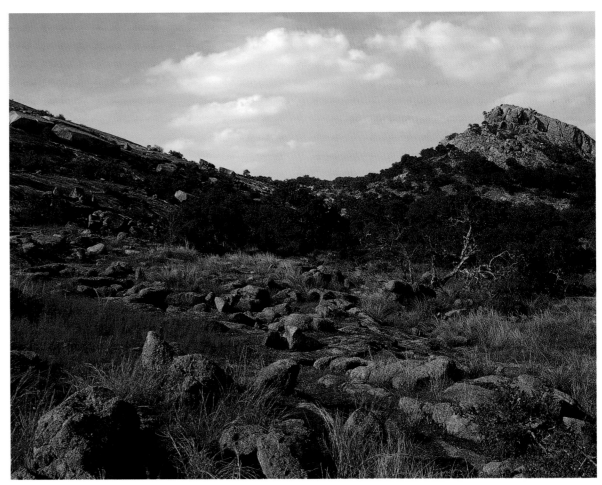

Enchanted Rock is one of the most beautiful and awe-inspiring attractions in the Texas Hill Country. It lies within a zone sometimes referred to as the Central Mineral Region, but more commonly known as the Llano Uplift. Such area geological features as Turkey Peak, Little Rock, and Enchanted Rock itself are the exposed portion of a large igneous batholith believed to be at least a billion years old. Spanish explorer Cabeza de Vaca may have been the first to discover the rock, around 1536. The area went through many different owners between 1836 and 1978, when The Nature Conservancy purchased it and handed it over to the Texas Parks and Wildlife Department.

Enchanted Rock State Natural Area is a great place to camp, hike, or climb. The park is home to more than 400 species of plants; 100 species of lichens, mosses, and liverworts; and dozens of species of animals and birds. A number of Native American artifacts have been uncovered at the 114 archaeological sites in the area. Because of its beauty and proximity to most of the population centers in the state, the park currently gets so many visitors that during the busiest seasons, such as spring break, many have to be turned away to avoid overcrowding and potential damage to the environment.

Llano Llano County Courthouse, 1907

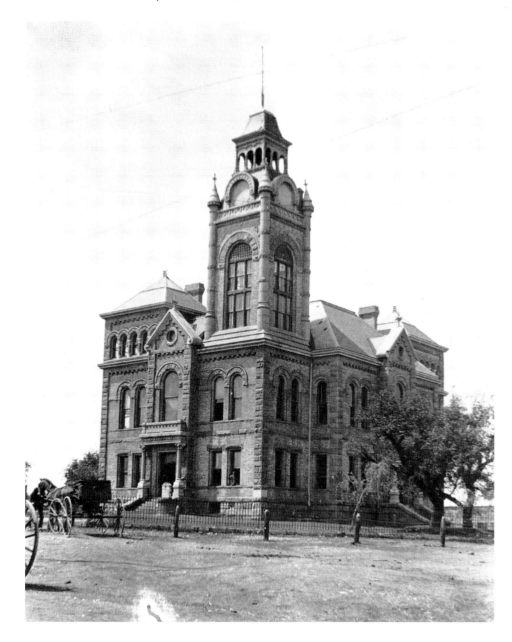

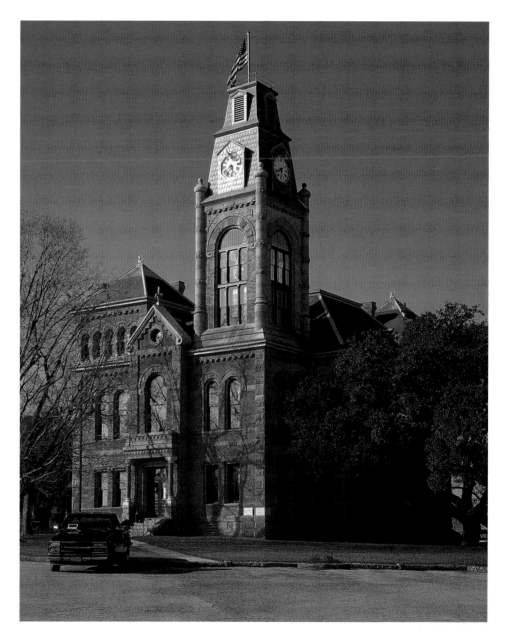

Llano was established in 1856 as a farming and ranching community. For a while in the 1880s, it looked like the town was going to strike it rich when substantial iron deposits were discovered nearby. Plans to mine the ore were scrapped, however, when no coal was available to make steel. The Llano County Courthouse was built in the Romanesque Revival style in 1892 and stands at the center of the downtown historic district. It is one of only a few old courthouses in Texas that haven't had additions. A time capsule, to be opened on the city's 200th anniversary in 2056, rests under a granite boulder on the west side of the building.

Today, the farming and ranching community of Llano bills itself as the "Deer Capital of Texas" and hosts many hunters during deer season, from November to January. The granite and tourism industries continue to be important underpinnings of the town's economy. The courthouse is listed on the National Register of Historic Places, as are the Llano jail, the Southern Hotel, and the Badu Building, a former bank and home of French immigrant and mineralogist N.J. Badu.

Llano Roy Inks Bridge, 1907

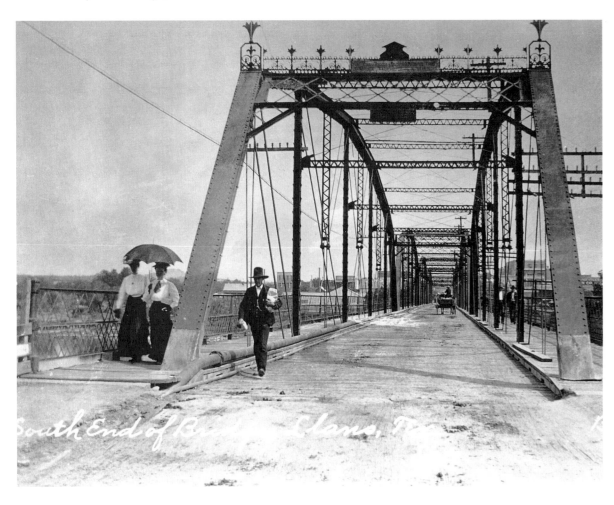

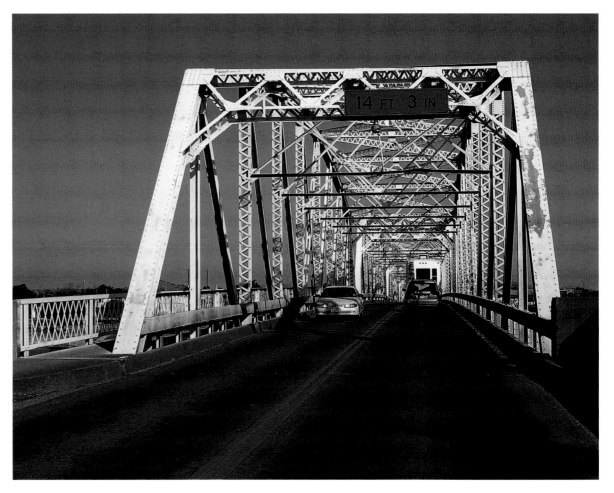

A major flood on the Llano River in June 1935 reached a record crest of 42 feet, washing away a bridge that had stood since 1892. The city built a new steel bridge, a Parker-type truss bridge with four spans and named it for Roy B. Inks, a former mayor of Llano.

In June 1997, another flood came roaring down the Llano River, this time reaching a crest of only 38 feet. The bridge easily withstood its biggest test. The Roy Inks Bridge was listed in the National Register of Historic Places in 1998. In October 2005, the Texas Department of Transportation will solicit bids to have the bridge restored. Work is scheduled to begin on it by January 2006.

Austin Congress Avenue, circa 1890s

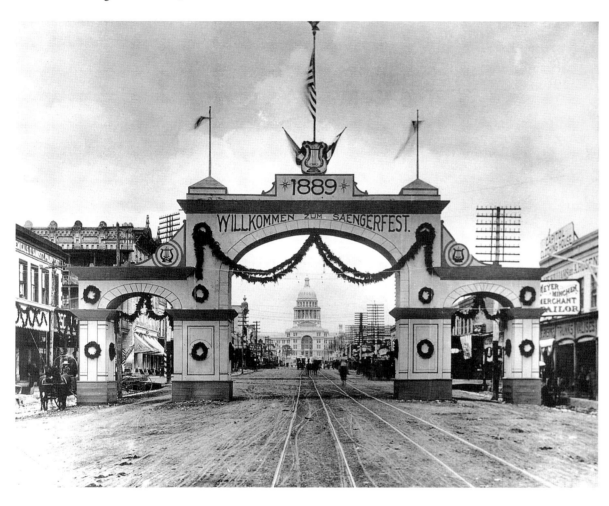

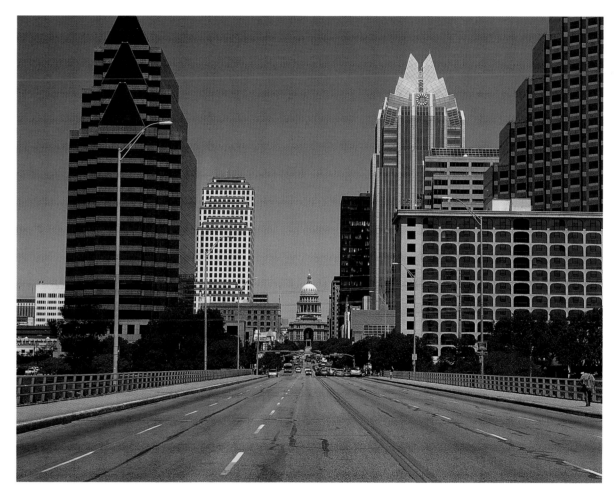

Original plans for the state capitol included a broad avenue stretching from the building toward the Colorado River, about a mile to the south. By the early 1870s, Texas had its first capitol, and Congress Avenue featured a mix of government and private buildings. Telegraph poles, new trees, and gas lamps punctuated the street, but the occasional roaming cow was an indication that Austin was not quite yet the sophisticated city it aspired to be. Only 20 years later, a new capitol was built to replace the original, destroyed by a fire. An electric streetcar line was installed, and a new depot was built at Third Street for the International and Great Northern Railroad.

Congress Avenue has remained one of Austin's principal business streets for more than 150 years. Its business district is listed on the National Register of Historic Places. Preservationists fought the destruction of some of Congress Avenue's most important old buildings. During an age in which 40-story office buildings seem to be popping up all over, the Avenue still provides one of the most beautiful views of the State Capitol. Today, the Congress Avenue Bridge spanning Town Lake is home to the largest urban bat colony in North America, estimated at 1.5 million Mexican free-tailed bats. Each night from mid-March to October, the bats emerge from under the bridge at dusk to search for food.

Austin University of Texas Tower, 1937

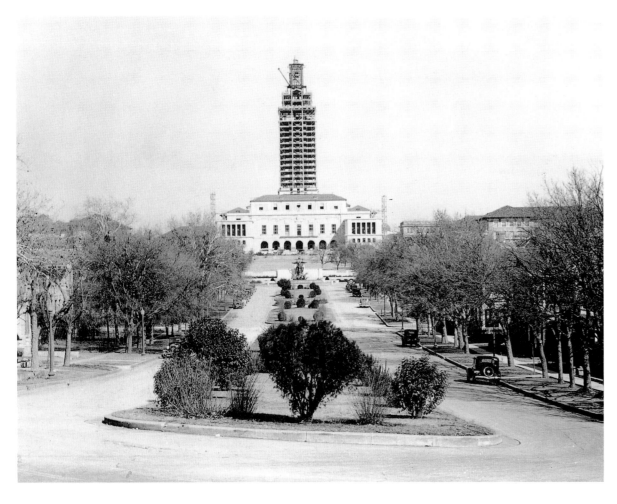

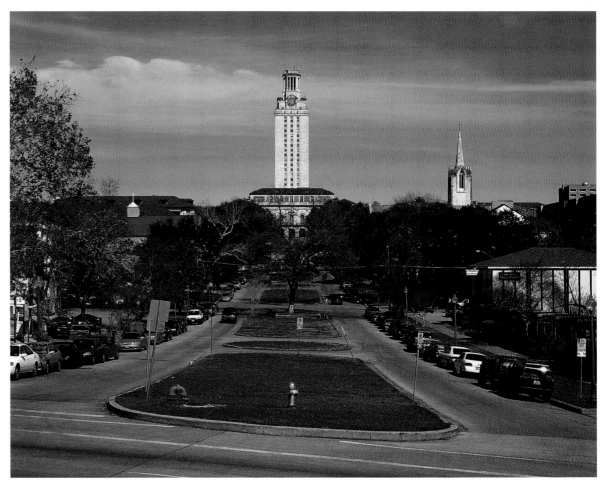

Built in 1936 as the first phase in the replacement of the Old Main Building, the University of Texas Tower became the centerpiece of the University of Texas (UT) at Austin campus. It was completed in 1937 at a cost of more than $3 million. At 307 feet high, the Spanish Colonial tower is slightly shorter than the State Capitol but stands taller because it was built on higher ground. The first song played on the 56-bell carillon was "The Eyes of Texas," the university's school song. The tower's most infamous day in history was August 1, 1966, when student Charles Whitman perched atop the tower and started shooting. The tragic event resulted in 13 casualties and many more injuries.

The tower's carillon still rings to remind students of class times and it plays music three times a week, which can be heard all over campus. The observation deck of the UT Tower, which affords a spectacular view of the UT campus as well as surrounding parts of the city, closed in 1974 to prevent despondent students from jumping from the tower. Thanks to the cooperative effort of students, staff, and the university's administration, the observation deck has recently been remodeled and reopened to the public for the first time in more than three decades. The tower is illuminated by orange light in celebration following UT's sports victories.

Austin State Capitol, 1888

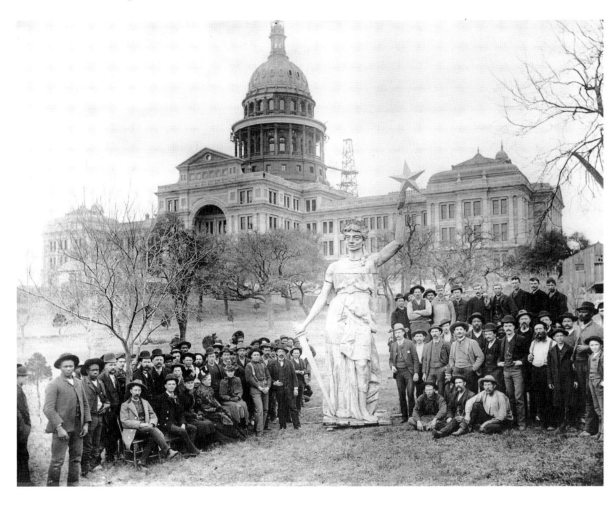

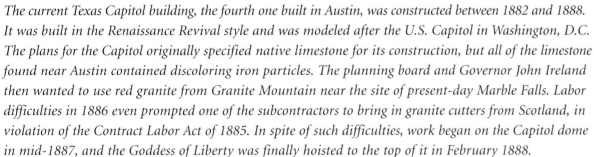

The current Texas Capitol building, the fourth one built in Austin, was constructed between 1882 and 1888. It was built in the Renaissance Revival style and was modeled after the U.S. Capitol in Washington, D.C. The plans for the Capitol originally specified native limestone for its construction, but all of the limestone found near Austin contained discoloring iron particles. The planning board and Governor John Ireland then wanted to use red granite from Granite Mountain near the site of present-day Marble Falls. Labor difficulties in 1886 even prompted one of the subcontractors to bring in granite cutters from Scotland, in violation of the Contract Labor Act of 1885. In spite of such difficulties, work began on the Capitol dome in mid-1887, and the Goddess of Liberty was finally hoisted to the top of it in February 1888.

In February 1983, a fire badly damaged the east wing of the Capitol and provided the impetus for restoration of the entire building. A few weeks after the fire, the legislature formed the State Preservation Board, whose first project was to replace the weathered figure of Liberty atop the dome. In November 1985, the original Goddess of Liberty was removed by helicopter. A new statue, cast of aluminum in molds made from the original, was placed on the dome in June 1986. The original statue has been restored and is exhibited on the Capitol grounds in a special structure built for it in 1995. In 1988, work began on a master plan to restore the Capitol and to build an underground annex north of the building. Construction was completed by January 1993, and the restoration of the 1888 Capitol was finished in early 1995 at a cost of about $200 million.

Austin Barton Springs, 1926

 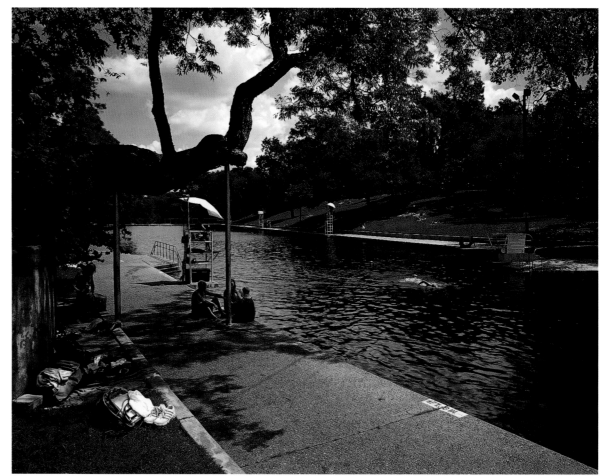

Barton Springs, one of Austin's most famous and beloved attractions, is the fourth largest springs in Texas, pumping out 27 million gallons of clear water daily. The source of the artesian waters is the cavernous Edwards aquifer, which stretches almost 200 miles from Austin to Brackettville. Barton Springs Pool has been a popular swimming hole for more than a century. It became even more well known when it became part of a city park in 1917. In the mid-1920s, workers enlarged the irregular-shaped pool to 1,000 feet long by building a concrete dam and sidewalks on both banks of the pool. In 1933, the area was named Zilker Park after A.J. Zilker, who donated land for the park.

Barton Springs is as popular as ever, albeit a lightning rod of controversy, whether the subject is upstream development or the protection of a unique amphibian. In 1992, two University of Texas scientists filed an emergency petition seeking federal protection of the Barton Springs salamander, whose only known surface habitat is the springs. In 1998, the U.S. Fish and Wildlife Service named this salamander an endangered species. Since the 1980s, some limits on use of the springs have been imposed to control pollution. Today, Barton Springs remains one of Austin's crown jewels, drawing people from all walks of life to revel in its year-round 68-degree waters.

Austin Mt. Bonnell, 1930s

Covert Park

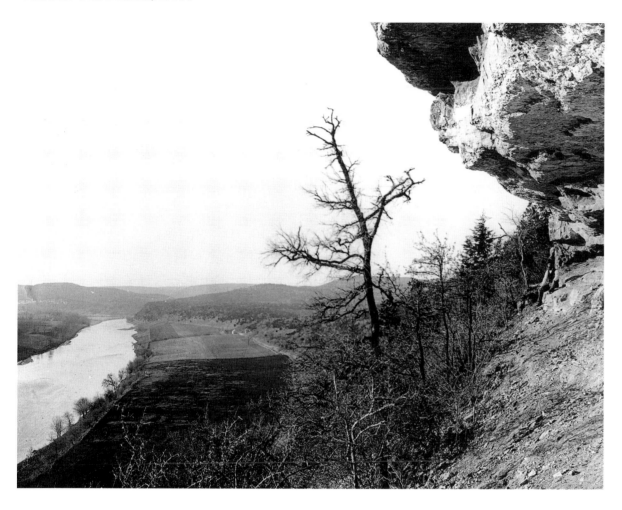

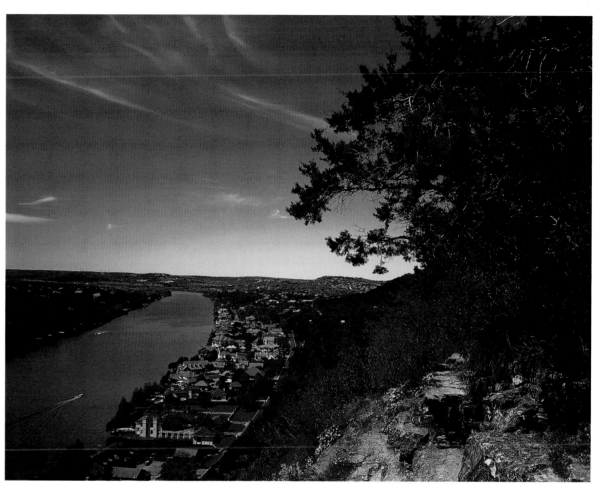

Mt. Bonnell is a natural limestone hill in west Austin that offers a spectacular view of the city and Lake Austin. Not really a mountain at 775 feet above sea level, it is still one of the highest points in the area. It was named after George W. Bonnell, a New Yorker who came to Texas in the summer of 1836 to recruit volunteers to fight for Texas independence. He also served as commissioner of Indian affairs under Sam Houston during the days of the Republic of Texas. In one of the many colorful stories about Mt. Bonnell, the death-defying Miss Hazel Keyes slid down a cable stretched from the summit of the hill to the banks of Lake McDonald below (now Lake Austin) in 1898.

Mt. Bonnell continues to be a popular lookout and picnic spot for Austinites. It is part of Covert Park, a 54-acre tract given to the City of Austin in 1939 by F.M. Covert, Sr., an Austin businessman. The exact vantage point of the old photo is no longer accessible. I found this vantage point nearby, which still gives a good idea of the amount of change Austin has experienced in recent years.

Austin Bull Creek Overlook, 1912

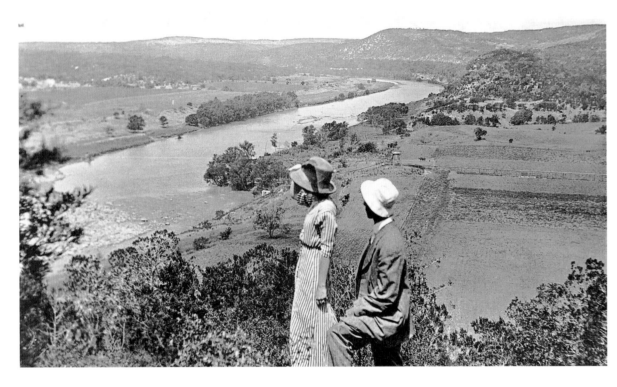

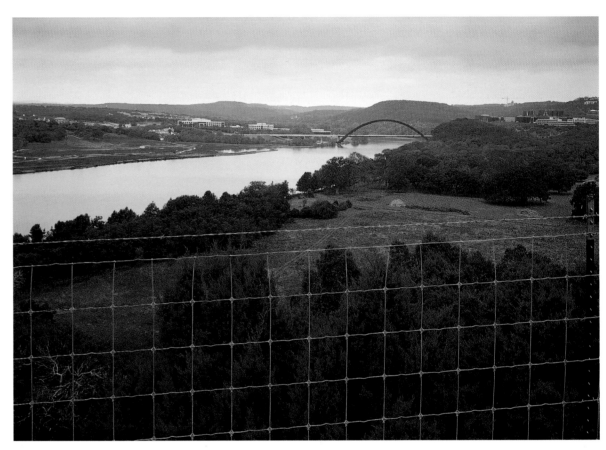

Austin has long been a desirable place to live, with its rolling hills, sparkling, spring-fed creeks, and mild climate. Tonkawas, Comanches, and Lipan Apaches camped and hunted along the tributaries of the Colorado River for hundreds of years before the first Anglo settlers arrived in the 1830s and named their village Waterloo. The hills of the eastern Edwards Plateau have many scenic overlooks, and Austinites in days past traveled up the winding Bull Creek Road to take in the spectacular view of the Colorado River valley below.

Bull Creek Road, more commonly called Ranch Road 2222, is still one of Austin's most scenic roads, but also one of its most dangerous, with sharp turns, steep grades, and a low water crossing. Traffic has increased dramatically on RR 2222 over the past 20 years, and it has been the scene of a number of serious automobile accidents. In the distance is the Percy Pennybacker Bridge, a steel arch bridge over Lake Austin on Loop 360, which was completed in 1982.

Fredericksburg 50th Anniversary Celebration, 1896

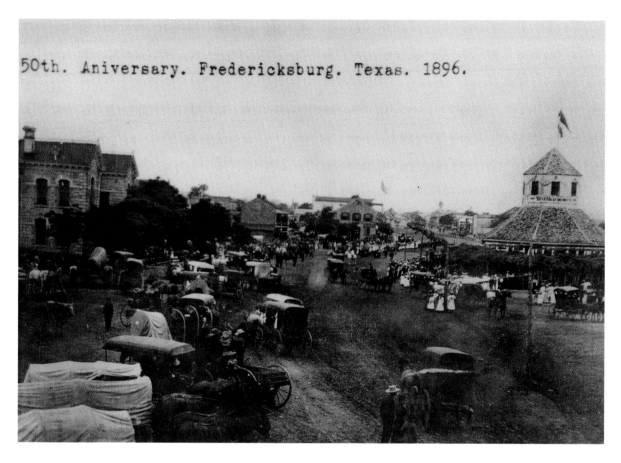

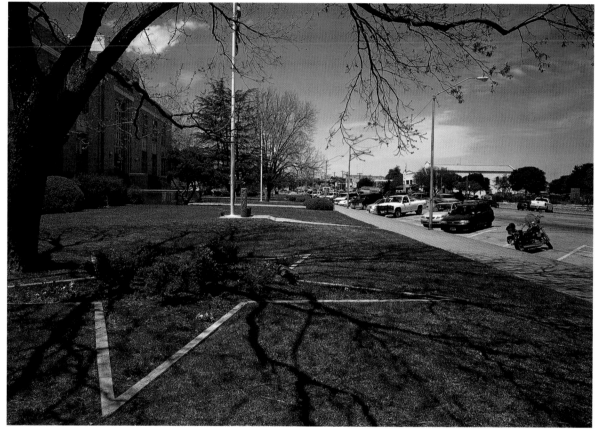

This celebration in the middle of Main Street in Fredericksburg commemorated the 50th anniversary of the town's founding by German settlers. The building on the left was the county courthouse. The octagonal building on the right was the original Vereins-Kirche, a combination school, church, and town meeting hall for more than 50 years. Main Street was, and is, one of the widest main streets in Texas, providing a roomy venue for big celebrations such as this one.

The current Gillespie County Courthouse, on the left, blocks the view of the former one, which is now the Pioneer Memorial Museum. The Vereins-Kirche was dismantled in 1897, but was reconstructed in 1936 thanks to the efforts of the Gillespie County Historical Society. The replica of the Vereins-Kirche was completed with the help of the Civil Works Administration, which provided jobs for a large number of men during the Great Depression. After its completion in time for the Texas Centennial celebration in 1936, the structure became the home of the Pioneer Museum. When the museum was moved in 1955, the Vereins-Kirche became the home of the Gillespie County archives. Today, the Vereins-Kirche houses permanent exhibits on the history of the area and provides a space for rotating photographic exhibits.

Fredericksburg Nimitz Hotel, 1880s

Admiral Nimitz Museum

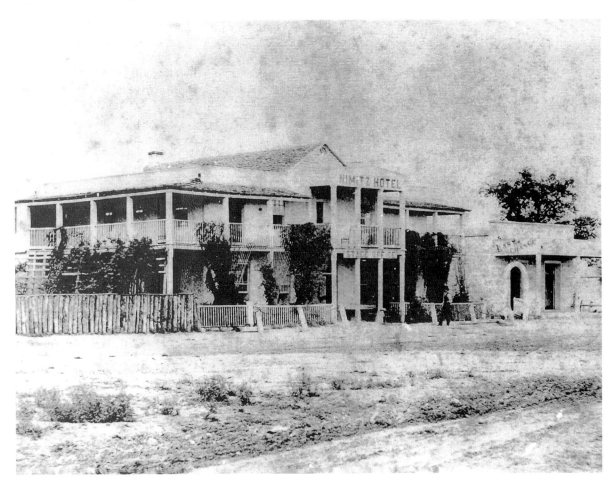

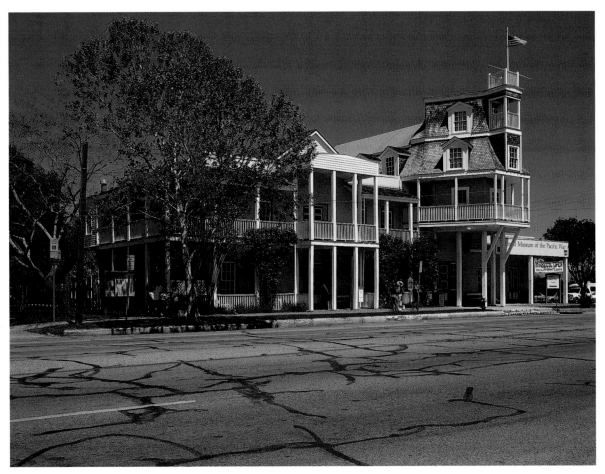

Charles Henry Nimitz, grandfather of Fleet Admiral Chester W. Nimitz, was born in Prussia in 1826. His family moved in 1844 to Charleston, South Carolina, where they operated a hotel. Nimitz moved to Fredericksburg in 1846 and established the Nimitz Hotel sometime during the 1850s. The hotel quickly garnered a reputation for delicious food and comfortable lodging. Nimitz eventually added a brewery, a saloon, and a general store at the hotel and expanded it to 50 rooms. The steamboat-like façade was added sometime after 1888. Among the notable guests who stayed at the hotel were Presidents Rutherford B. Hayes and Ulysses S. Grant and Confederate Gen. Robert E. Lee. Nimitz handed over the hotel to his son Charles in 1906, but continued to live there until his death in 1911. The hotel was sold and remodeled in 1926 and the ship-like structure was removed.

The hotel closed in 1963 and was sold to the nonprofit Fleet Admiral Chester W. Nimitz Naval Museum the following year. It was renovated, the steamboat façade has been reconstructed, and it opened as a museum on the anniversary of Admiral Nimitz's birth, February 24, 1967. The hotel is now part of the Admiral Nimitz State Historical Park, which is administered by the Texas Parks and Wildlife Department. The Nimitz Hotel is currently closed for renovations and is scheduled to reopen as part of the museum complex in 2006.

Fredericksburg Main Street, 1903

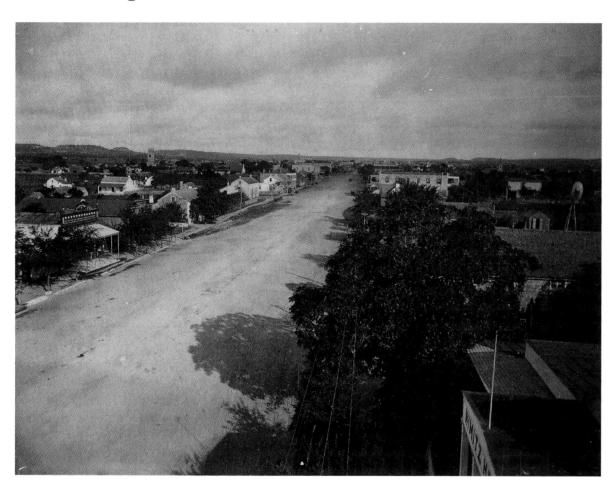

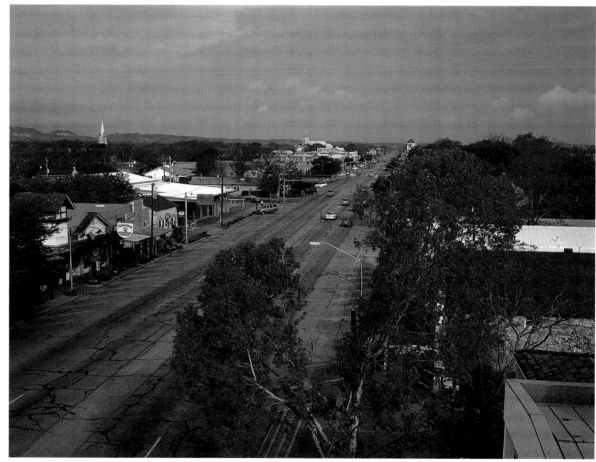

Fredericksburg was one of a group of German settlements founded in south and central Texas in the mid-19th century. The first residents of the new town came from New Braunfels in 1846. One of the settlers, John O. Meusebach named the new village after Prince Frederick of Prussia. The town was laid out with one long main thoroughfare as in German villages along the Rhine River, from which many of the colonists had come. Two years later, Fredericksburg had 1,000 residents, a wagon road to Austin, and a multipurpose structure known as the Vereins-Kirche, which functioned as a church, school, and meeting hall. This photo of Main Street was taken from the lookout tower of the Nimitz Hotel.

Fredericksburg has not only retained its quaint German heritage over the decades, it also has translated it into a thriving tourism industry. Many original buildings still stand along Main Street, and the German influence on the town's architecture is still apparent in its Sunday Houses, bed-and-breakfast accommodations, and municipal buildings. On almost any weekend, there isn't a parking space to be found in the central business section of Main Street. The relatively peaceful appearance in this photo resulted from taking the picture at 9:00 a.m. on a Sunday morning, well before the shops opened.

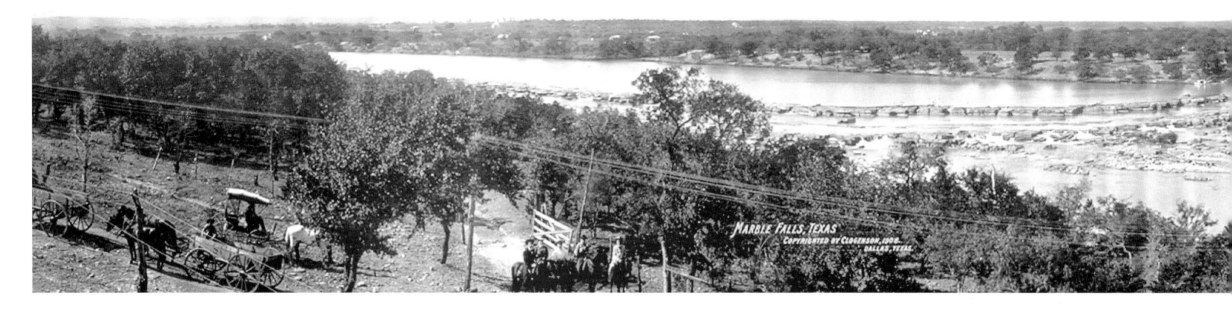

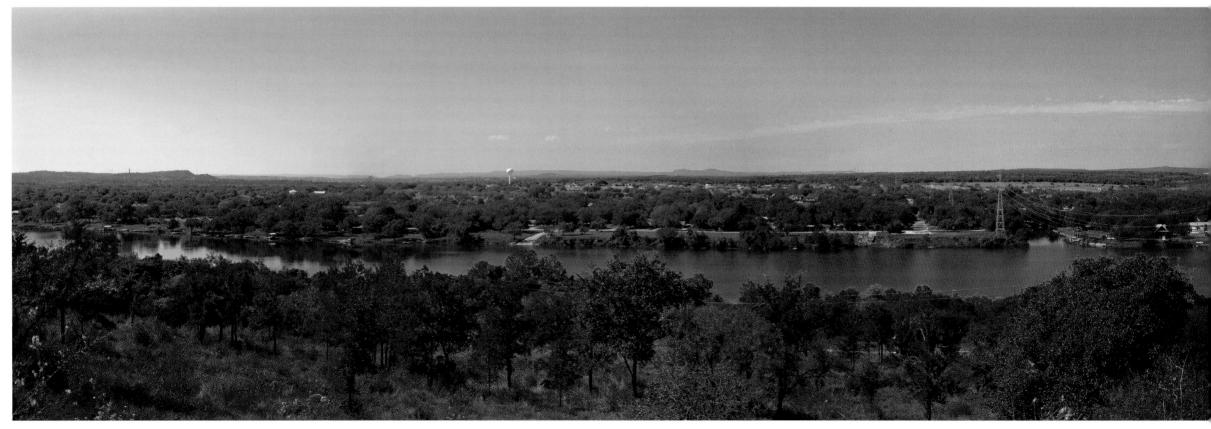

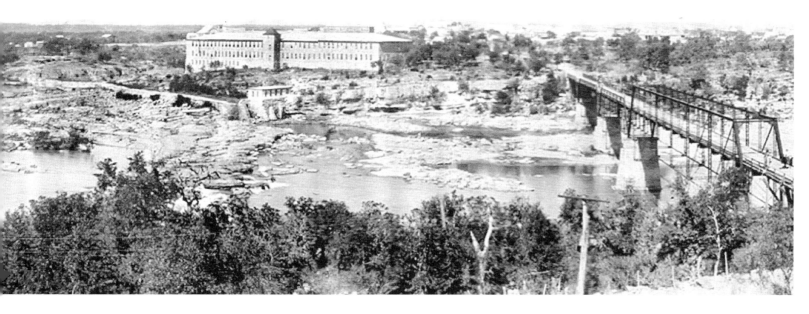

The falls around which the town of Marble Falls was built are visible in this panorama from the early 20th century. Early visitors to the area aspired to establish a settlement around the scenic Colorado River landmark, but it was not until 1887 that a group led by Adam Rankin Johnson, under the auspices of the Texas Mining and Improvement Company, began to handle the new town's affairs. By the turn of the 20th century, the town boasted almost 2,000 residents. In 1907 it held its first election. Plans to build a dam to provide power for the city and its growing industries were not fulfilled until 1925. The Max Starcke Dam, completed in 1950, formed Lake Marble Falls, providing needed power but flooding the scenic falls.

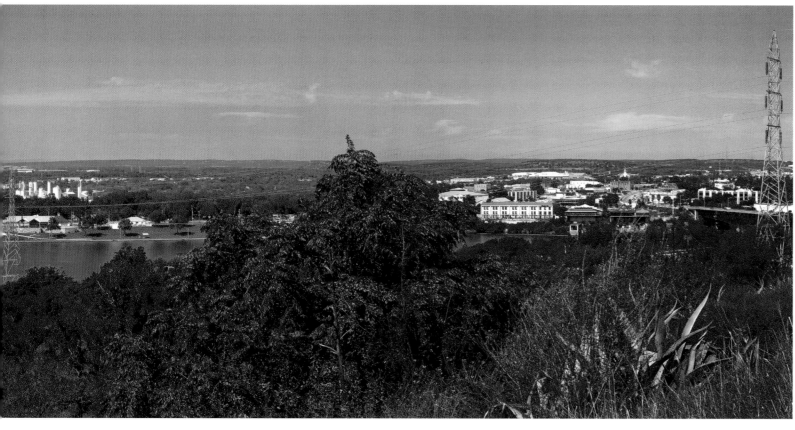

Marble Falls and the surrounding Highland Lakes region continue to develop as a major tourism and resort industry. In spring, scenic drives along the lake are especially beautiful with fields and roadsides covered in bluebonnets and other wildflowers.

Guadalupe River Slumber Falls, circa 1940s

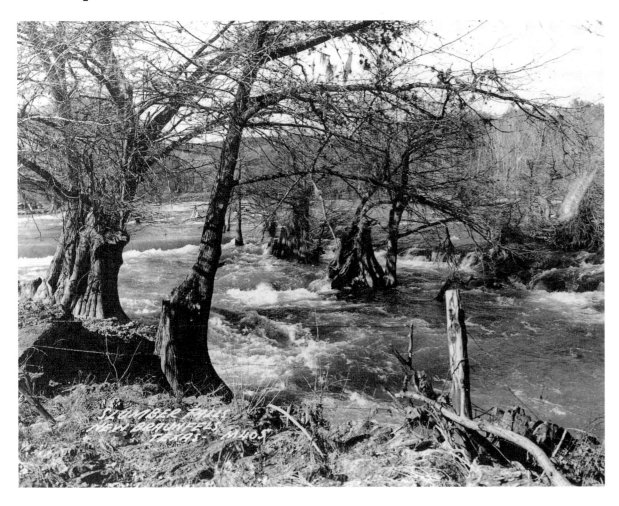

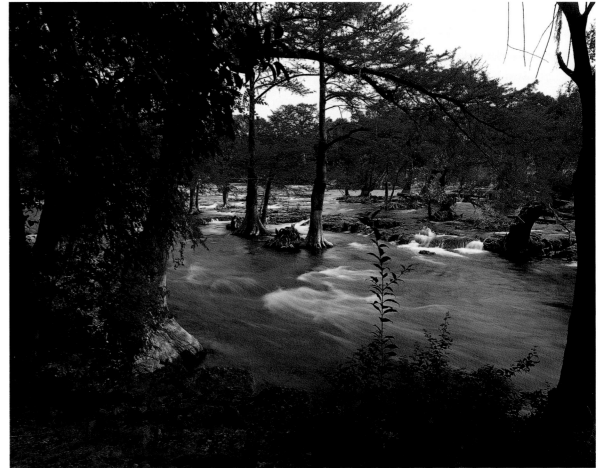

The Guadalupe River flows southeast from its two sources in Kerr County, passing through nine counties before reaching San Antonio Bay in the Gulf of Mexico. The steady flow from the springs that feed the Guadalupe and its tributaries have made the river a reliable source of waterpower. By 1920, the Guadalupe Waterpower Company built a series of dams between New Braunfels and Seguin. Flooding, however, continued to be a problem. In 1933, the state legislature established the Guadalupe-Blanco River Authority to oversee the control, storage, and distribution of water from the Guadalupe and Blanco rivers. In 1958, the U.S. Army Corps of Engineers, in cooperation with the river authority, started building the dam at Canyon Lake, about 15 miles upriver from New Braunfels. After its completion in 1964, the dam provided the first effective flood control for areas downstream.

While Canyon Lake can store a great deal of water from upstream rains, it can't do anything about flooding rains that fall downstream from the dam. In the span of only four years, the Guadalupe experienced two 100-year floods. In October 1998, a steady flow of moisture from the Pacific Ocean below Mexico resulted in 32 inches of rain in the Seguin area, just south of New Braunfels. The towns of Cuero and Gonzales were almost completely submerged for several days. In June and July 2002, a similar rain event occurred, causing flooding as bad as or worse than the 1998 event. In between historic floods, the river is actually quite peaceful, allowing thousands of people to float down it on inner tubes in summer.

Guadalupe River Kerrville, circa 1940s

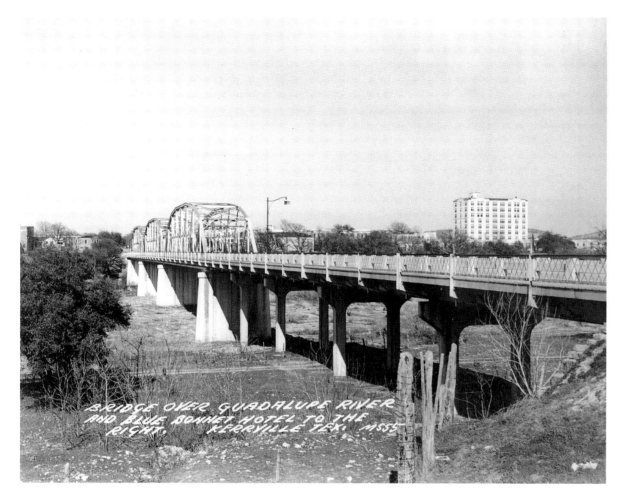

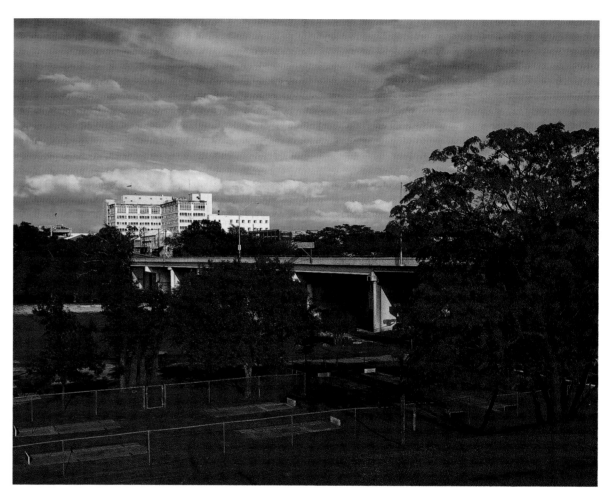

Kerrville grew from a settlement of shingle makers who lived along the Guadalupe River. They harvested the cypress trees to make their product. Charles Schreiner, a former Texas Ranger who also served with the Confederacy, was one of its early settlers. He established a general merchandising business in 1869, and by 1910 his company owned more than a half-million acres in the area. Schreiner's network of commercial enterprises included wool and mohair production, banking, ranching, marketing, and brokering operations, which steered the area's economy upward for the next 50 years.

Rugged hills, scenic green valleys, and cypress-lined streams have made Kerrville one of the most popular tourist destinations in Texas. Plenty of camps, dude ranches, hotels, and lodges accommodate its visitors. Kerrville's economy continues to grow and diversify through business, agriculture, health care, education, and the arts, as well as tourism. The Wall Street Journal *once described Kerrville as one of the wealthiest small towns in America.*

Upper Guadalupe River circa 1940s

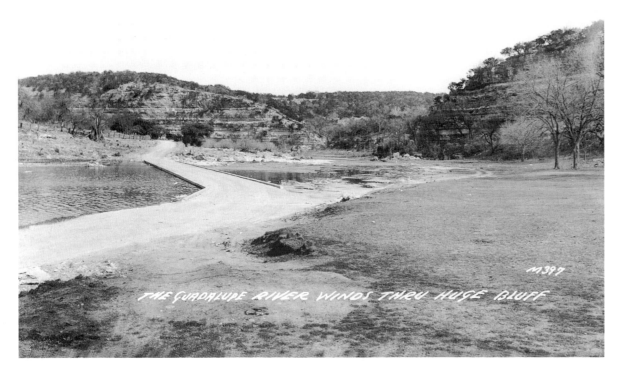

THE GUADALUPE RIVER WINDS THRU HUGE BLUFF

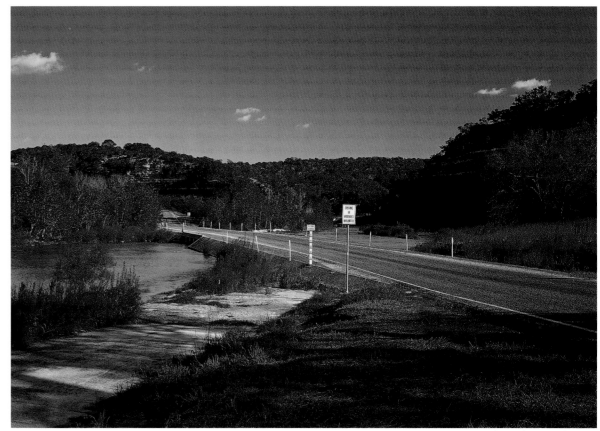

Artifacts from the Archaic Era uncovered in the Guadalupe River valley indicate that humans lived there for thousands of years. It is easy to understand why, with the area's idyllic scenery, crystal clear waters, and temperate climate. The upper Guadalupe flows across part of the Edwards Plateau. High limestone bluffs adjacent to the river support bald cypress, mesquite, and juniper trees. Sections of the upper and middle reaches of the river are suitable for canoeing, but a number of small waterfalls prevent uninterrupted navigation of the entire river. The lower Guadalupe is generally much quieter and has more sand bars that lend themselves to camping and day use.

This section of the upper Guadalupe has not changed much in the 60 years since the first picture was taken. Just downstream from here in the Hunt and Ingram area, the river is lined with summer camps for children and adults. Although the lower Guadalupe flows through fairly heavily populated areas, this section has retained much of its wild character over the years. Canoeing and kayaking are possible on the river, but a thriving industry centered on "toobing" is responsible for most of the summer recreation.

Portions of these captions were reprinted with permission from the Handbook of Texas Online, *copyright Texas State Historical Association.*

Bandera circa 1940s

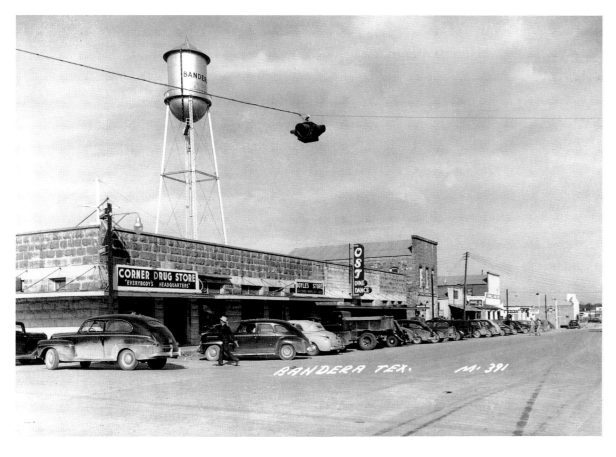

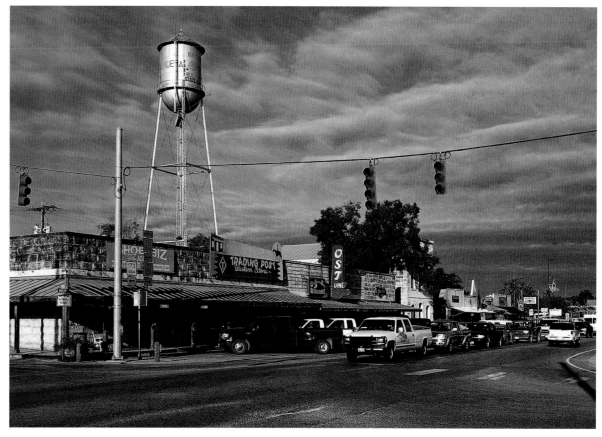

Bandera was founded in 1853 as a lumber mill site. Immigrant workers were recruited from the Polish colony in Karnes County, about 100 miles to the south. Settlers were encouraged to move into the area after a U.S. cavalry presence was established at nearby Camp Verde in 1856. Bandera then prospered after the Civil War as a staging area for cattle drives on the Western Trail, and its identity as the "Cowboy Capital of the World" was born. The local economy declined after 1900 when a series of floods devastated the town.

During the Great Depression, even ranching fell on hard times. To survive, Bandera transformed itself into a resort town with riverside camps, restaurants, dance halls, and rodeos to complement the dude ranches erupting in the area. The town is still a blend of dude ranches and working ranches, and it has retained its frontier appearance and western heritage. Rodeos are held throughout the summer months, and a number of honky-tonks are in full swing on weekends.

Bandera Dam on the Medina River, circa 1940s

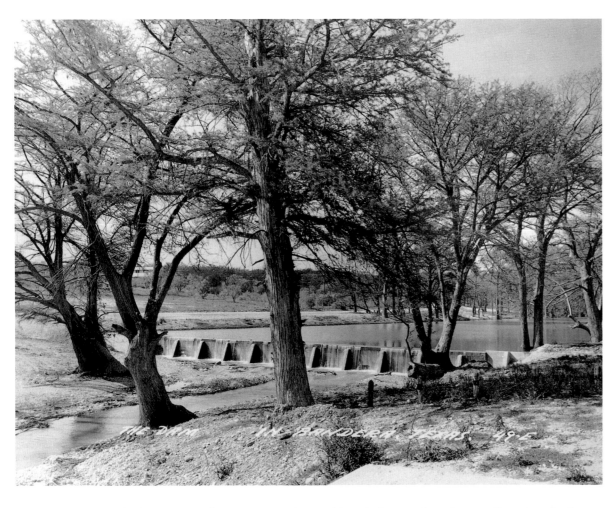

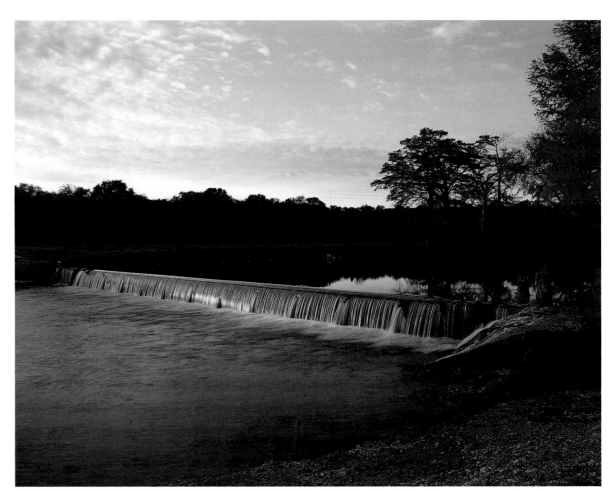

The Medina River had a variety of names appearing on historical maps, but the moniker given by Ponce de Leon has endured. De Leon named the river after an engineer, Pedro Medina, who created the navigation tables used by De Leon on his trek through the area. The numerous cypress and pecan trees that lined the stream inspired many to write about its charm and made it a favorable location for the establishment of various settlements.

This section of the Medina River flows through the town of Bandera. It plays a large role in Bandera's welfare, and residents still cast a wary eye on it every time a big storm blows through the area.

EAST TEXAS

Dallas ☆ Fort Worth ☆ Bonham ☆ Texarkana ☆ Camden ☆ Kilgore
Longview ☆ Marshall ☆ Nacogdoches ☆ Washington

"Nor is it the habit of Texans to look back. We have a tradition of looking forward
and not looking back to see where we have been or who is following us."
—President Lyndon B. Johnson

Dallas Dealey Plaza, 1935

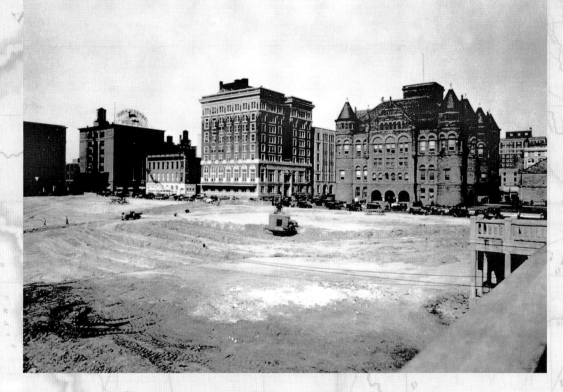

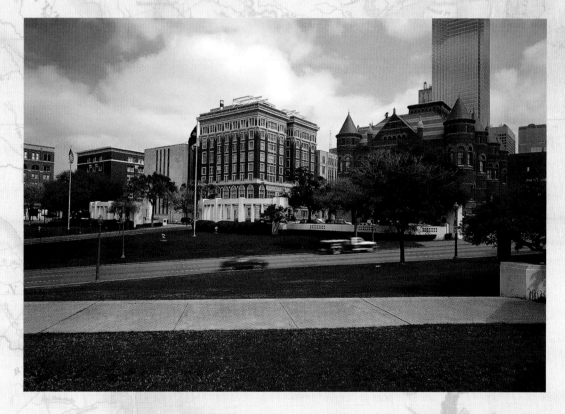

This park was named for George Bannerman Dealey, the principled Dallas Morning News publisher and journalist who battled effectively for improving the city of Dallas. His actions led to the founding of the Dallas Civic Improvement League in 1902, and he vehemently opposed the actions of the Ku Klux Klan in the 1920s. He was also instrumental in the founding of Southern Methodist University and was a director of the Children's Hospital of Texas.

This photo, shot from the Cockrell Colonnade across Commerce Street from Dealey Plaza, shows the Texas School Book Depository, from which Lee Harvey Oswald fired the shots that killed President John F. Kennedy; the Criminal Courts and Dallas County Records Buildings; and "Old Red," the Dallas County Courthouse built of Arkansas gray granite and red sandstone in 1892. Behind the courthouse is the Bank of America Plaza, the city's tallest skyscraper at 72 stories (921 feet). It is also the third tallest building in the State of Texas.

Dallas Commerce Street Bridge, 1908

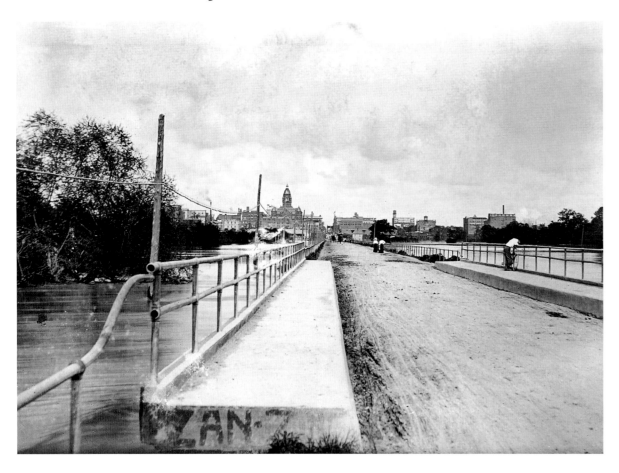

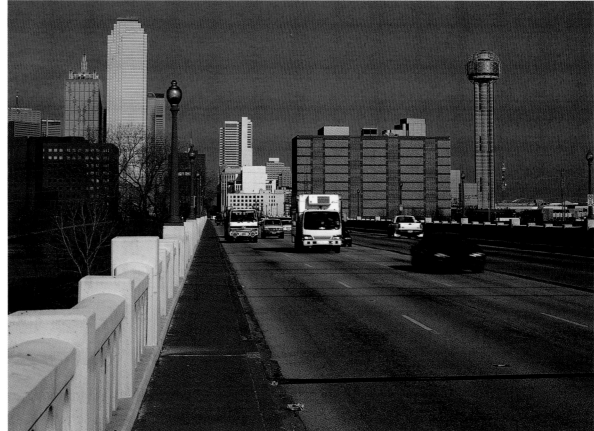

Today's Commerce Street Bridge is at the site of the first toll bridge built at the end of Commerce Street in 1855. Dallas' first steam sawmill on the Trinity River was established near Commerce Street, along with large Greek-style home. Alexander Cockrell, one of Dallas' early movers and shakers accomplished all of the above 150 years ago, believing that the mark of a man was what he accomplished with his own ambition and ingenuity. Cockrell's Dallas Bridge and Causeway Company built the toll bridge out of red cedar, only to see it destroyed three years later in one of the Trinity River's many floods. This photo of the Commerce Street Bridge shows how high the water got during the great 1908 flood.

The future of the Trinity River flood basin has been an ongoing topic of debate in Dallas-Fort Worth political circles for decades. At risk are riparian ecosystems and important wetlands. At the same time, the flooding potential of the Trinity River has been increasing in the wake of continued urbanization in its watershed. According to recent studies conducted by the Fort Worth District of the Corps of Engineers, channels and levees created for flood control over the years have resulted in the elimination of most of the original floodplain forest and aquatic habitats.

Dallas Main Street, 1905

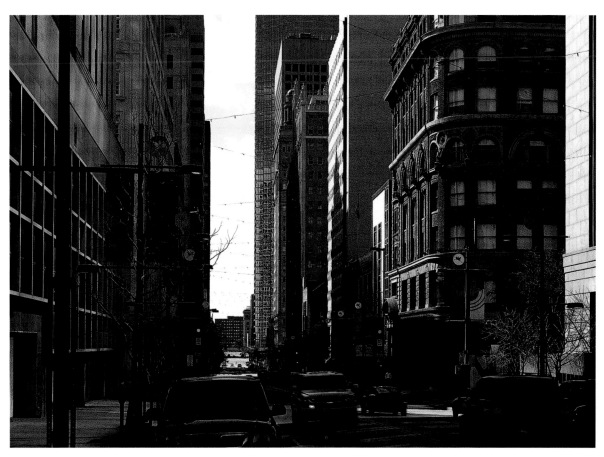

When the railroad came to Dallas in the mid-1870s, the population soared from 3,000 to more than 7,000 in one year. Many businesses were established and new buildings were erected. Large, grand hotels were built but most buildings remained plain and utilitarian. Main Street was once the center of the principle retail district in Dallas, but faded in that role when retail stores began to move into malls on the outskirts of the city during the 1960s and 1970s.

Downtown Dallas is once again becoming home to a growing base of upscale restaurants and bars as well as retailers. The City of Dallas, along with a number of private organizations is working to revitalize the downtown Dallas retail community. Potential retail space available in both old and new buildings is estimated at between a quarter- and a half-million square feet.

Dallas Oak Cliff Viaduct, circa 1920s

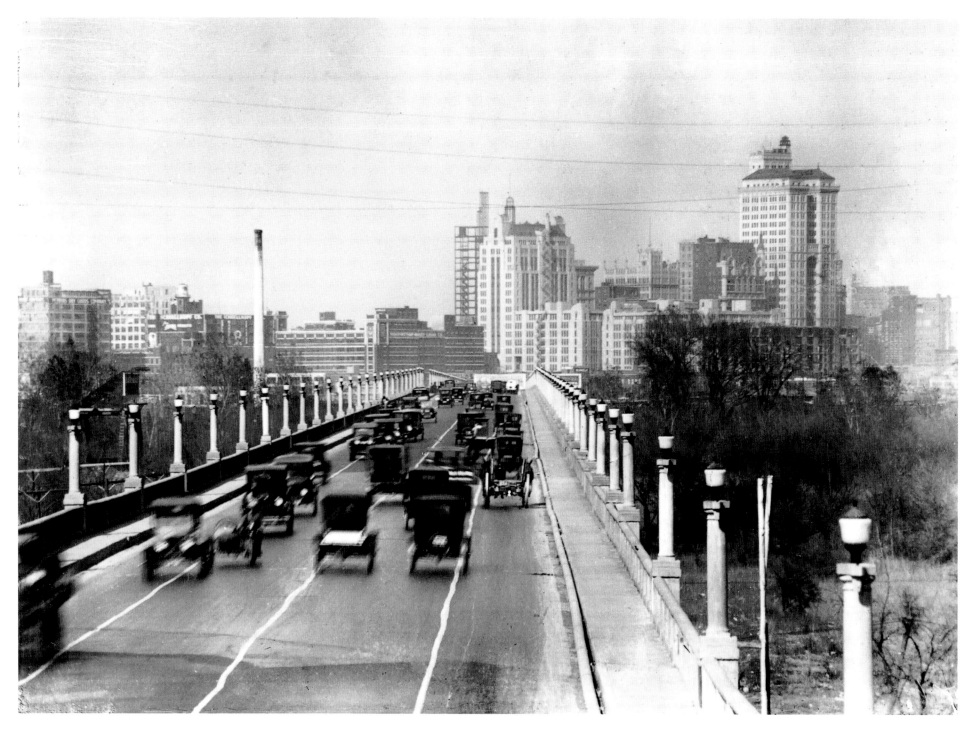

The Houston Street Viaduct, originally called the Oak Cliff Viaduct, was built to transport Dallas citizens back and forth across the Trinity River during its frequent floods. It opened in February 1912 at a cost of $675,000. The 5,106-foot bridge was designed to withstand the kind of floodwaters that had washed away all earlier bridges, wooden as well as steel. The city's worst flood in May 1908 swelled the river to almost two miles wide and 53 feet deep, cutting off all traffic between Dallas and Oak Cliff. In the wake of the tragedy, which caused $5 million in damages and killed 11 people, the city approved a $20 million project to move more than 21 million cubic yards of dirt to build levees to tame the river and keep it away from downtown Dallas.

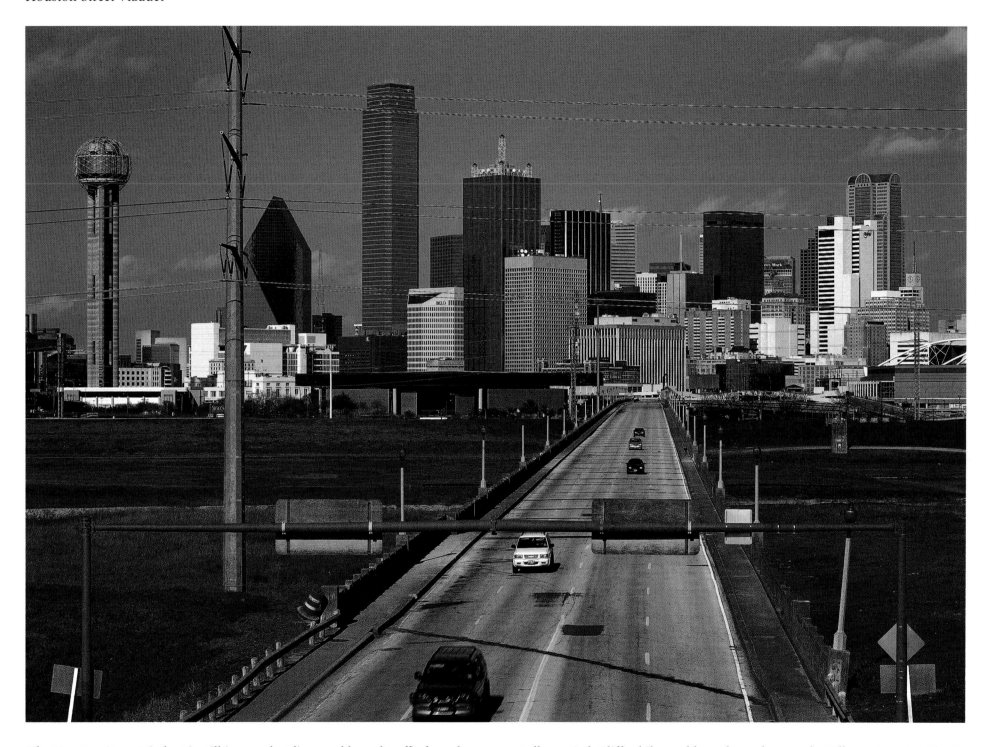

The Houston Street Viaduct is still in use, shuttling southbound traffic from downtown Dallas to Oak Cliff, while northbound travelers use the Jefferson Street Bridge to get to the downtown area. The bridge has sidewalks on both sides, making it popular with joggers.

Dallas City Hall, 1900

Adolphus Hotel

Dallas' first high-rise city hall was completed in 1889. The Palo Pinto sandstone and brick structure was built in 17 months at a cost of $80,000. The building, located on the northwest corner of Commerce and Akard, towered four stories above street level. The impressive new city hall replaced a three-story wooden building directly behind it. The Dallas News described the new city hall as "modern, mainly, with a slight leaning to the Gothic." Adolphus Busch, cofounder of the Anheuser-Busch brewery in St. Louis, Missouri, demolished the unique structure in 1912 to make room for the 260-room hotel that still bears his name. According to the Adolphus Hotel website, "Busch didn't fight city hall, he bought it."

Busch died in Germany before he ever got a chance to see his creation. In 1949 the hotel was sold to Leo Corrigan, the owner of the famous Biltmore Hotel in Los Angeles, who added 500 more rooms. The hotel was sold again in 1980 to the New England Mutual Life Insurance Company and Westgroup, which undertook an $80 million renovation and reopened it, this time with only 435 rooms. Queen Elizabeth, Greer Garson, Yul Brenner, Bing Crosby, Amelia Earhart, Arnold Schwartzenegger, and Donald Trump are just a few of the celebrities who have stayed there. Today, the hotel has 428 luxurious rooms, three restaurants including The French Room, one of the city's best, and an impressive collection of museum-quality artwork.

Dallas Lake Cliff Park, circa 1910s

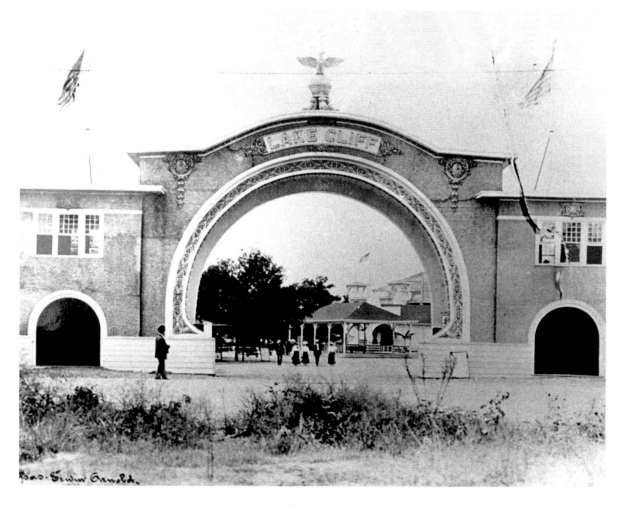

In 1906, Charles Mangold and John Zang built an amusement park in Lake Cliff Park in the southern Dallas community of Oak Cliff to attract potential homeowners and increase property values. The noted architectural firm Lang and Witchell designed the $100,000 park, which included a Ferris wheel, a stadium, and a 30-acre lake. A 6-foot eagle statue flanked by large American flags greeted visitors who passed through the arched entryway. Residents found relief from Dallas' searing summer heat in Lake Cliff, which featured "the largest floating bathhouse in the South."

In 1913, financial problems forced the owners to sell Lake Cliff Park to the city of Dallas for $55,000. Most of the rides and attractions were gradually removed over the years, but the swimming pool remained until 1959 when the Dallas Park Board finally closed it. In 1994, the Lake Cliff Historic District was listed on the National Register of Historic Places. Recent efforts have been made to restore many of the old homes in Lake Cliff that were built during the park's glory years. Lake Cliff Park is at the corner of Colorado and Zang boulevards in the southwest part of Dallas.

Dallas View of Southern Methodist University from Dallas Hall, circa 1930s

Immediately following the Great Depression, discovery of nearby oil fields ensured Dallas' survival. The oil business was booming in the 1930s, and the business it brought to the city, along with the defense industry during World War II, established Dallas as a modern city with nationwide influence.

Over the years, Dallas has lost little of its importance on the national stage. Whether it be the assassination of President John F. Kennedy, the eponymous dramatic television series, or the most publicized cheerleaders in the United States, there is always something to bring the national spotlight back to Dallas.

Dallas Southern Methodist University, circa 1930s

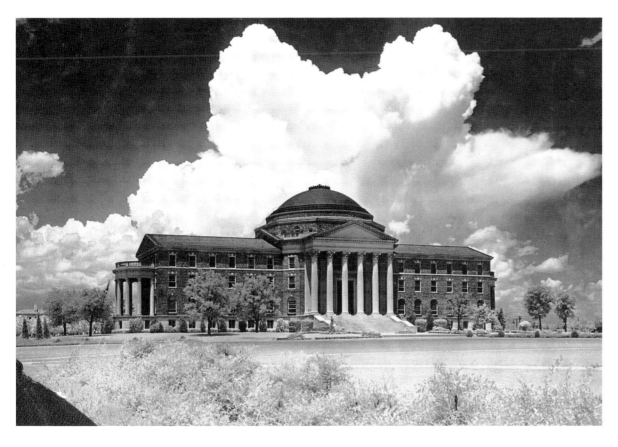

Southern Methodist University (SMU) opened on September 22, 1915, with an enrollment of 706 students. It consisted of two buildings situated on a small hill in the middle of the north Texas prairie, including Dallas Hall (pictured here). The school is privately funded and is nonsectarian in its teaching, although it is related to the Methodist Church. SMU offers masters and doctoral degrees as well as 80 different undergraduate degree programs. The architecture of buildings constructed after World War II follows the modern Georgian style.

Today, SMU has 73 permanent buildings and an enrollment of more than 10,000 students. Dallas Hall is registered on the National Registry of Historic Places. A scene from the 1989 film Born on the Fourth of July *was shot around the exterior of the west wing of Dallas Hall.*

Fort Worth Main Street

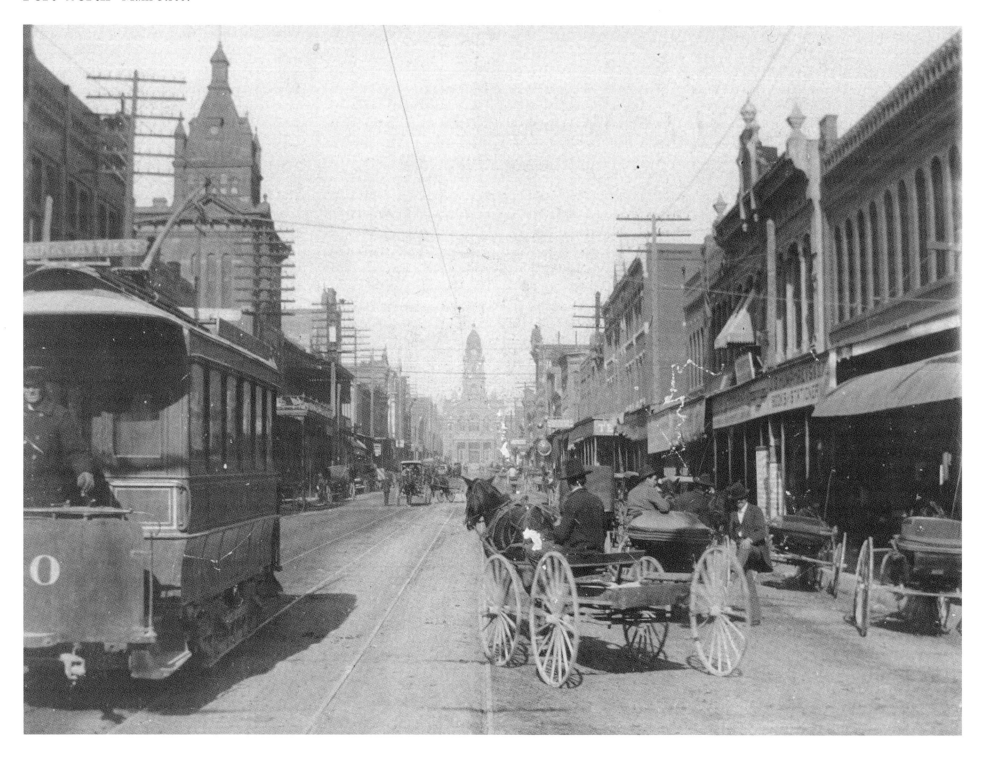

In 1849, the U.S. Army built an outpost on the banks of the Trinity River and named it Camp Worth in honor of General William Jenkins Worth, a veteran of the Mexican War. When the army built a line of forts farther west, Camp Worth (now Fort Worth) was abandoned and taken over by settlers. The settlement experienced sporadic growth over the next 50 years, and like so many other towns, began to prosper once the railroads came to the area. The Fort Worth Street Railway Company even ran a mile-long route down Main Street. The cattle industry became the town's bread and butter in the latter part of the 1800s, when it acquired its still-popular nickname, "Cowtown." Fort Worth was the starting point for many who traveled the legendary Chisholm Trail, one of the major routes for cattle drives to the north.

Main Street is the site of the annual Main Street Fort Worth Arts Festival held in April. Thousands attend the four-day festival to see a juried fine art-and-crafts show, live concerts, performance artists, and street performers. The buildings on Main Street are mostly new; however, the original 1895 pink granite courthouse still stands at the end of the avenue.

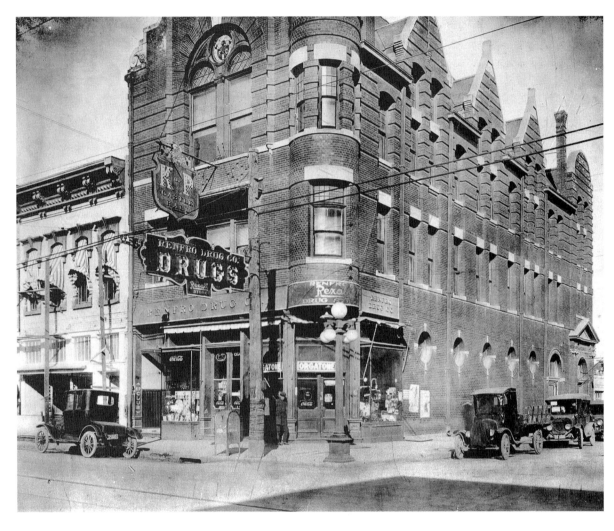

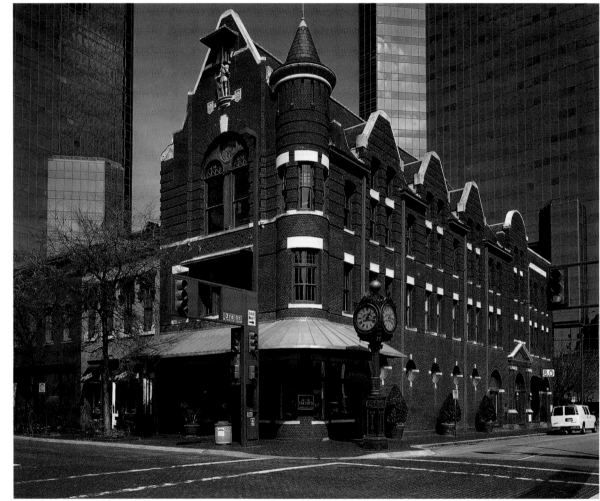

The Knights of Pythias, a fraternal order established in Houston in 1872, built its Fort Worth lodge at 315 Main Street in the style of a medieval guildhall. When it burned to the ground in 1901, another lodge was built very similar to the first. Architect Marshall R. Sanguinet, who also designed the Flatiron Building, designed the lodge in the style of a Flemish or Dutch medieval civic structure. The Pythians leased out the bottom two floors to offset the cost of maintaining the building and used the third floor to conduct their meetings, an arrangement common among fraternal orders. Among the tenants who occupied the first floor over the years were a drug store, attorneys, real estate agents, physicians, and a veterinary surgeon.

After lodge membership and tenancy tapered off during the 1960s and 1970s, the Knights of Pythias sold the building. In 1978, Bass Brothers Enterprises purchased it and renovated it as part of the Sundance Square Project. The interior was remodeled with retail and office space. The Knights of Pythias Castle Hall was designated a Recorded Texas Historic Landmark in 1962, and listed on the National Register of Historic Places in 1970.

Fort Worth Flatiron Building, 1912

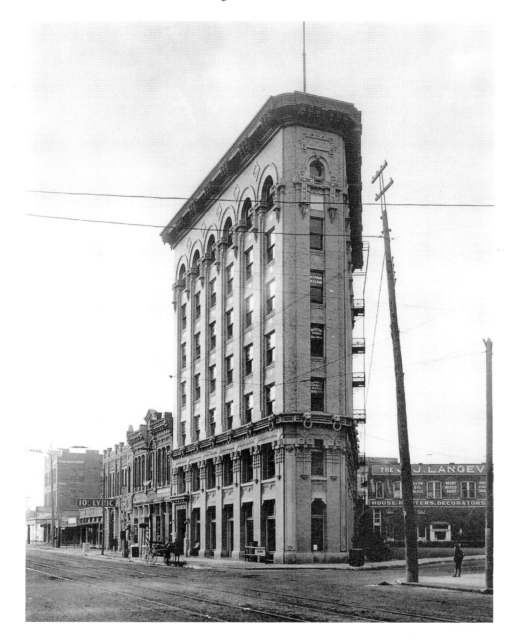

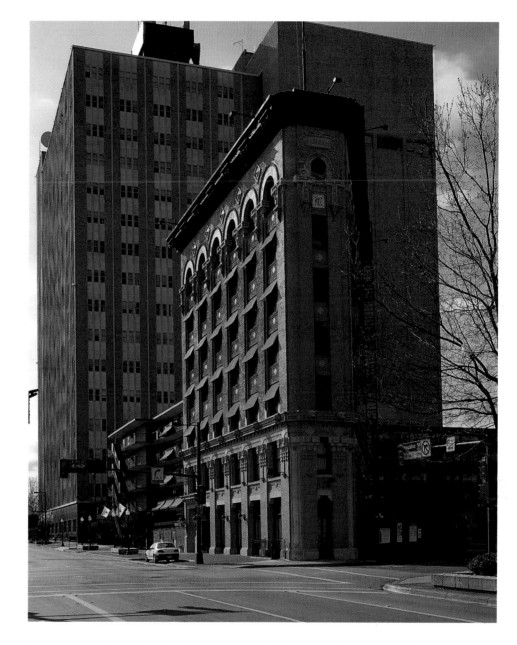

The seven-story Flatiron Building in downtown Fort Worth was the creation of Dr. Bacon Saunders, a surgeon and dean of the Fort Worth Medical College. Saunders modeled his 1907 creation after Daniel H. Burnham's Flatiron Building in New York City. Local architects Marshall R. Sanguinet and C.G. Staats designed the structure, and the construction firm of Buchanan and Gilder built it for $70,893. The architects applied the principles of the Chicago School in their design, which utilizes steel-frame construction to support tall buildings and employs designs that emphasize their verticality. The building features a buff-colored brick veneer and limestone trim, and geometrically patterned ornamentation inspired by architect Louis Sullivan, one of the pioneers of high-rise construction techniques.

The Flatiron Building, the oldest surviving skyscraper in Fort Worth, remains one of the city's most enduring landmarks. Over the decades it has had a number of different owners and uses but has also been through prolonged periods of vacancy. The local community has expressed interest in and support for the Flatiron Building, and efforts are underway to restore it. It was listed on the National Register of Historic Places in 1971, designated as a Recorded Texas Historic Landmark in 1970, and a City of Fort Worth Landmark in 1994.

Fort Worth Texas Christian University, circa 1910s

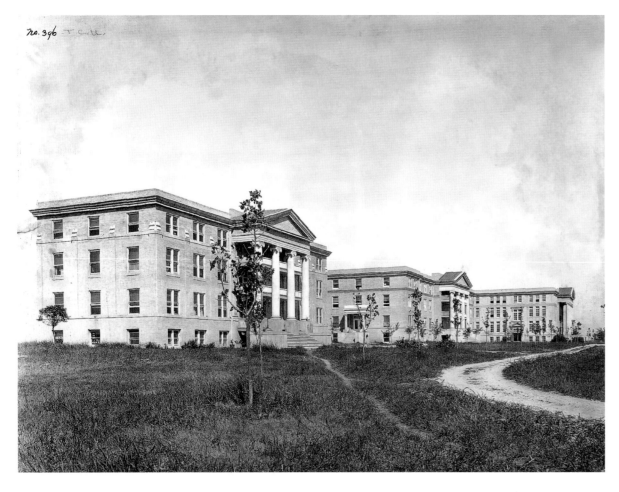

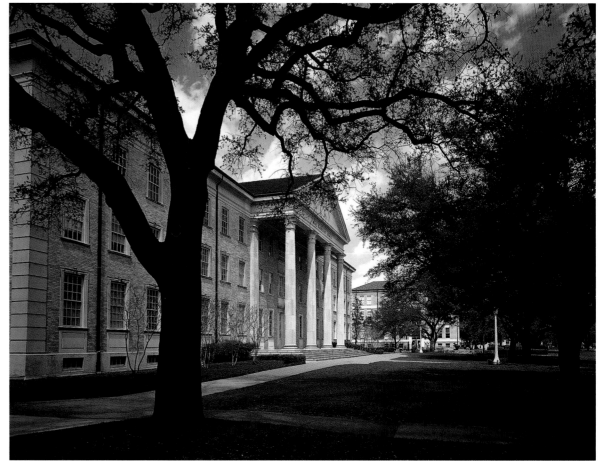

Texas Christian University began as a school founded by Disciples of Christ ministers, Addison and Randolph Clark, and their sister Ida, in a one-room building in Fort Worth in 1869. Concerned about the distractions and temptations of the big city, they moved the school in 1873 to Thorp Spring, in Hood County. In 1895, under the auspices of "Add-Ran Christian University," they moved yet again to Waco, only to suffer a calamitous fire. They settled in Fort Worth in 1910 after the city offered them $200,000 and 56 acres on which to build their new campus. When the school officially opened a year later, there were three buildings: Goode Hall, Jarvis Hall, and the Main (or Administration) Building. All three were built in Classical Revival style, as were many of the campus buildings that followed. The three elegant structures were in stark contrast to the undeveloped, wild landscape around them.

Jarvis Hall, pictured here, functions today as a women's dormitory. Reed Hall, formerly the Main (or Administration) Building, also still stands. Both buildings have undergone some remodeling over the years. The campus has so many trees now that trying to duplicate the original vantage point would have shown very little of any of the buildings, so I moved in for a close-up of Jarvis Hall instead.

Bonham circa 1940s

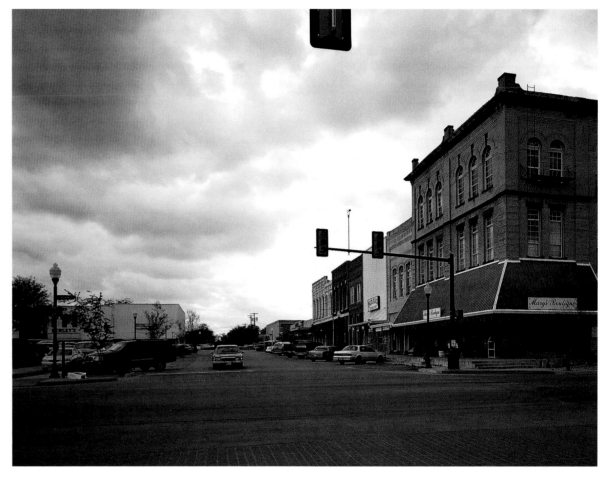

Bonham is situated 12 miles south of the Oklahoma-Texas border. Bailey Inglish, a Kentuckian, arrived in the area in 1836 and a year later built Fort Inglish, a blockhouse and stockade on nearby Bois d'Arc Creek. Inglish and another settler, John Simpson, donated the original townsite, which was named Bois d'Arc. It was renamed Bonham in 1844 in honor of James B. Bonham, one of the heroes of the Alamo. The town was a division point on the Texas and Pacific railroad in 1873, and by 1888, it was developing its own agricultural industry. Bonham once had the largest cotton mill west of the Mississippi. During the Great Depression, Work Projects Administration and Civilian Conservation Corps crews built a number of structures for the town, including some buildings for the high school. A prisoner of war camp was built here during World War II as well as Jones Airfield, a pilot training facility.

Bonham achieved fame as the home of Samuel T. Rayburn, a leader of the national Democratic Party and Speaker of the House of Representatives. The Sam Rayburn House and Sam Rayburn Library are open to the public. A historic downtown walkabout on the town square features 12 informational plaques featuring the important people, places, and events in Bonham's history.

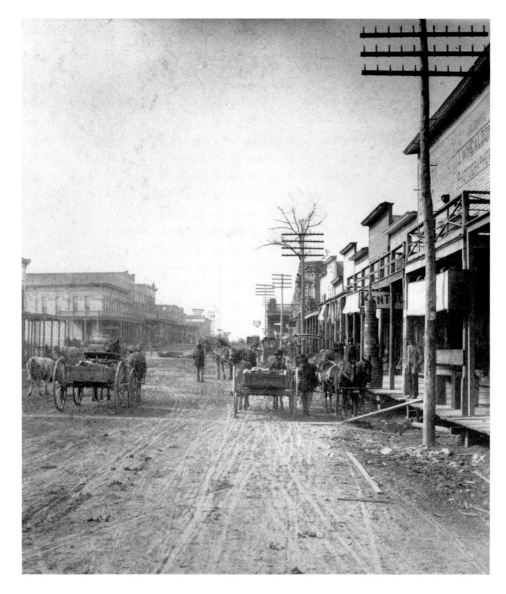

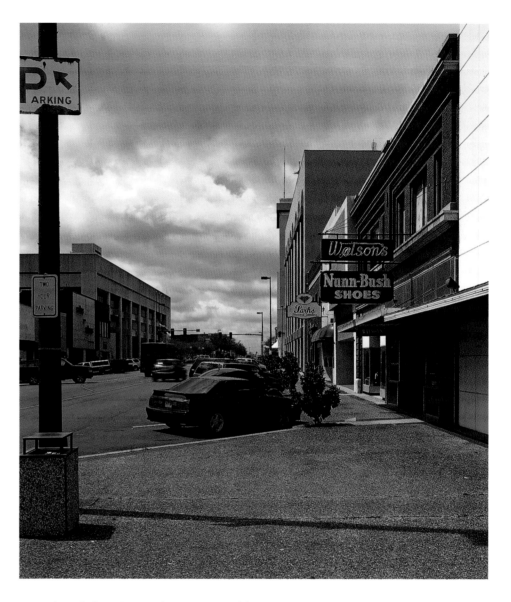

Texarkana was established at a site that was once a Caddo Indian village on the Great Southwest Trail. The trail was used by Native Americans to travel between villages in the Mississippi basin to those in the southern and southwestern United States. The Texas and Pacific Railroad, which had put down rails in Texas up to the Arkansas state line, laid out the Texas portion of what would later become Texarkana. The town was known as Texarkana, Arkansas, until Texas congressman John Morris Sheppard secured a postal order changing the name officially to Texarkana, Arkansas-Texas. By 1925, many of the residents of the town worked for the railroad or in agricultural product processing plants. The construction of Red River Army Depot and the Lone Star Army Ammunition plant helped to revive the city's economy in the early 1940s.

Texarkana's location at the junction of four important railroad systems has made it one of the major railroad centers in the region. The city has remained an important commercial and industrial center due to its proximity to three natural resources: rich forests, fertile agricultural lands, and abundant and diverse mineral deposits. While commercially one city, Texarkana consists of two separate municipalities with two mayors and two sets of councilmen and city officials.

Camden 1910

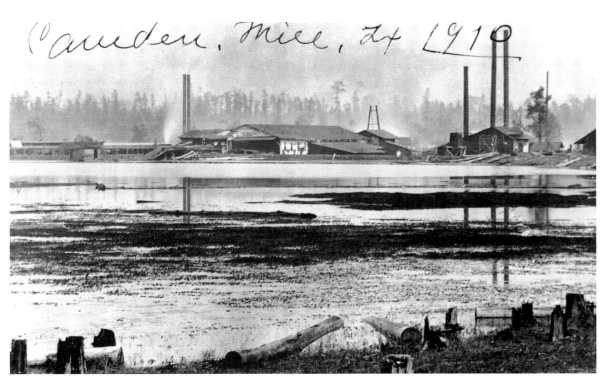

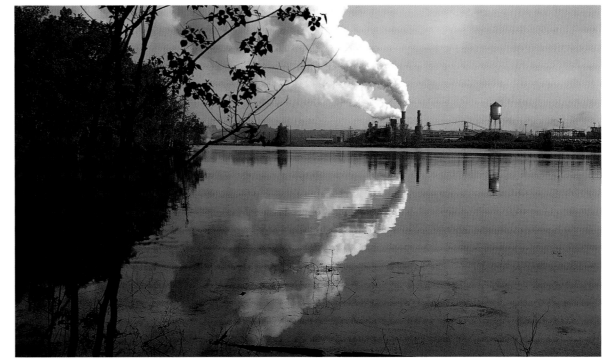

Camden was established in 1898 by the W.T. Carter and Brothers Lumber Company. The town's first mill burned in 1909 and was replaced with a modern concrete and steel lumber plant. Polk County is a predominantly rural area, and the timber industry anchored its economy then as it does now.

Today, the lumber and related service industries employ the greater part of the Polk County workforce. The Moscow, Camden & San Augustine Railroad operates a 7-mile line headquartered in Camden. The line extends west from Camden to a connection with the UP Lufkin Subdivision at Moscow. Its traffic is primarily related to the East Texas timber industry, and consists of lumber and lumber-related projects. There is a 1.8-mile walking trail through one of the finest old pine stands in East Texas, with 225-year-old long leaf pines and 170-year-old loblolly pines. The trail is three miles east of town on FM 62.

Kilgore circa 1940s

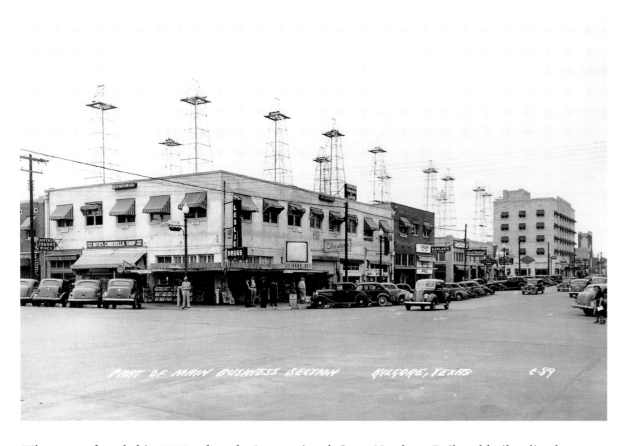

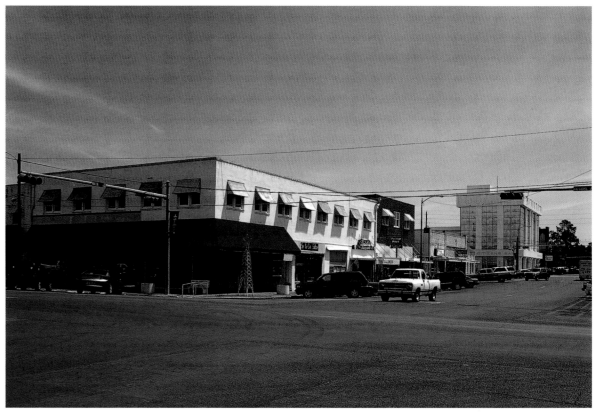

Kilgore was founded in 1872, when the International-Great Northern Railroad built a line between Longview and Palestine. The town was named after Constantine Buckley Kilgore, from whom the land was purchased. The town grew slowly, building a post office, church, and school by the mid-1880s, and adding banks, churches, a hotel, and cotton gins by 1914. The Great Depression hit Kilgore hard in the 1930s, forcing many businesses to close and residents to move. No one could have foreseen what happened in 1930 with the discovery of the great East Texas oilfield: A community on its last legs, reeling from the Great Depression, suddenly became a boomtown. Thousands of wildcatters streamed in, setting up camps in every available space. In 1931, Texas governor Ross Sterling ordered martial law to control production and bring order to the area. In only six years, Kilgore's population swelled to 12,000, and by 1939 there were 1,200 oil derricks within its city limits, most of which were concentrated within one city block that came to be known as the "World's Richest Acre."

The huge increase in production ultimately caused oil prices to fall and the boom began to subside in the mid-1930s. Major oil companies gradually bought out most of the independents, and by the eve of World War II the boom was largely over, although oil production in the area continues. Today, the East Texas Oil Museum chronicles the rise and fall of the oil boom. Kilgore College continually produces one of the nation's premier dancing drill teams, the famed Kilgore College Rangerettes.

Longview Gregg County Courthouse, circa 1940s

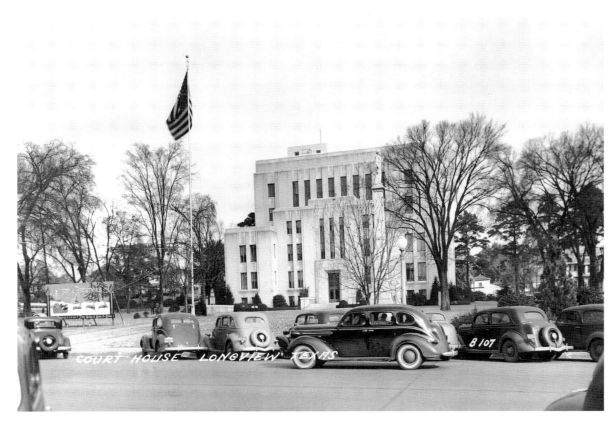

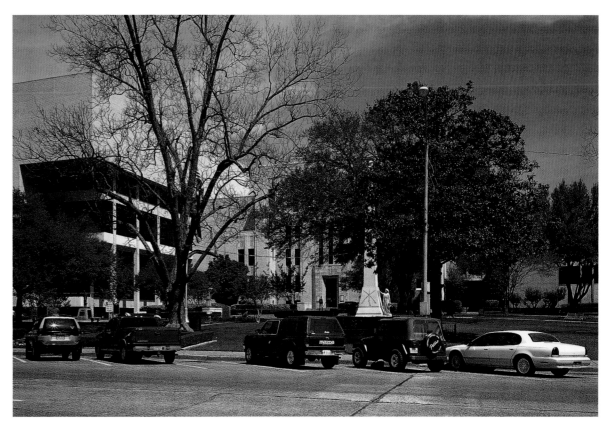

The 13th Texas Legislature passed a bill creating a new county on April 12, 1873, originally calling it Roanoke, but later changing it to Gregg, in honor of Confederate War hero John B. Gregg. The county was extended southward to add a portion of northern Rusk County in 1874. Gregg County had several courthouses between 1874 and 1932. The architectural firm of Voelker and Dixon designed the current Gregg County Courthouse in the Art Deco style that was popular at the time. C.S. Lambie & Co. built it in 1932 for $194,500 using brick, terra cotta, and marble.

The county added a large Contemporary style annex to the courthouse in 1982 that dwarfs the original structure. Trees that have grown up since the first picture was taken tend to obscure it as well.

Marshall circa 1940s

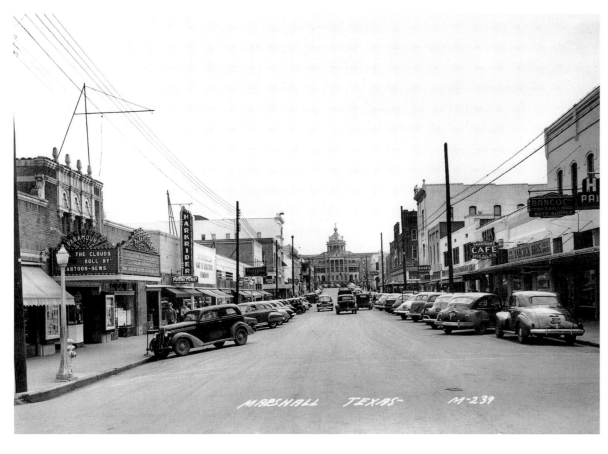

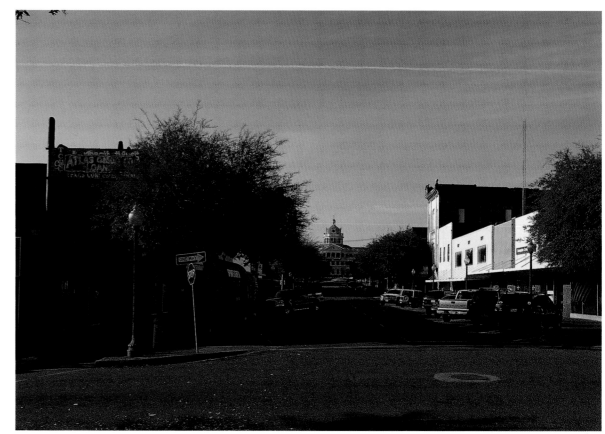

After its founding in 1841, Marshall became an important border town for stagecoaches. Due to its prime location, in less than 20 years it grew to be the fourth largest city in Texas. The influx of business aided Marshall in becoming the seat of the richest county, and in turn, became the region most populated with slaves in the state. Confederate support was strong, and the city became the capital of the Confederate government of Missouri, exiled by its home state. After the Civil War, the railroad helped Marshall regain importance during Reconstruction.

Over the past 50 years, Marshall's history has been quite turbulent due to the struggle for civil rights and racial equality. This tension built in the 1950s and '60s, resulting in hotly contested Supreme Court battles and the first student sit-ins in Texas. With the help of its prosperous neighbor city Kilgore, Marshall experienced great progress until the 1980s, when the Texas oil bust lowered the population by nearly 1,000 in only 10 years.

Marshall Harrison County Courthouse, circa 1940s

Harrison County Historical Museum

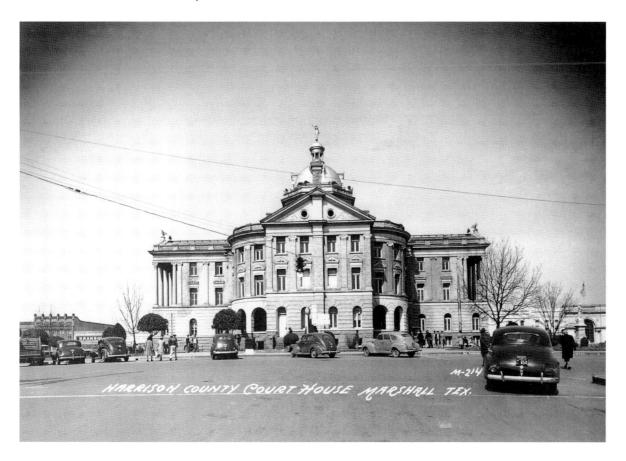

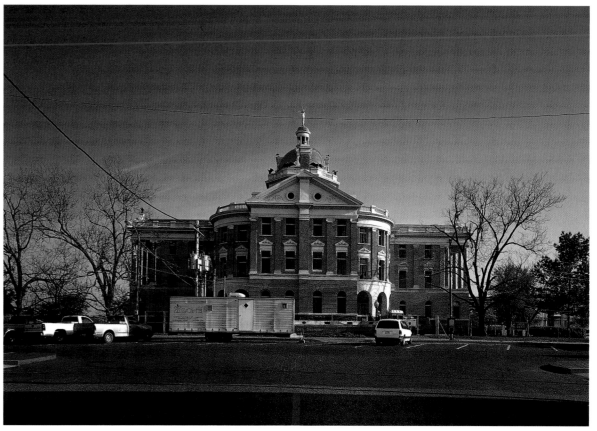

Marshall was founded in 1841 and named for Chief Justice John Marshall. By 1850, the town encompassed one square mile of land centered around a courthouse. The county had three different courthouses before architect J. Reily Gordon designed this one in 1900. The former courthouse is now the Harrison County Historical Museum.

The Courthouse Preservation Council of Harrison County is supervising the restoration and renovation of the historic 1900 Harrison County Courthouse and its surrounding square in downtown Marshall. At Christmas, the city lights the former courthouse and grounds in an elaborate holiday display. Marshall has many of its historic homes and structures listed on the National Register of Historic Places, and the Texas Historical Commission has awarded many historical landmark medallions to the city. In 1976, the National Municipal League designated Marshall an All American City.

Nacogdoches Old Stone Fort, 1885

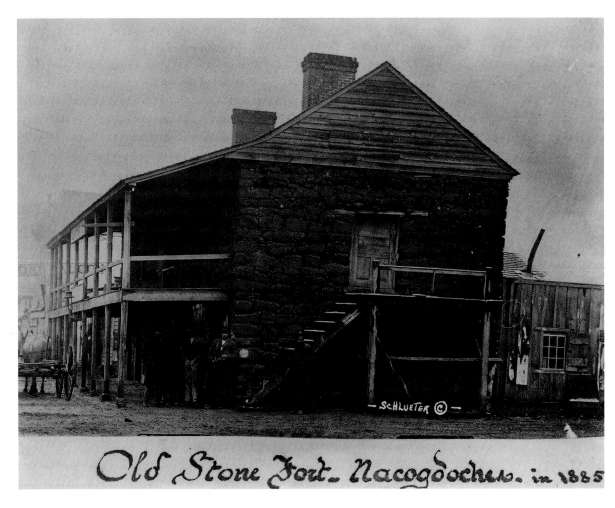

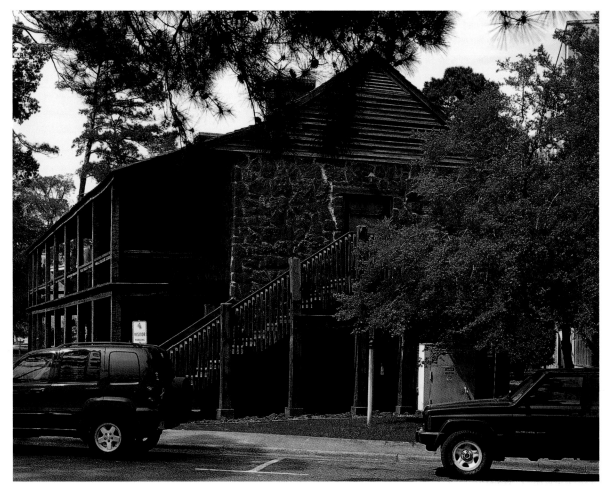

The Old Stone Fort was the first trading house in Nacogdoches and the frequent seat of civil government. It was built by Antonio Gil Ibarvo, a Spanish settler who laid out the town of Nacogdoches in two square sections, one for the government and one for the church. The fort was headquarters for several unsuccessful attempts to establish a Republic in Texas. The original structure was built in the late 1700s on the corner of Fredonia and Old San Antonio Road (now Main Street), using native iron ore. The building's interior walls were constructed using large adobe bricks. Much of the trading done in the fort was with local Native Americans who bartered skins and hides for various U.S. products. The building, at a whopping 20 feet tall, was the tallest structure in Nacogdoches for almost a century.

The present-day structure, a replica of the original Stone Fort, was reconstructed using stones from the original building. The Old Stone Fort is located on the campus of Stephen F. Austin State University, where it houses a museum dedicated to the preservation of East Texas and Nacogdoches history. The building itself serves as an example of Spanish Colonial residential architecture.

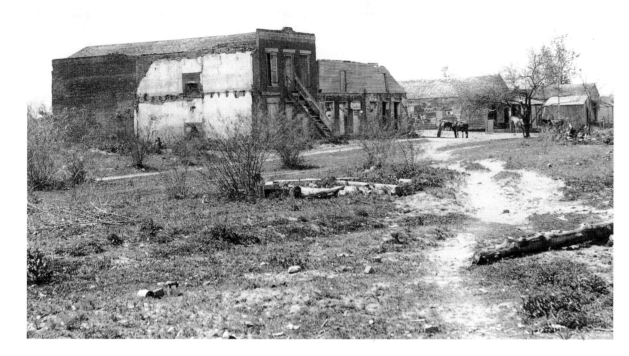

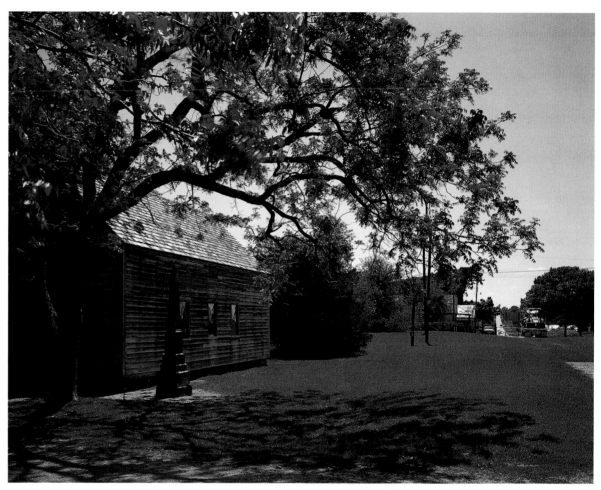

Washington, Texas, was a small, dusty, insignificant town on the Texas Blackland Prairie in the 1830s, when 59 delegates elected from each municipality in Texas convened in an unfinished frame building near a ferry landing on the Brazos River. While Santa Anna's forces were storming the Alamo, the Convention of 1836, under the direction of Sam Houston and George Childress, declared Texas "a free and sovereign nation," wrote a new constitution that established the Republic of Texas, and organized an ad interim government. A special committee of the Congress selected Austin (then called Waterloo) over Washington as capital of the Republic. Sam Houston moved it back to Washington until 1845, when it was moved permanently back to Austin.

Just a few hundred feet from the present-day town of Washington is a replica of the tiny frame building, on the same spot in which Texas' Declaration of Independence was signed in 1836. It is now part of Washington-on-the-Brazos State Historical Park. The park encompasses the site of the historic town that was the first county seat of Washington County, the capitol of Texas from 1842 to 1845, and the home of the last president of the Republic of Texas, Anson Jones. Recent additions to the park include a new visitor center, the Star of the Republic Museum, and the Barrington Living History Farm.

SOUTH TEXAS

San Antonio ✯ Victoria ✯ Goliad ✯ Refugio ✯ Laredo
San Juan ✯ Pharr ✯ McAllen ✯ Harlingen ✯ Brownsville

"I have answered the demand with a cannon shot, and our flag still waves proudly from the walls – *I shall never surrender or retreat*...VICTORY OR DEATH!"
—William Barrett Travis, The Alamo, 1836

San Antonio Mission San José y San Miguel de Aguayo, 1910

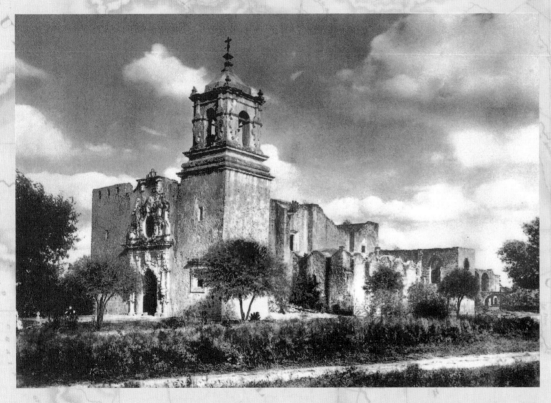

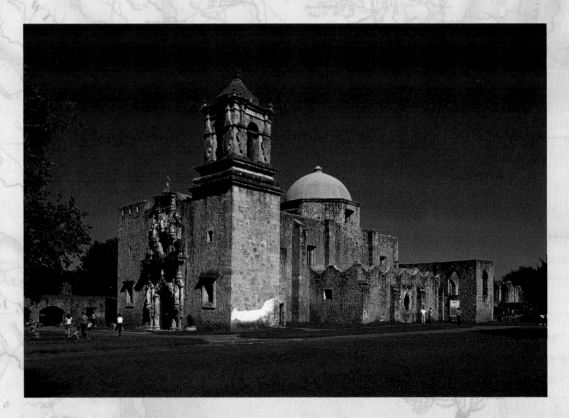

Mission San José y San Miguel de Aguayo was founded in 1720. It was named in honor of Saint Joseph and the Marqués de San Miguel de Aguayo, the governor of the Mexican Province of Coahuila and Texas at the time. Franciscan missionaries built the mission on the banks of the San Antonio River, several miles to the south of the earlier mission, San Antonio de Valero (the Alamo). San José was the largest of the missions in the area. Its population included as many as 300 Native Americans who farmed its fields and raised livestock. San José became known as the "Queen of the Missions," and its great success made it a target for Apache and Comanche raiders.

By the 1920s, San José was in poor shape after years of neglect. Among the casualties were the church's dome and bell tower. The federal government and the San Antonio Conservation Society worked to restore it in the following decades. In 1937, San José was rededicated, and in 1941, it was declared a State Historic Site as well as a National Historic Site. It remains an active parish.

San Antonio
Mission Nuestra Señora de la Purísima Concepción, circa 1880s

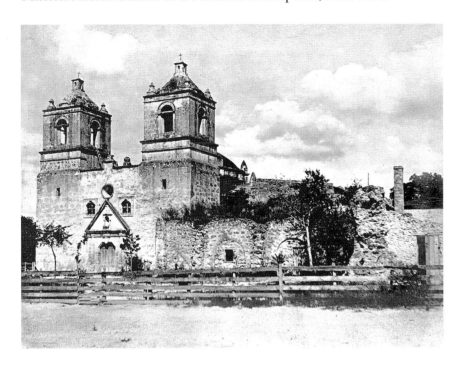

First established in 1716 in East Texas and relocated to San Antonio in 1731, Mission Nuestra Señora de la Purísima Concepción was completed in 1755. The church functioned as a supply post in 1824 and was re-established as a religious institution after several years.

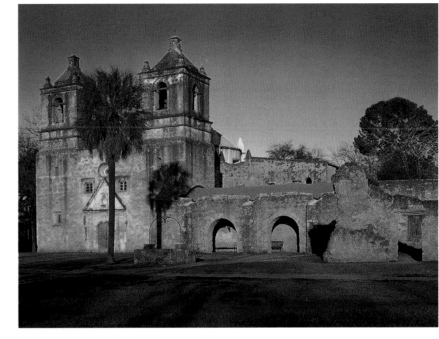

Today, besides the original stone church, a number of other original buildings still stand, including the president's office, the sacristy, and portions of the second friary, which were all built between 1755 and 1760.

Mission San Francisco de la Espada, 1905

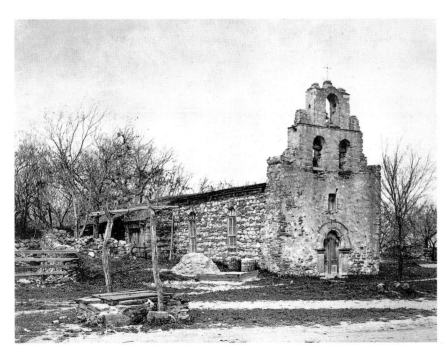

Founded in 1690 near present-day Weches, San Francisco de las Tejas was the first mission in Texas. It was relocated to the San Antonio River area in 1731 and renamed Mission San Francisco de la Espada. This photograph shows the church's unique entrance and three-bell espadaña (bell tower).

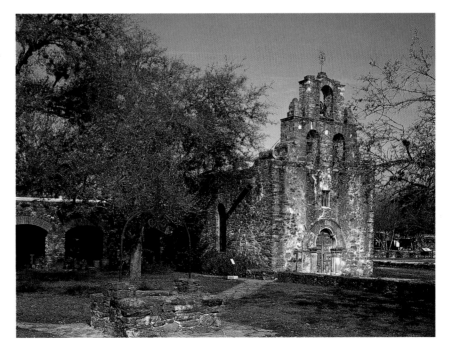

Mission Espada is the southernmost of the four missions located along the San Antonio River. In 1995, Rancho de las Cabras near Floresville, the ranch that supported Mission Espada, became part of the San Antonio Missions National Historical Park and is currently open on a limited basis.

San Antonio Mission San Juan Capistrano, circa 1900

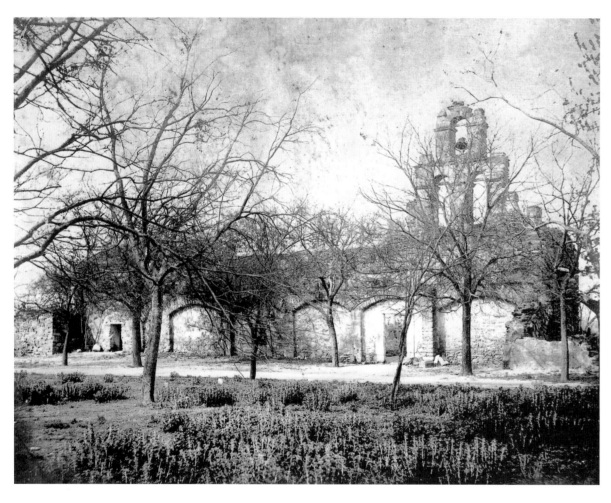

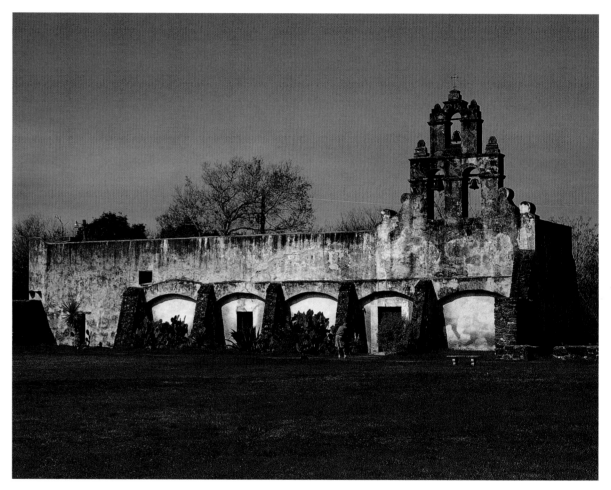

Mission San Juan Capistrano was founded in 1716 in eastern Texas as San José de los Nazonis. In 1731, it was renamed and moved to San Antonio, only 12 miles from the Alamo. The stone church, a friary, and a granary were completed 25 years later. A larger church was halfway built, but it had to be abandoned due to a declining population. San Juan became extremely successful with farming and ranching enterprises, supplying produce for an area extending from Louisiana to Coahuila, Mexico. At one time, the mission owned more than 7,000 head of livestock. Its thriving economy enabled it to survive epidemics and Native American attacks in its final years.

In 1934, a public-works project unearthed some Native American quarters as well as unfinished church foundations. In an attempt to stabilize the structure, five buttresses were added to the church's east wall in 1968, and the original metal cross that was over the church's sacristy was returned to its original position on the espadaña (bell tower). The mission complex was added to the National Register of Historic Places in 1972.

San Antonio Mission San Antonio de Valero, 1868

The Alamo

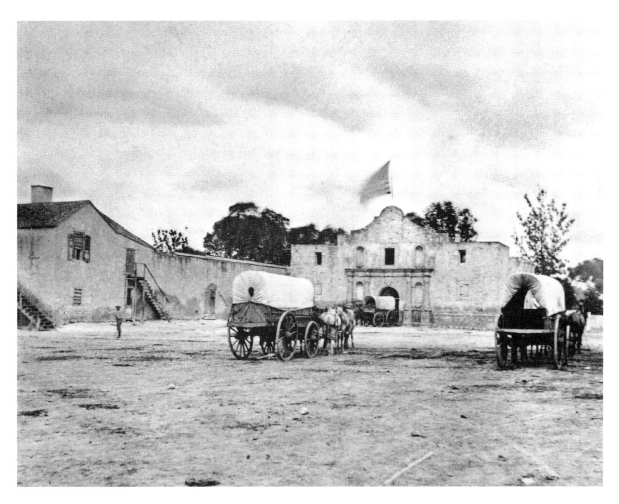

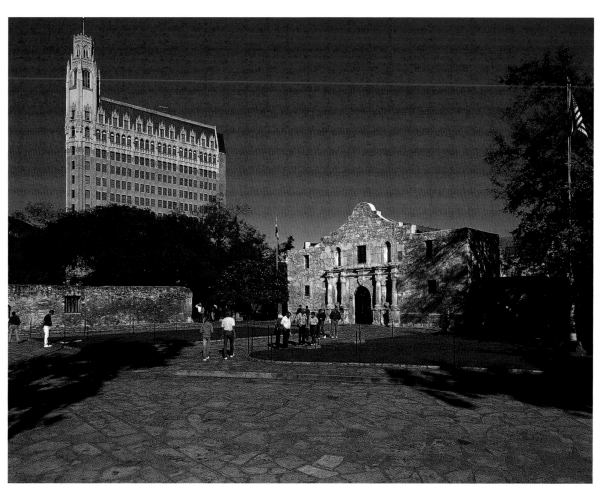

Colonel William B. Travis led the Texas troops at the Alamo, commanding a force of approximately 190 men in siege and bitter battle. Mexican Gen. Antonio López de Santa Anna led a staggering force of around 5,000. Despite being so outnumbered, Travis' troops held off the Mexican army for 13 days, and reportedly killed more than 600 Mexican troops before finally succumbing on March 6, 1836. After the fall of the Alamo, the building was practically in ruins, but no attempt was made at that time to restore it. For several years, the city of San Antonio, the Catholic Church, and the U.S. government all claimed ownership of the Alamo. Confederate forces used the building until the end of the Civil War.

On January 25, 1905, the Texas legislature passed a resolution placing the Alamo under the care of the Daughters of the Republic of Texas, who manage it to this day, although it remains at the center of disputes over its custody, presentation, and boundaries. The Alamo is now in the custody of the city of San Antonio, and for many years has been the top tourist destination in the state.

San Antonio Mission San Antonio de Valero, 1918

Mission San Antonio de Valero was established in 1718 and named in honor of Saint Anthony de Padua and the Duke of Valero, the Spanish viceroy. The mission has been at its present site in downtown San Antonio since 1724. The cornerstone of the chapel was laid on May 8, 1744. The mission, one of several in Texas founded by Spanish missionaries to Christianize and educate Native Americans, was later used as a fortress in a number of skirmishes prior to the famous siege of 1836.

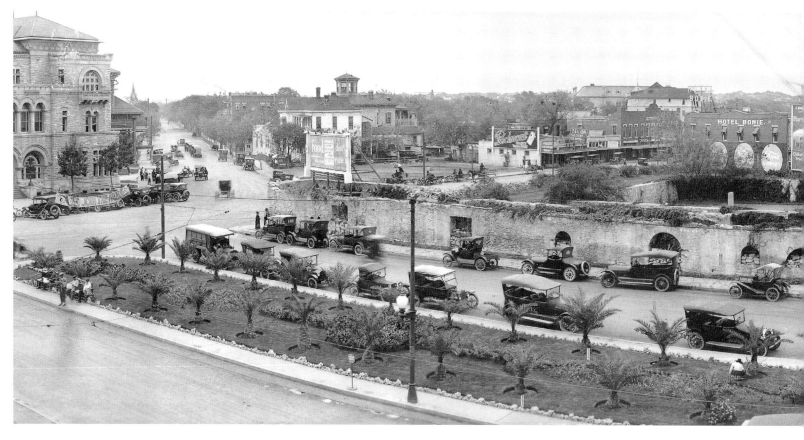

The Alamo

The exact origins of the name "Alamo" are uncertain; however, one of two theories usually prevails. The first suggests the name comes from the Second Flying Company of San Carlos de Parras, a company of Spanish soldiers from Álamo de Parras, Coahuila, Mexico. Others claim the name originated from the Spanish word for cottonwoods, "álamo," and that the mission was possibly named after a nearby grove of them.

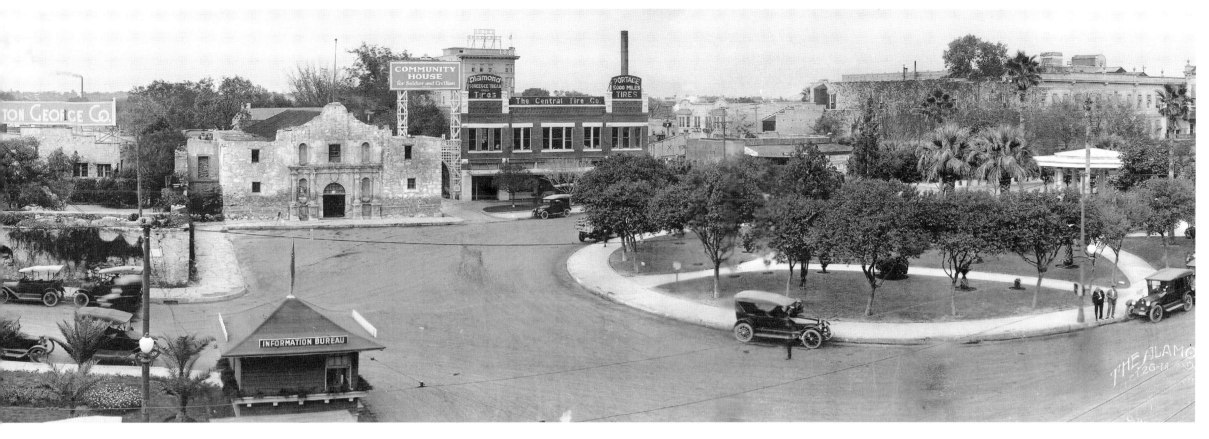

111

San Antonio San Antonio River, 1918

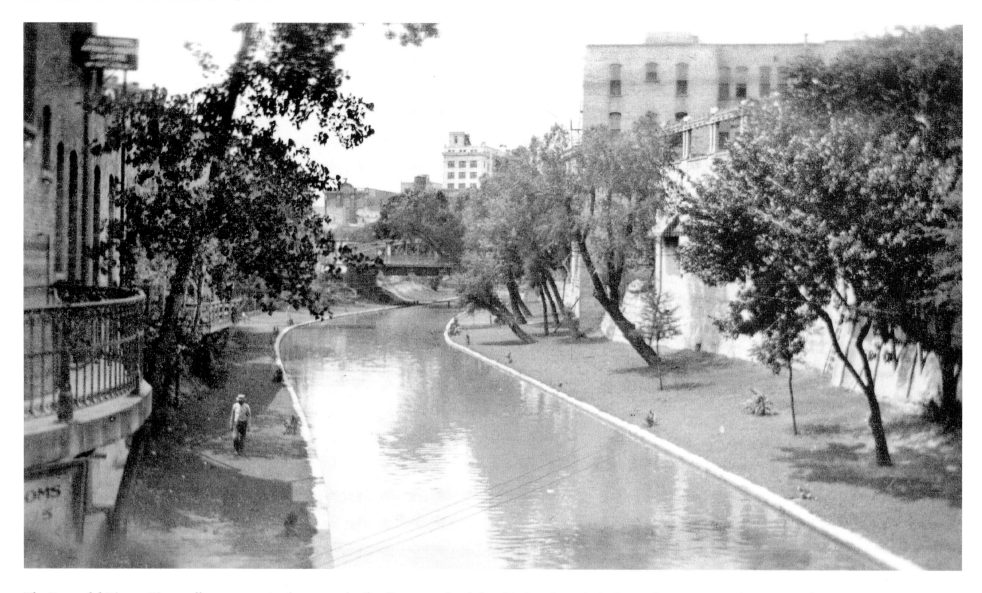

The Paseo del Rio, or Riverwalk, was conceived as a result of a disastrous flood that hit San Antonio in September 1921, just three years after this photo was taken. The crest of the flood reached nearly nine feet on Houston Street, killing 50 people and causing millions of dollars in damage. An engineering firm recommended constructing Olmos Reservoir upstream to serve as a retention basin, creating a bypass channel, and covering the river with concrete. Instead, architect Robert H. Hugman proposed turning the area into an urban park with restaurants, shops, apartments, and a walkway. Along with these, he had specific ideas for a system of dams and channels, footbridges, and street-access stairways. He also suggested boat rides on gondolas, modeled after those of Venice, Italy. In December 1938, a plan was approved and Hugman was made project architect. More than 1,000 men worked on the initial phase of the project, which included the building of walkways and retaining walls, the cleaning and deepening of the channel, and extensive landscaping. Approximately 11,700 trees and shrubs were planted by the city; garden clubs also donated many plants. The project was completed in March 1941, but the Riverwalk was not an immediate success.

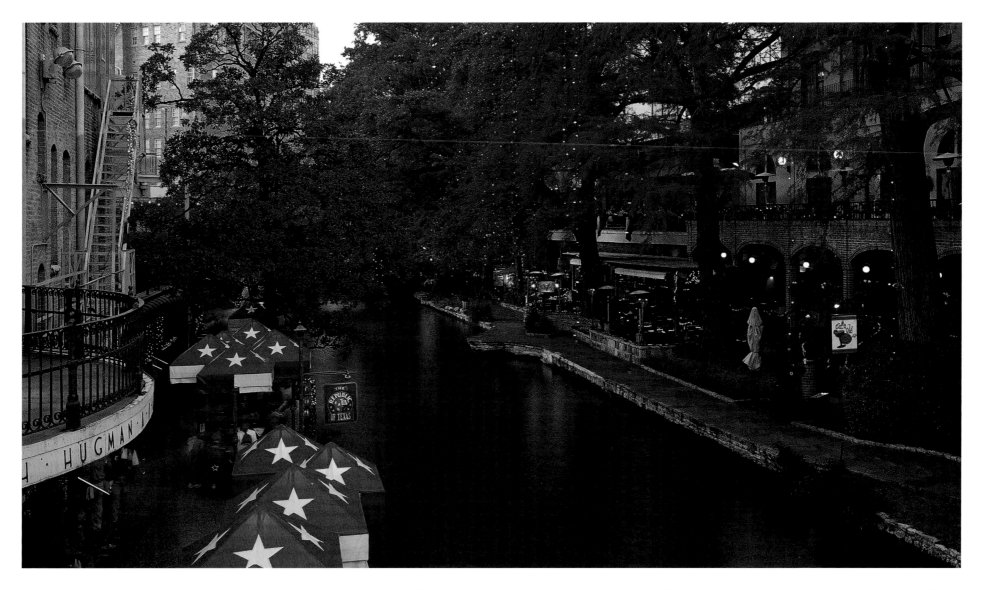

The San Antonio Riverwalk commission was established in 1962, and a new master plan to improve the Riverwalk was drawn up. Improved lighting was installed, several merchants turned their stores to face the river, and the first restaurant, Casa Rio, opened. During HemisFair '68, the first officially designated international exposition in the southwestern United States, the river was extended through the new city convention center complex. The Paseo del Rio Association was established as an independent nonprofit corporation to promote the area, and many new shops and restaurants opened. In the late 1980s, a large shopping mall, Rivercenter, was built beside the convention complex. Today, an estimated one million people ride the gondolas each year, and the Paseo del Rio generates $800 million dollars in tourist revenue annually.

Portions of these captions were reprinted with permission from the Handbook of Texas Online, copyright Texas Historical Association

Victoria Victoria County Courthouse, 1895

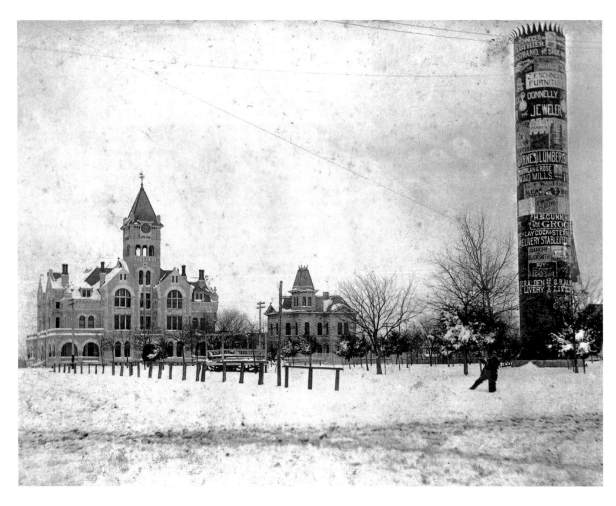

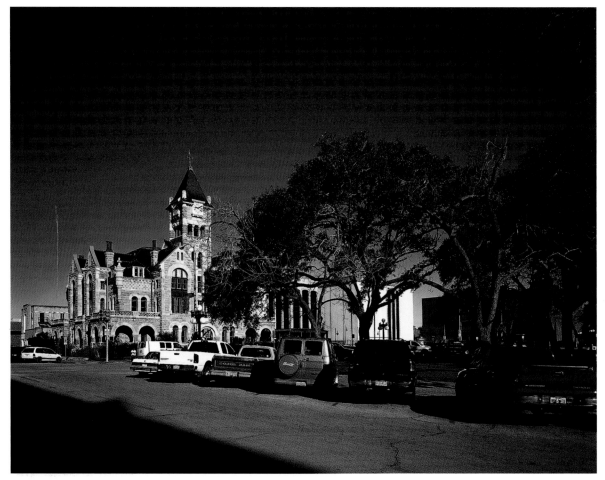

The Victoria County Courthouse was built in 1892 in Romanesque Revival style. Architect J. Riely Gordon designed the courthouse, but he was fired when he failed to honor his contract, which stipulated that he be present every day of construction. You can see similarities with the Fayette County Courthouse in La Grange that Gordon built the previous year. Gordon designed 13 other courthouses in Texas, including those in Bexar, Comal, Ellis, Lee, and McLennan counties. He also designed the Arizona state capitol building.

As I was researching photos for this project, I found quite a few images of South Texas locations that showed snow on the ground in 1895. I heard some time ago that the winter of 1895 was the coldest on record in Texas and was the last time snow had fallen as far south as Brownsville. When I first saw this old photo of the Victoria County Courthouse with snow, I had no way of knowing that on Christmas Eve, 2004, Victoria, Brownsville, and much of South Texas and the Gulf Coast would experience an equally anomalous winter storm that would dump as much as 14 inches of snow in some places. Unfortunately, with virtually no warning of the storm and because it was Christmas, there was no way I could get out to record the hundred-year event.

Goliad Presidio La Bahía, 1908

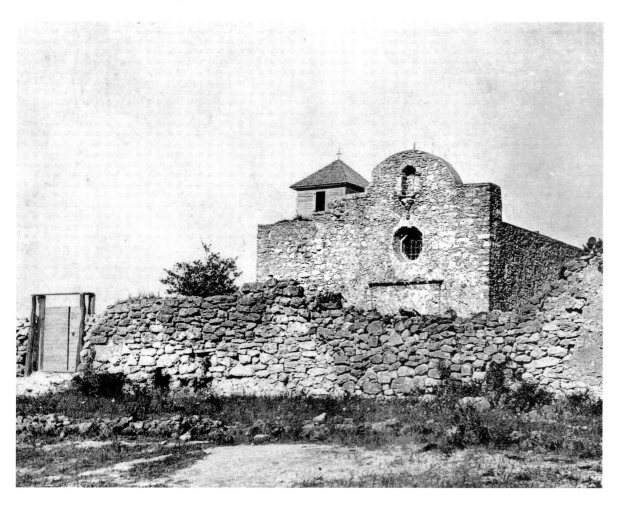

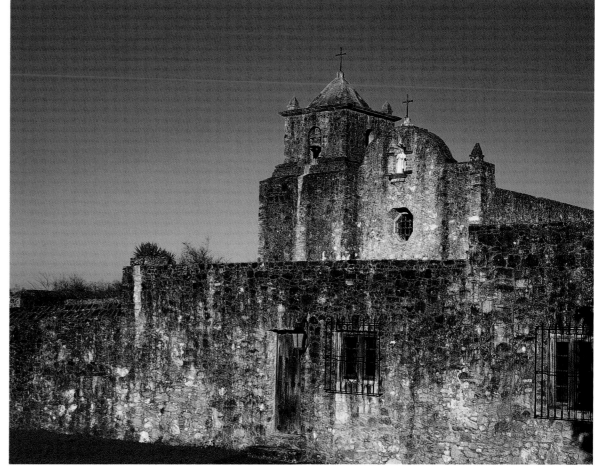

In 1722, Presidio La Bahía was founded near present-day Port Lavaca. It was moved to its present site in 1749 to protect nearby Mission Espíritu Santo and Mission Rosario. The fort has a tumultuous history. In the early 19th century, various groups launched attacks against the fort, including the Gutierrez-Magee Expedition, and expeditions led by James Long and Henry Perry, who occupied or assailed the fort for various idealistic and profiteering motives. It was here that 92 Texas citizens and soldiers drew up and signed Texas' first, formal Declaration of Independence on December 20, 1835. In the ensuing War for Texan Independence, Col. James Fannin and 341 Texan prisoners of war were massacred in and around the fort by their Mexican captors on Palm Sunday in 1836. The Presidio and two missions constitute the only surviving example of a Spanish Colonial mission/presidio complex in Texas and one of very few in North America.

Presidio La Bahía and Mission Espíritu Santo, home of the largest ranching operation in Texas in the 18th century, are now part of Goliad State Park. In the mid-1960s, the fort was restored to its 1836 appearance based on documents and archeological evidence dating back to the Texas Revolution (1835–1836). The Presidio chapel, Our Lady of Loreto, still serves as a community church. Visitors may tour the grounds and chapel and visit the Presidio's museum, which contains exhibits that explore the history and daily life of the missionaries and Native American converts, as well as some of the original artifacts they used. Presidio La Bahía was designated a National Historic Landmark in 1967.

Refugio Our Lady of Refuge Catholic Church, 1902

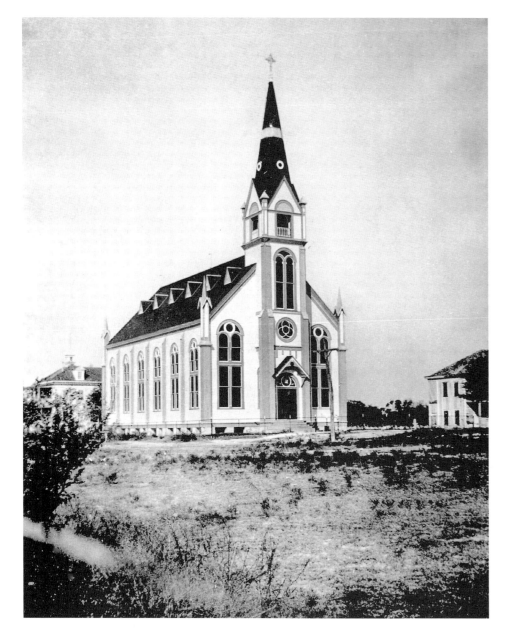

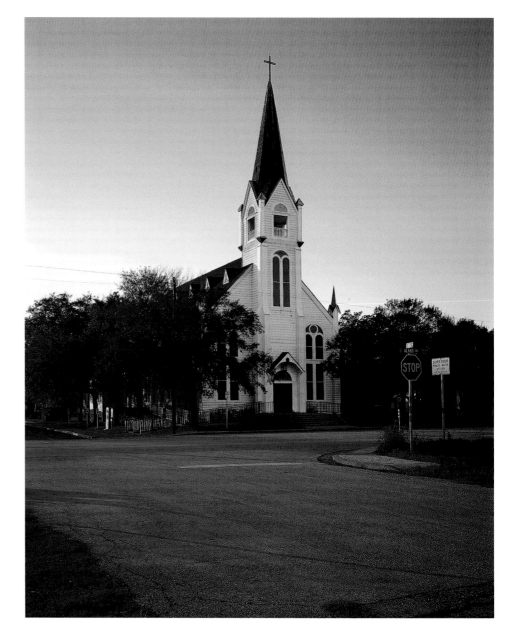

In 1795, the Nuestra Señora del Refugio Mission was moved to a permanent site on the north bank of the Mission River in South Texas, after having been at several other locations in the area. The Refugio Mission, the last Spanish mission to be secularized after the area became part of Mexico, operated continuously until February 1830. In 1831, James Power and James Hewetson acquired the rights to the old mission building and the town that surrounded it, and that same year, the villa of Refugio was officially established. When Irish settlers moved into the mission area during the 1830s, they named their town for the mission, and the mission ruins were probably used as building materials for their new settlement.

Much of the old mission site is presently owned by Our Lady of Refuge Catholic Church, which was dedicated in 1901. The landmark church, located on the west end of Refugio on Highway 77, is the congregation's fourth church building. The remains of the original mission are in a layer below the present church and have been the subject of two archeological digs that have resulted in the uncovering of numerous artifacts.

Laredo Market Hall, 1890

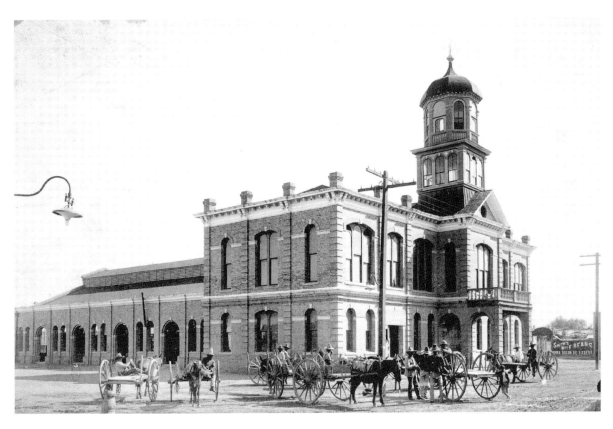

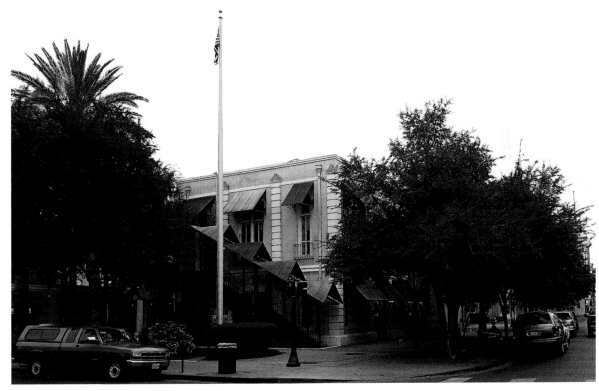

This photograph of the Market Hall is believed to be the earliest made of that structure. The building was completed in 1886 for $60,000. The small portico over the western entrance to the building was later removed. According to Laredo, A Pictorial History *by Jerry Thompson, a severe storm on April 28, 1905 brought high winds, hail, and heavy rain to the area in advance of a killer tornado that took the lives of 21 people. The tornado tore roofs off buildings across the city, collapsed two spans of the International Bridge, and destroyed the distinctive cupola on the Market Hall building.*

The former Market Hall, almost obscured by cedar elm trees, is now the headquarters of the Webb County Heritage Foundation and the Laredo Center for the Arts. The Center was founded to promote an international cultural arts climate for the city.

Laredo San Agustín Church and Plaza, circa 1880s

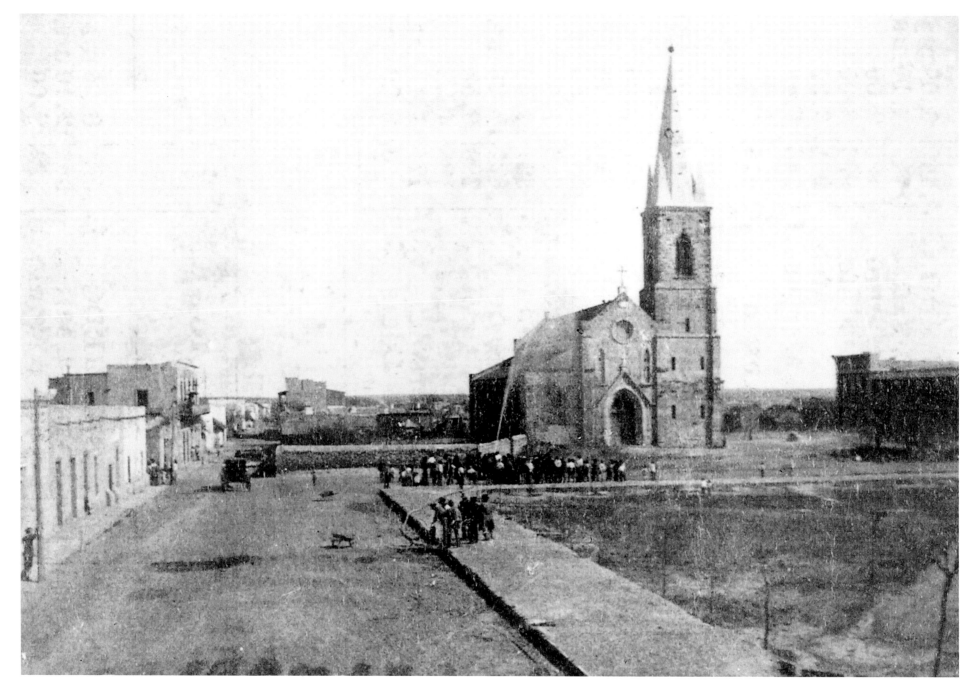

Laredo is one of the oldest cities in Texas. The San Agustín de Laredo Historic District encompasses what was the original city of Laredo, founded in 1755 by Don Tomás Sánchez de la Barrera y Garza. From 1839 to 1840, Laredo was the capital of "The Republic of the Rio Grande," an unsuccessful attempt to break with the government of Mexican President Santa Anna. One of the most prominent buildings in the district is San Agustín Roman Catholic Church, established in 1778. This masonry Gothic style church has a large spire that rises over San Agustín Plaza. Many buildings in the district illustrate local building styles and technologies while reflecting Spanish and Mexican influences. The majority of the residential buildings consist of a complex of masonry buildings around a courtyard.

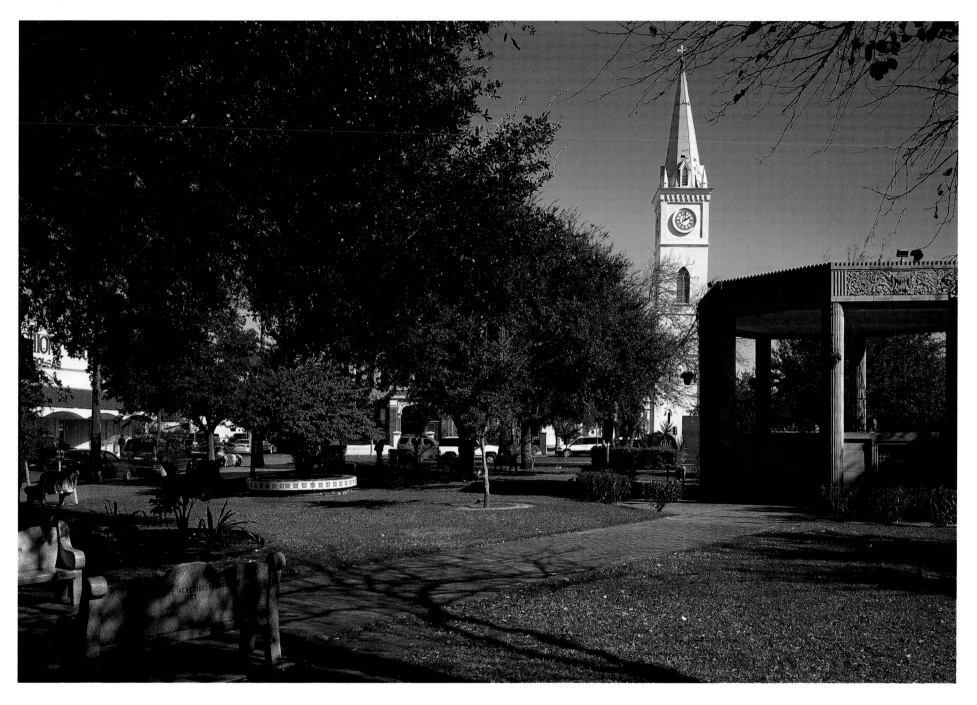

The current church was built between 1866 and 1872, but it has undergone a number of facelifts and additions since then. The Capitol of the Republic of the Rio Grande, a stone and adobe building that faces the plaza, functions today as a museum. By the 1970s, the area around San Agustín Plaza had ceased to be the social and commercial center of the city. To protect and preserve the old plaza, the San Agustín de Laredo Historic District was formed in 1973. The district is the last surviving example of a settlement from the colonization of the Lower Rio Grande (1728 to 1755), under the guidance of José de Escandón, Viceroy of Mexico.

San Juan City Park, circa 1940s

San Juan was organized in 1909 by John Closner and was reportedly named for him. The town was incorporated on December 29, 1917, and by 1924, had a school building, a new waterworks, a cotton compress, a cannery, and a cotton gin. During the 1940s, San Juan had the largest concrete pipe manufacturing plant in the South. San Juan also was in an area with a rapidly growing citrus fruit and vegetable industry, and its "Bougainvillea Trail of Texas" was building San Juan's reputation as a tourist destination in the Rio Grande Valley. The Virgen de San Juan del Valle Shrine, constructed in 1954, was also instrumental in attracting many pilgrims and tourists to the area.

On October 23, 1970, Francis B. Alexander smashed a rented single-engine plane into the Virgen de San Juan del Valle Shrine, which at the time was occupied by more than 130 people. Damages to the shrine were estimated at $1.5 million, but residents began almost immediately to reconstruct the church. In April 1980, the new shrine was dedicated and the televised ceremonies were shown nationally on the Spanish Information Network. Today, San Juan has a population of more than 26,000. Its economy is based primarily on agriculture and tourism, and many of its visitors still come to see the shrine.

Pharr Main Street, circa 1940s

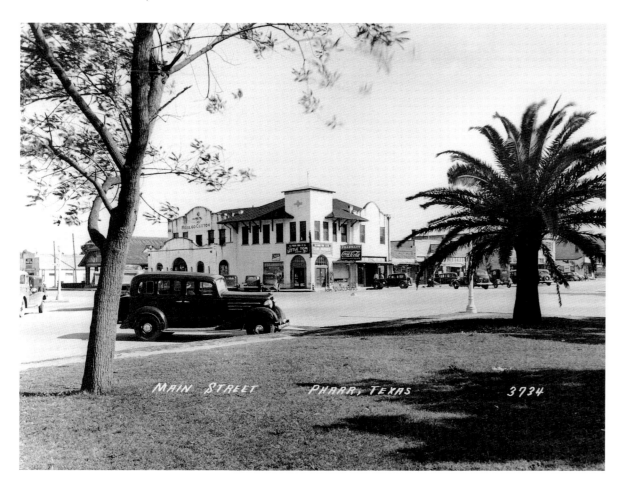

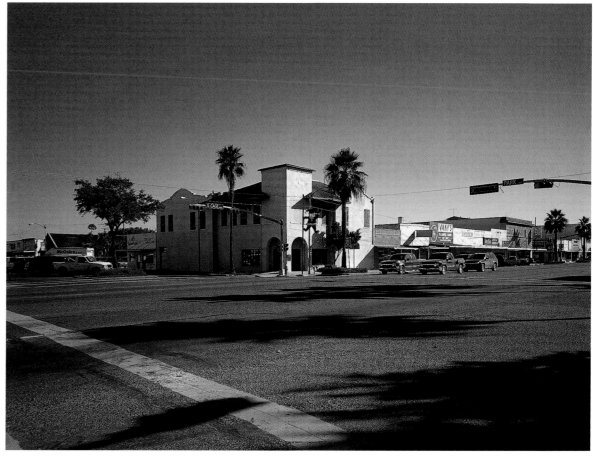

Pharr is along the Missouri Pacific railroad line and old US 83, five miles west of McAllen in south central Hidalgo County. It developed from a Spanish land grant made in 1767 to Juan José Hinojosa. The Hinojosa family and heirs sold off portions of their land to various groups in the late 19th century. In 1909, John Connally Kelley, Sr., and Henry N. Pharr, a Louisiana sugarcane grower, acquired 16,000 acres of land with two miles of Rio Grande frontage. Pharr founded the Louisiana and Rio Grande Canal Company and constructed an irrigation system for a sugar plantation. Kelley formed the Pharr Townsite Company, which platted the town that he named Pharr in honor of his partner. By 1911, the community was a stop on the St. Louis, Brownsville and Mexico Railway. A hotel, bank, and various businesses were also in operation. Pharr's plantation venture failed with the collapse of the Rio Grande Valley sugarcane industry. Kelley then took over the irrigation system and continued to supply water to area vegetable and cotton farms.

Pharr's climate is ideal for growing sugarcane, cotton, and citrus crops. Its proximity to Mexico and South Padre Island make it a popular tourist destination. The town's growth can be attributed in part to the growth of nearby McAllen, the increasing number of births among the young Hispanic population, and the movement of vacationers and retirees to the area because of its warm climate.

McAllen La Casa de Las Palmas, 1918

LA CASA DE LAS PALMAS McALLEN TEXAS.

The town of McAllen began developing after the arrival of the railroad in 1905. With the introduction of an irrigation system, farming became feasible and agriculture in the Rio Grande Valley began to flourish. Before long, McAllen had the makings of a small town, with a hotel, a grocery store, a church, a bank, and a weekly newspaper. The site pictured here was originally a city park populated with antelope, javelina, and deer. In 1918, a group of businessmen built La Casa de Las Palmas, a three-story hotel with a red tile roof. It was quite elegant with a center patio and twin towers. La Casa de Las Palmas served as a business, social, and civic center for the Rio Grande Valley. In 1919, it sheltered many area residents during a severe hurricane.

Through the 1970s and the 1980s, McAllen continued to grow, and the hotel was rebuilt in its original style after a fire destroyed it in 1973. The city remains one of the top ports of entry to the United States via the city of Reynosa, Mexico. McAllen continues to be a popular destination for "Winter Texans," who come from colder, northern climates of the United States to bask in year-round comfort. The city is near some of the best birding spots in the country: Santa Ana National Wildlife Refuge, Bentsen-Rio Grande Valley State Park, and Chihuahua Woods, a nature preserve that protects one of the last remnants of native thornscrub habitat in south Texas.

Harlingen circa 1920s

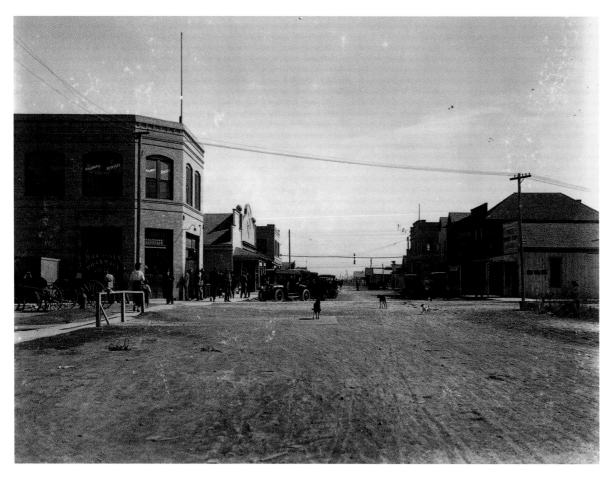

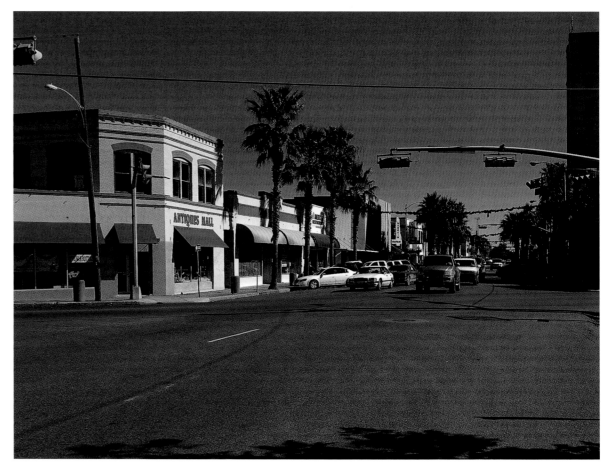

In 1904, Lon C. Hill established a town on the north bank of the Arroyo Colorado and named it Harlingen, after a city in Holland. The local economy was initially based almost entirely on agriculture, with vegetables and cotton as its main crops. World War II brought military installations to Harlingen, including Harlingen Army Air Field and Harlingen Air Force Base. When the base closed in 1962, the city converted it into an industrial airpark.

In 1992, the city was named an All American City, cited especially for its volunteer spirit and self-help programs. Harlingen today is a major distribution, shipping, and industrial center for South Texas. Large-scale construction of multifaceted retirement communities is a new phase of industrial development. The citrus industry serves as the city's most important economic base, with tourism a close second.

Brownsville Market House, 1878

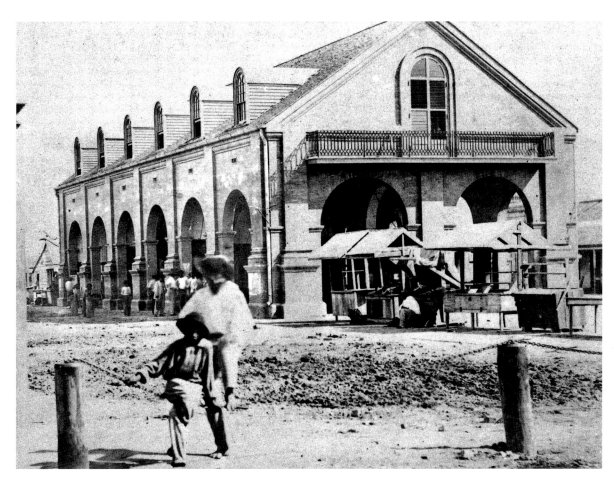

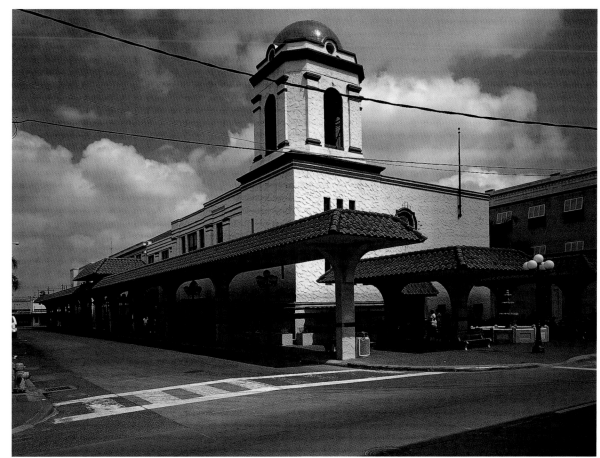

As far back as the 17th century, explorers were in the area that would become Brownsville. However, the town did not flourish until 1846, when the U.S. Army set up a post on the north bank of the Rio Grande across from the Mexican town of Matamoros. Two years later, Charles Stillman purchased a large tract of land near the fort and with his partner, Samuel Belden, laid out the town of Brownsville. The new town developed quickly and numerous stores sprang up along the riverfront. A city market opened in 1850, and Brownsville soon replaced Matamoros as the leading trade center for northern Mexico.

Brownsville is the Rio Grande Valley's largest city. Its industrial base is anchored by electronic, food processing, and petrochemical industries. Tourism is also a thriving industry; many people visit the area for its mild climate, excellent golf courses, proximity to Mexico, and access to South Padre Island.

Brownsville Palm Boulevard, circa 1940s

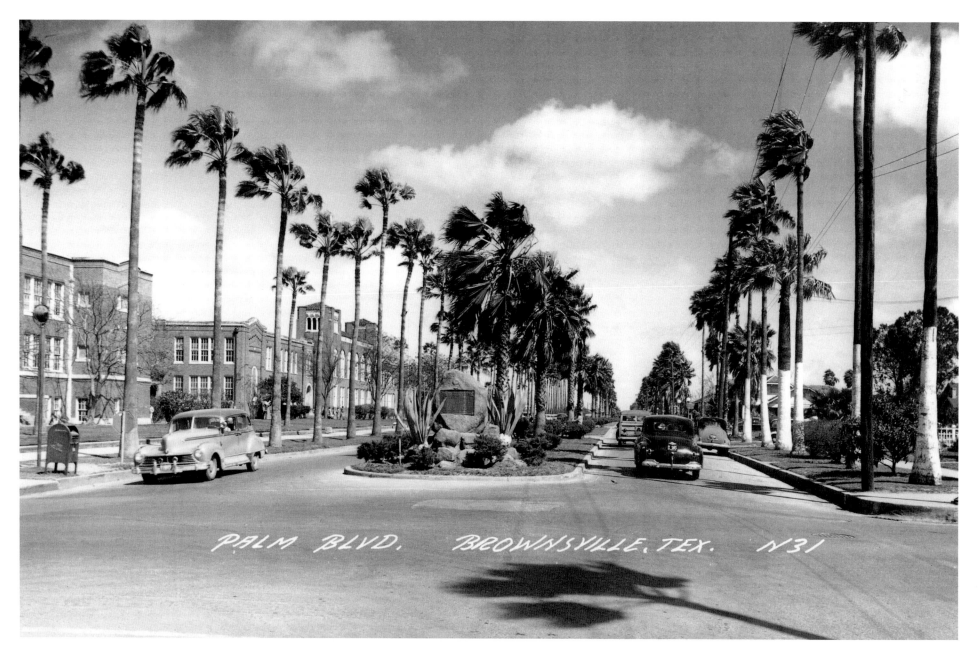

PALM BLVD. BROWNSVILLE, TEX. N31

Brownsville, which lies at the southernmost point in Texas, is blessed with the mildest weather in the state. Its semitropical climate has made it a popular tourist destination for many decades and a haven for "Winter Texans," who come here to escape the cold of northern climates. Brownsville's temperate climate allows for a longer growing season than almost anyplace else in the United States (southern Florida being the possible exception) and is ideal for a number of tropical plants such as bougainvillea, poinsettia, aloe vera, and palm trees. A severe freeze in 1983 killed many of the Rio Grande Valley's mature palm trees, and for several years, the tall, leafless trunks made for a sad sight until cold-hardy trees gradually replaced them.

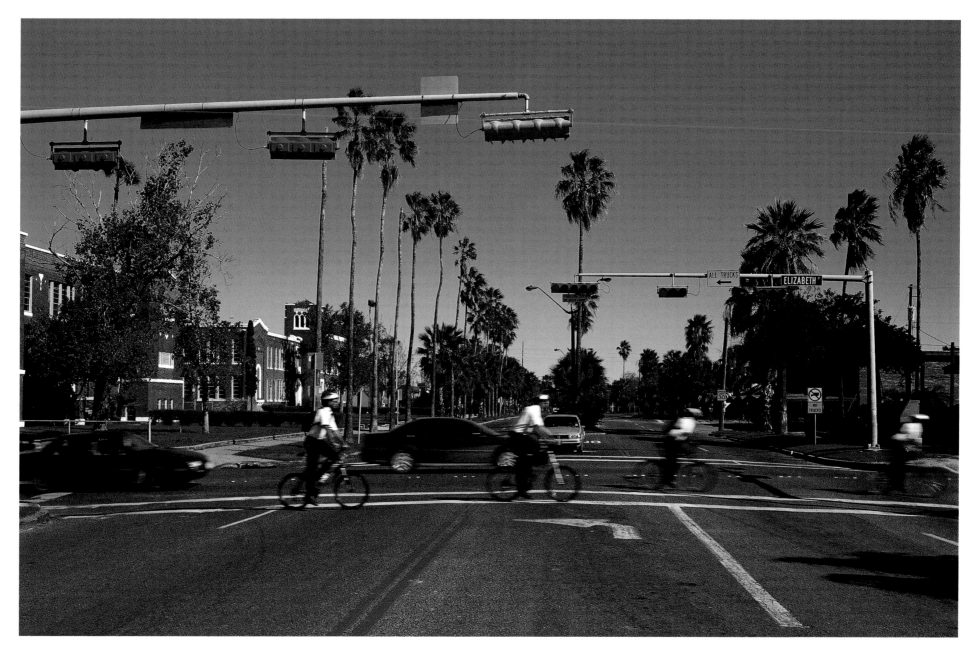

When I was looking for Palm Boulevard, I didn't expect it to have as many palm trees as it did in the 1940s—not just because of the record 1983 cold snap, but because of another severe freeze that occurred in 1989. I was pleasantly surprised to find almost as many trees in 2005 as there were in the old photo.

Brownsville Fort Brown, 1893

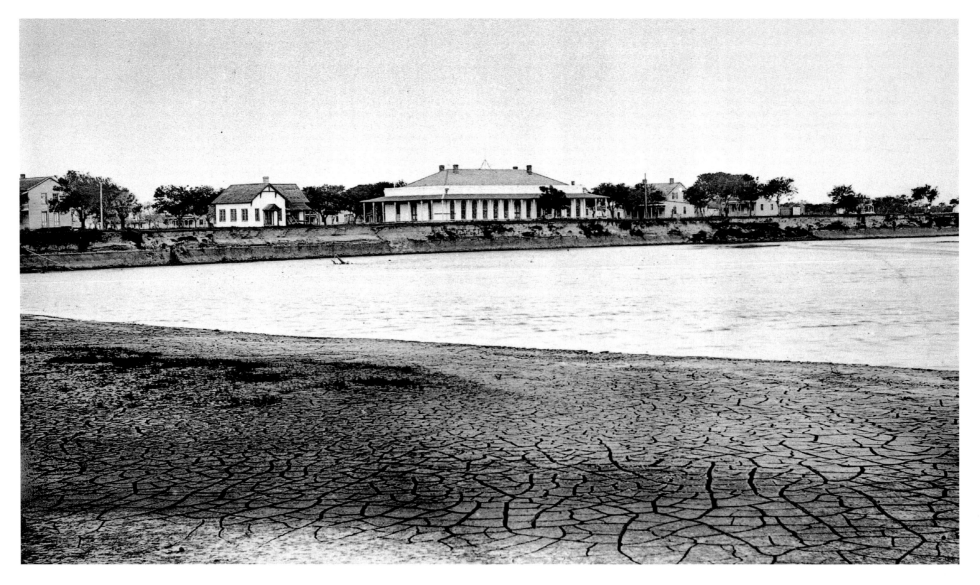

The U.S. Army established Fort Brown in 1846 under the command of Gen. Zachary Taylor. The fort was named after Post Commander Major Jacob Brown, who died during a Mexican attack on the stronghold. The original Fort Brown was built on the banks of the Rio Grande and was the site of a number of skirmishes during the Mexican-American War. Troops from the fort were also involved in one of the last battles of the Civil War, which occurred at nearby Palmito Hill. The battle occurred five weeks after the war was officially over, but the news had not yet reached Fort Brown. Later on, soldiers from Fort Brown hunted Pancho Villa during his reign of terror on the U.S.-Mexican border. The U.S. military presence in Brownsville was responsible for raising its population significantly and gave the area a measure of security and economic prosperity. Fort Brown is a National Historic Landmark, one of 40 such landmarks in the state of Texas, and it is listed on the National Register of Historic Places.

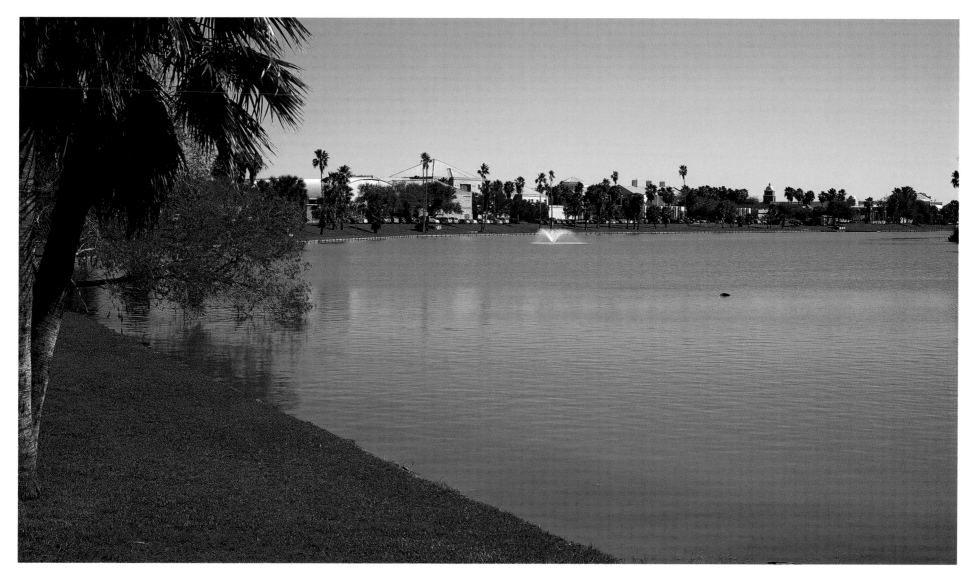

Some of the original buildings of Fort Brown were renovated and restored, and are utilized by the college and university.`

GULF COAST

Houston ☆ Goose Island ☆ Galveston ☆ Fulton
Corpus Christi ☆ Indianola ☆ Port Isabel

"Texas can make it without the United States, but
the United States cannot make it without Texas!"
—Sam Houston, President of the Republic of Texas

Houston Main Street, 1856

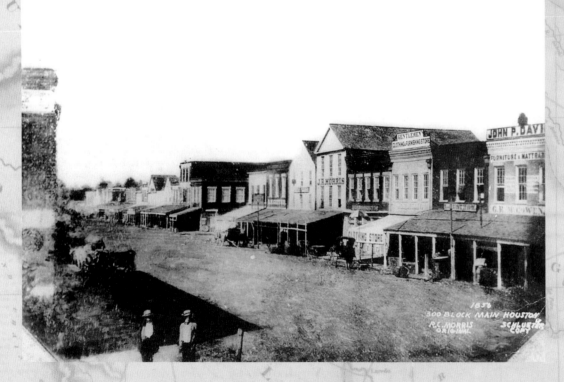

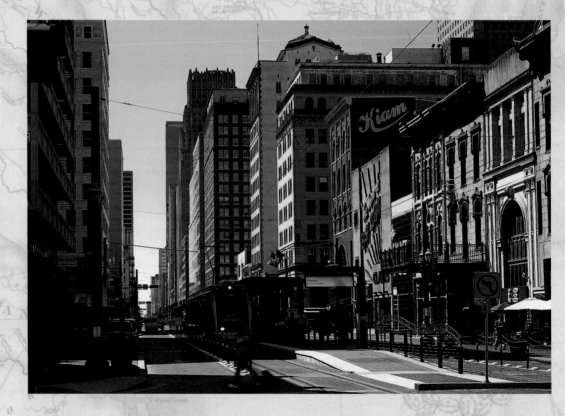

Main Street, Houston's longest at 24 miles, was the focal point of the downtown area for more than a century. According to David McComb's book, Houston, A History, the city tried numerous solutions to counter the dust and mud problems associated with dirt streets. In the 1880s, limestone squares over a bed of gravel, financed by a group of merchants, were laid on Main Street. Cypress blocks on a sand-and-gravel foundation, and wooden planks were tried as well, neither with much success. Other paving experiments with ground-up shells, gravel, bricks, asphalt, macadam, and wooden blocks finally resulted in 26 miles of pavement by 1903. When dust and mud continued to be a problem, the city used sweepers and sprinklers to clean it.

Houston's Metropolitan Transit Authority spent $324 million and three years constructing the 7.5-mile rail line that is the centerpiece in a planned 80-mile-long, $7 billion system. The line was built after a long series of contentious elections, funding controversies, and political disputes. The first section of the line runs right down the middle of Main Street, but two car lanes remain, one on either side of the rails.

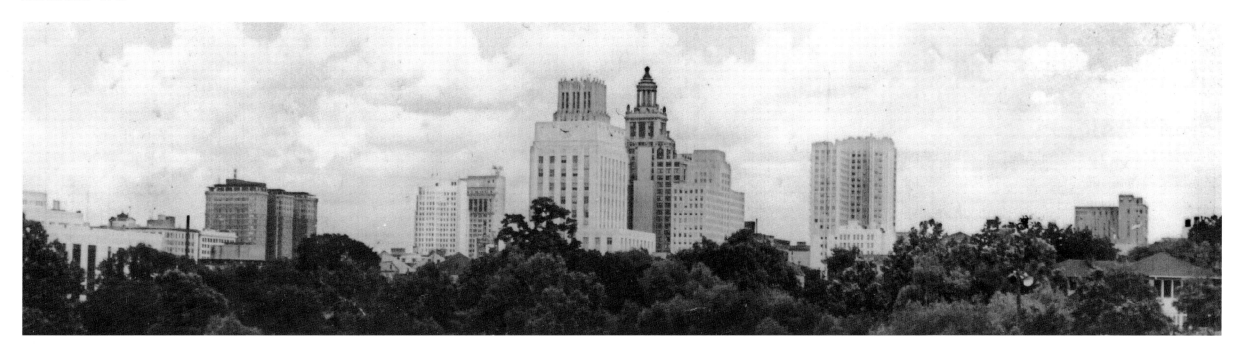

In this photograph from 1945, the 32-story Niels Esperson Building stands out as the tallest and most distinguished building in Houston's skyline. The 1927 buff-brick and limestone structure is the only example of Italian Renaissance architecture in downtown Houston, featuring detailed columns and terraces, topped off with a terra cotta tempietto. Mellie Esperson had the building constructed for her husband, Niels, a Texas real estate and oil tycoon. The 19-story Mellie Esperson Building was built as an annex to the original building. Other buildings in this view include the Rice Hotel, which is the dark building at left, and Houston City Hall—the white building in the center.

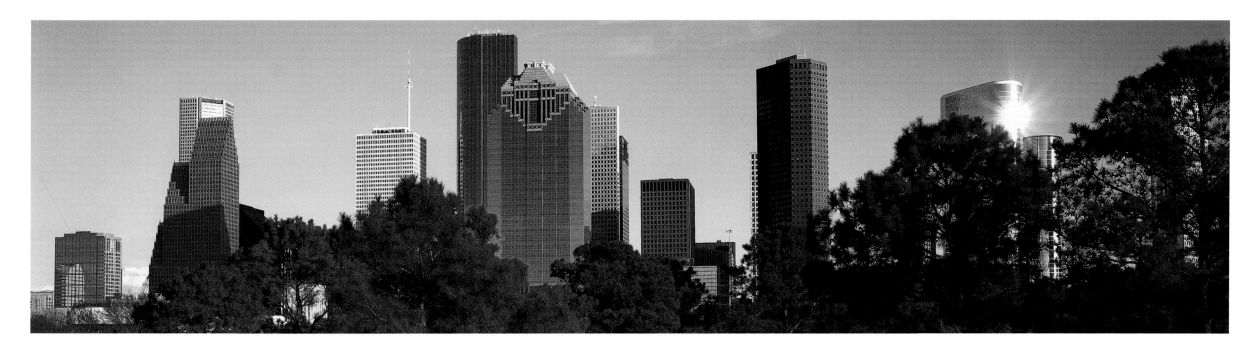

The Esperson buildings have been eclipsed from view by numerous modern glass and concrete skyscrapers, designed by some of the world's leading architects. When Houston went into a recession in the 1980s, the building boom that reshaped its skyline into a dazzling display of modern architecture subsided. The emphasis on architecture in this period shifted from skyscrapers to entertainment venues: a new convention center, a baseball stadium, a concert hall, and a performing arts center. It was not until the late 1990s that another skyscraper was built, when the Enron Corporation added another gleaming glass tower to accompany its existing headquarters building. Some of Houston's oldest downtown office buildings have been converted into apartment buildings and restaurants, but many were demolished during the building boom of the 1960s and '70s.

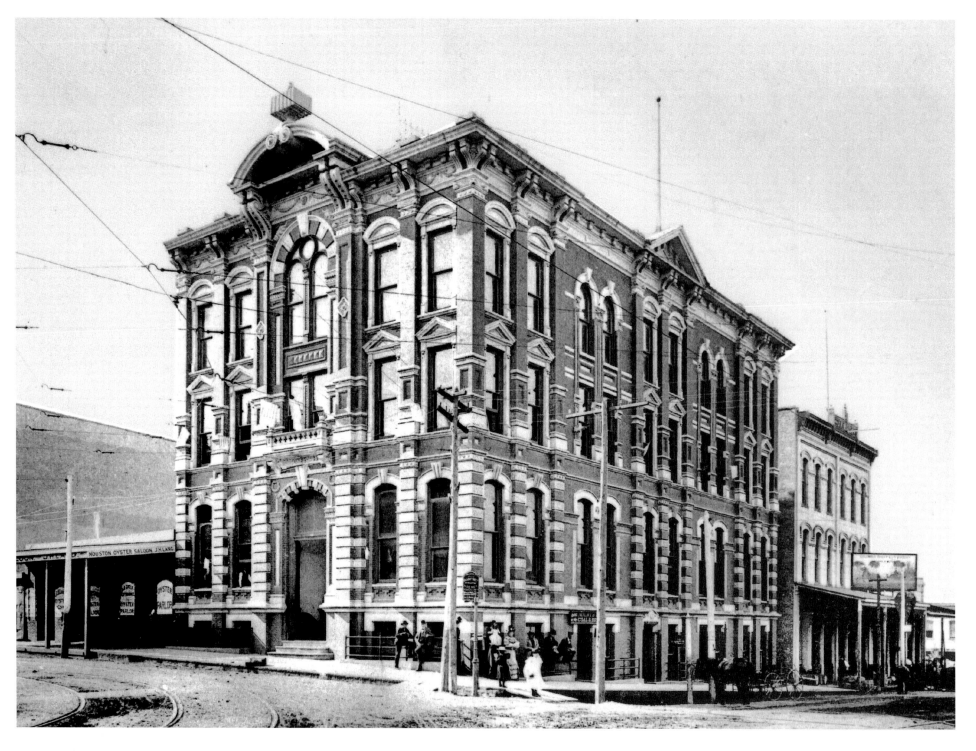

In 1885, the Houston Cotton Exchange and Board of Trade built a three-story headquarters building at Travis and Franklin Streets in downtown Houston. The Victorian building was a creation of Eugene T. Heiner, who has also designed a number of jails and courthouses in Texas. The Cotton Exchange building was enlarged to four floors and remodeled in 1907. The organization moved to another, larger building in 1924, taking the cornerstone from the old building and placing it in the lobby of the new one.

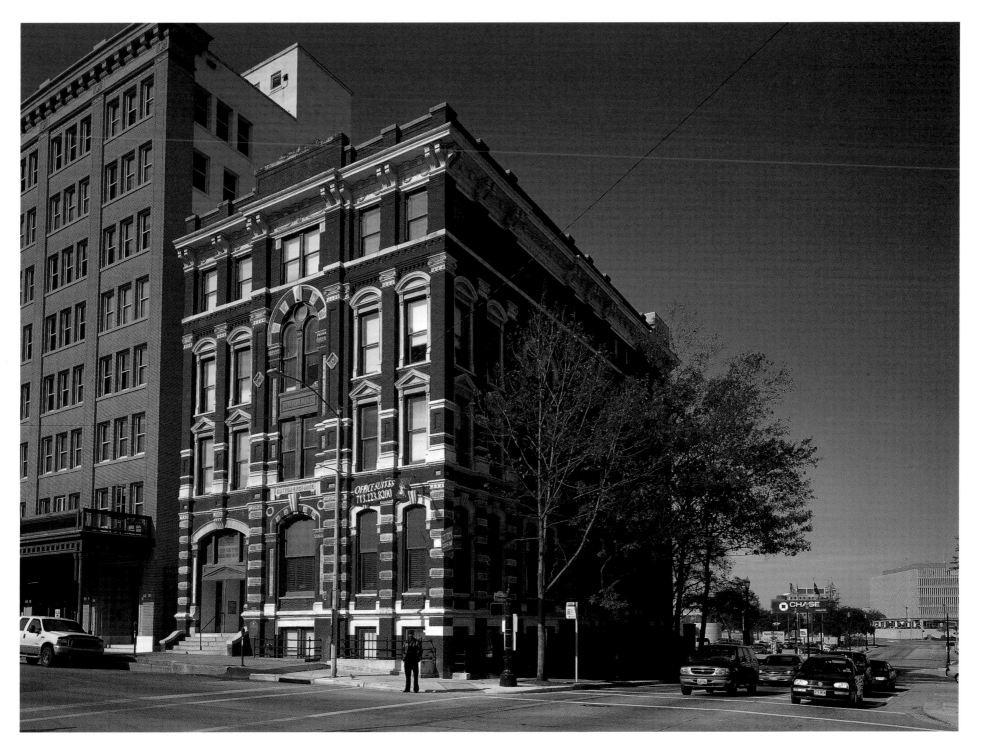

The original Travis Street building was restored in 1973 in a preservation effort that received national recognition. The building was one of the first in Houston to be listed on the National Register of Historic Places, and it was designated a Texas Historic Landmark by the Texas Historical Commission.

Houston Market Square, circa 1904

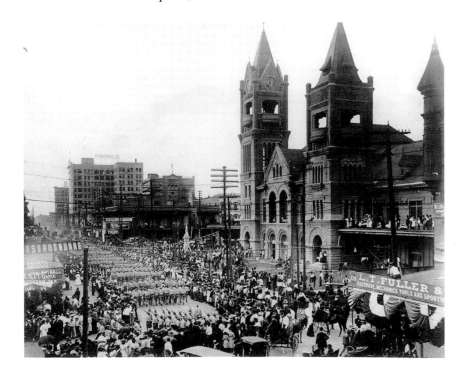

Market Square has been an integral part of downtown Houston for more than 150 years. Originally a market-place, four city halls and a bus terminal stood on the land until 1960, when a fire destroyed the terminal and the area was made into a city park.

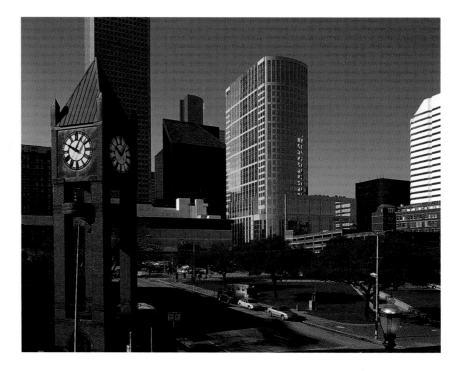

Completed in 1992, the modern park was designed to reflect a traditional town square, blending with the remaining historical buildings. The sidewalks are paved, incorporating salvaged masonry symbolic of Houston's rich history.

Houston Museum of Fine Arts, 1924

In 1900, the Public School Art League was formed to help promote fine arts in Houston's public schools. With the help of the land donated by the Hermann estate, the Museum of Fine Arts was established. With the dedication in 1917, it became the first art museum building in Texas.

Today housing over 45,000 pieces of art in several different buildings, the Museum of Fine Arts has amassed an impressive collection spanning thousands of years. The Art of Texas exhibits a wide span of works representing the Lone Star State.

Houston San Jacinto Monument and Museum, 1910

Houstonians stroll the grounds of the San Jacinto battlefield in this photo taken April 21, 1910, the 74th anniversary of Texas' final battle in the fight for independence from Mexico. An early monument is visible on the right in this photograph. Sightseers cruise along Buffalo Bayou, which extends from the Gulf of Mexico into the heart of Houston.

In 1939, the official San Jacinto Monument was completed, in commemoration of the heroes of the battle of San Jacinto, as well as all others who were instrumental in winning independence for Texas. Jesse H. Jones, a prominent Houstonian and chairman of the Texas Centennial celebration, along with architect Alfred C. Finn and engineer Robert J. Cummins, came up with the idea for the 570-foot-tall monument. Fossilized buff limestone from Austin was used to face the reinforced concrete shaft. A 34-foot star, symbolizing the Lone Star of Texas, crowns the monument. The San Jacinto Museum of History Association, under contract with the Texas State Parks and Wildlife Commission, has operated the monument and museum since 1966.

Houston Sam Houston Park, 1910

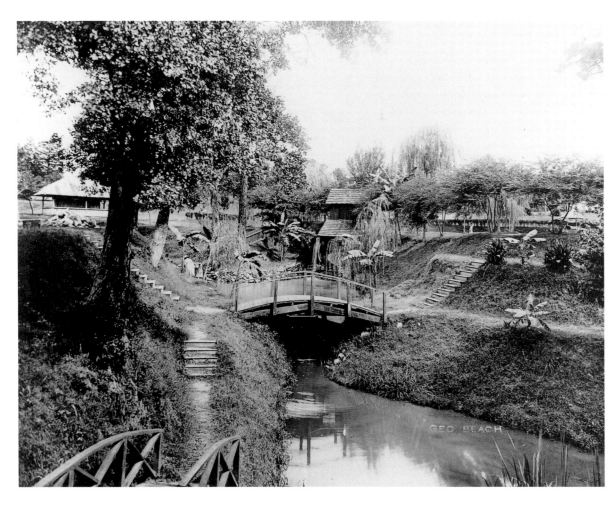

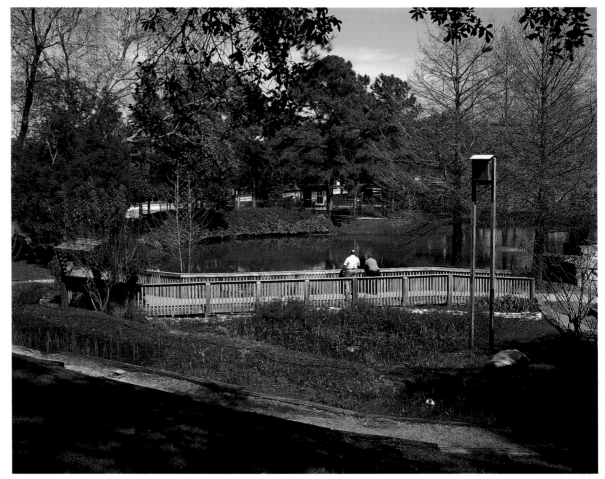

In 1900, Houston Mayor Sam Brashier created Sam Houston Park with the purchase of the Kellem-Noble House, which lay, at the time, on the outer fringes of Houston. In just a few years, the park was landscaped with a stream, a rustic bridge, several footpaths, and an old mill, all in the Victorian style.

Today, the 19-acre park features seven well-preserved structures, all illustrative of Houston's past, nestled beneath its towering glass-and-steel skyscrapers on the western edge of the downtown district. All have been restored, and all but one were relocated here, as the Kellem-Noble House has always been in the park. The oldest building is a small 1826 cabin called The Old Place, which was moved from the west bank of Clear Creek in 1973 and is thought to be the oldest surviving structure in Harris County. The park is managed by the Heritage Society, which is housed on its grounds.

Goose Island Big Tree, circa 1940s

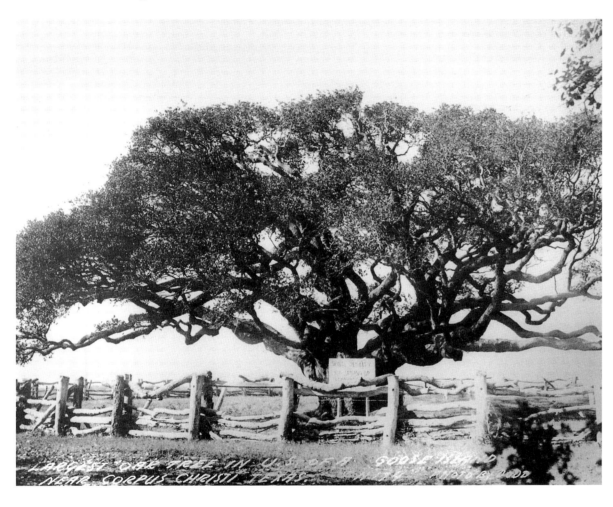

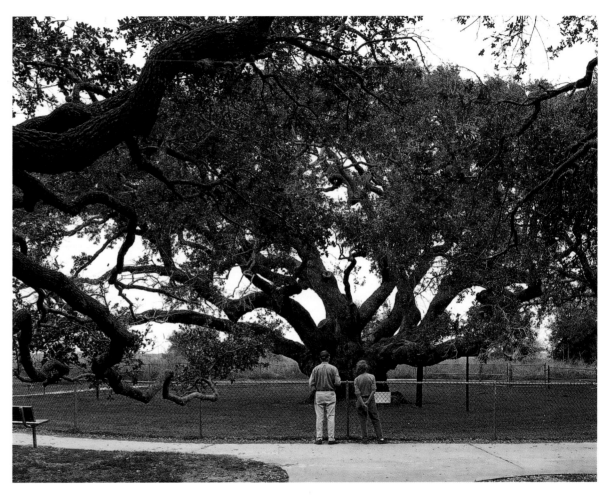

The Goose Island Big Tree is a live oak estimated to be more than 2,000 years old. The State Champion Tree's circumference is more than 35 feet and its average trunk diameter more than 11 feet. The Big Tree is only 44 feet tall, but its crown spread is 89 feet. The old tree has weathered hundreds of tropical storms and hurricanes over the centuries and has lost some of its largest branches in recent years.

The 307-acre Goose Island State Park includes the island as well as a small section of the mainland. The area was purchased by the state between 1931 and 1935 as wintering grounds for the endangered whooping crane and is a habitat for numerous other migratory and local birds. Goose Island State Park is just across St. Charles Bay from the Aransas National Wildlife Refuge and 12 miles northeast of Rockport. I have photographed the Big Tree many times over the years, and each time, it looks a little more fragile to me. The Texas Parks and Wildlife Department has placed several supports under some of the weaker main branches.

Goose Creek Oilfield, 1919

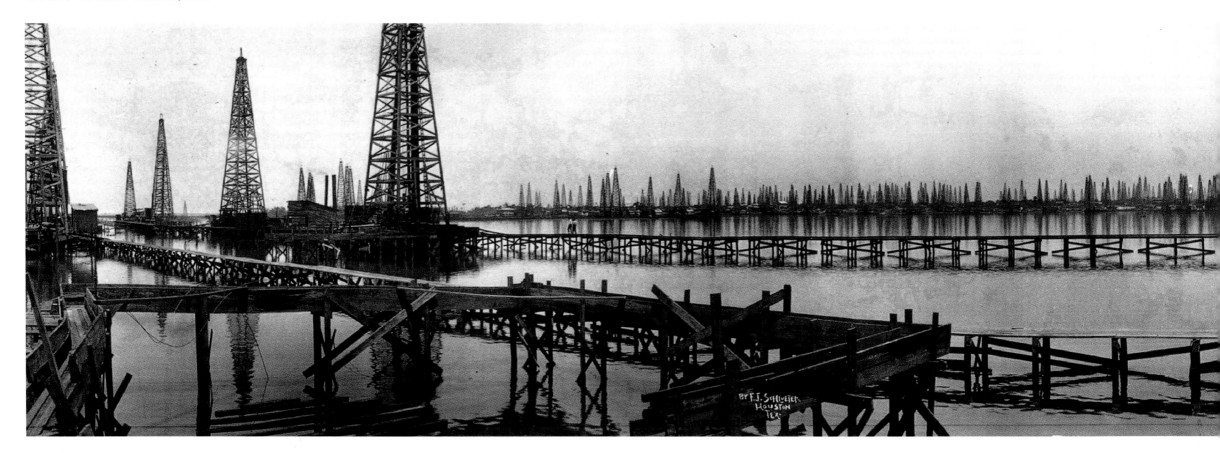

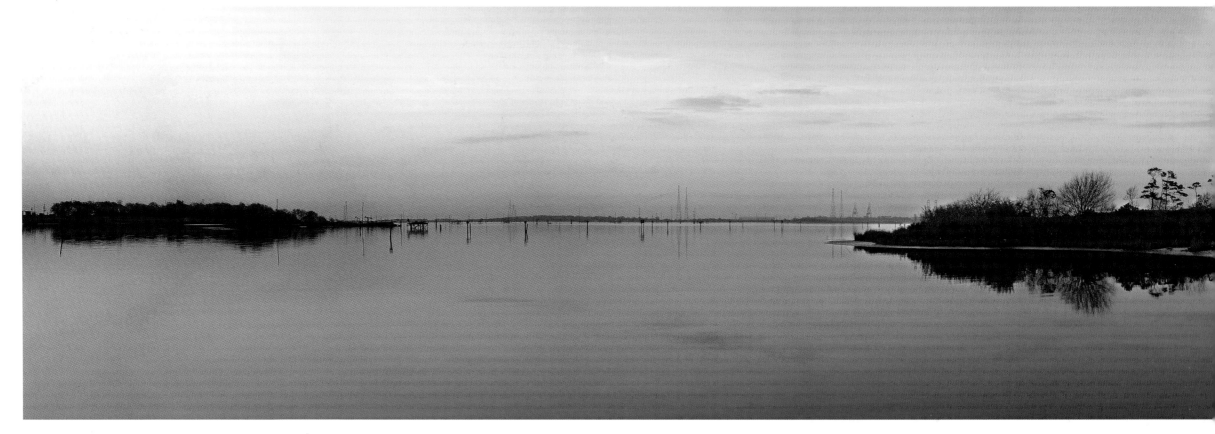

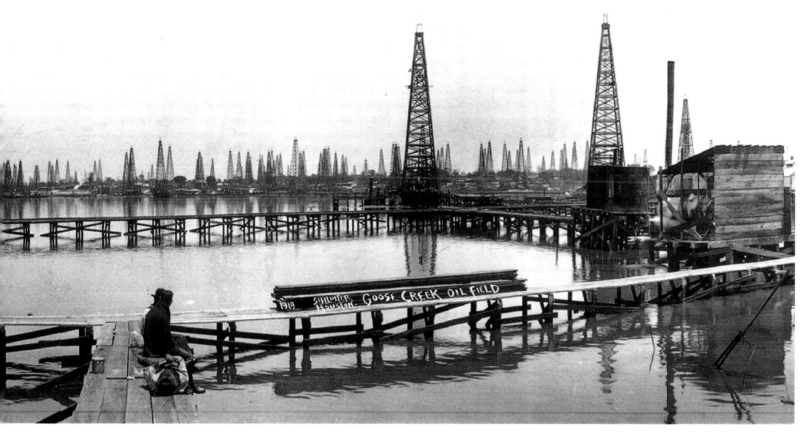

The first offshore oil drilling in Texas occurred in present day Baytown, southeast of Houston on Galveston Bay. In 1903, a man walking along Goose Creek noticed bubbles rising to the surface of the water. By lighting a match, he confirmed that it was natural gas, an indication of oil deep below the surface. Goose Creek Production Company found oil on June 2, 1908, but it was not until more than eight years later that the American Petroleum Company finally brought in its first gusher. The Goose Creek field reached its peak annual production of 8,923,635 barrels with onshore and offshore drilling by 1918.

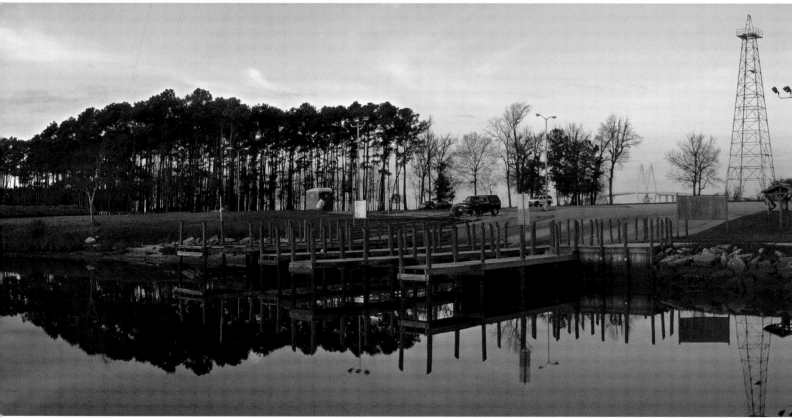

In 1921, Humble constructed an oil refinery adjacent to the Goose Creek field and named the plant and town site Baytown. The discovery of oil here led to exploration for similar oil reserves occurring in underground salt domes. As a result, some of the largest oilfields in the United States were discovered. I took this photograph on the banks of Goose Lake, where Goose Creek empties into Tabbs Bay. The area on the right is now a park with a boat launch for fishermen. The derrick in the far right edge of the picture was erected in 1983 after Hurricane Alicia came through here. It commemorates the early days of the oilfield when hundreds of derricks stood here and in nearby Tabbs Bay.

Galveston Bishop's Palace, circa 1920s

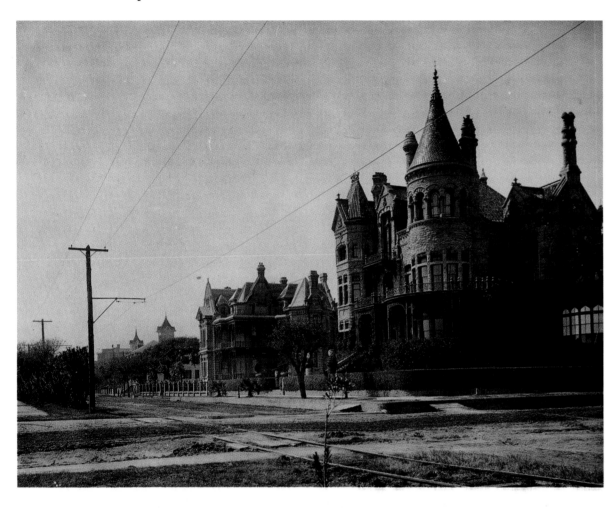

The Bishop's Palace is one of Galveston's most famous Victorian structures. It was originally the home of Walter Gresham, an attorney and U.S. congressman during the late 19th century. Noted Galveston architect Nicholas J. Clayton designed and built the three-story château-style residence between 1887 and 1893 at a cost of $250,000. During the disastrous 1900 hurricane, the Gresham family opened the doors of its home to 200 homeless victims. After the Catholic diocese of Galveston-Houston purchased the house in 1923 as a residence for Bishop Christopher Byrne, it became known as the Bishop's Palace. The diocese opened the house to the public in 1963.

The Bishop's Palace today is ranked among the top 100 homes in the nation for its architectural significance. It features beautifully detailed rosewood, satinwood, and white mahogany woodwork, with fireplaces imported from around the world. The exterior masonry has been meticulously crafted from granite, limestone, and sandstone. The structure was declared a Texas Historic Landmark in 1967 and was added to the National Register of Historic Places in 1970. Since 1975, it has also been included in the East End Historic District.

Galveston The Strand, 1894

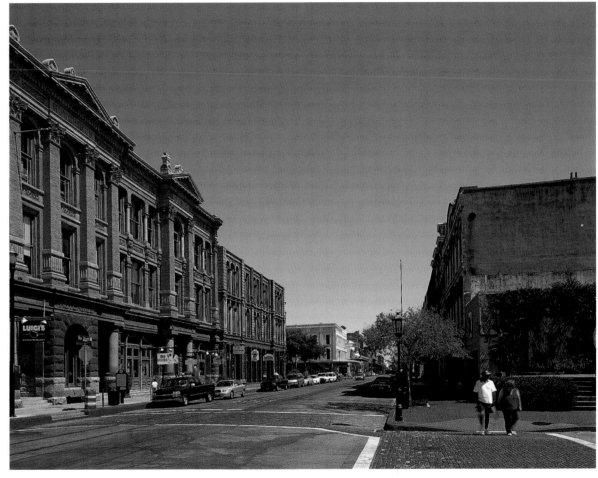

Dating back to the 1830s, The Strand, or Avenue B, has played an integral role in Galveston's history. While the avenue extends throughout much of the city, the name "The Strand" has usually been applied to the five-block business district situated between 20th and 25th streets. Throughout its 19th-century history, Galveston was the hub of commercial and cultural traffic for the entire state of Texas and even enjoyed the name "Wall Street of the Southwest" for a while. Many early wooden buildings on The Strand either burned or were destroyed by hurricanes. Owners eventually replaced wooden structures with iron-fronted brick buildings, but the great 1900 hurricane damaged so many of the buildings on The Strand that businesses began to relocate away from the wharf. The area eventually became a warehouse district and gradually fell into a state of disrepair.

As the deterioration of The Strand continued into the 1960s, the Junior League of Galveston County stepped in and restored two of its buildings, stoking renewed interest in the area. In 1973, the Galveston Historical Foundation initiated The Strand Revolving Fund, which spurred further restoration efforts and found creative new uses for many of the buildings in The Strand Historical District. The fund, along with efforts by private investors, continues to revitalize and rebuild the area, transforming it into a major tourist attraction and a viable business community. The area is now listed on the National Register of Historic Places. Shops, restaurants, historical exhibits, and art galleries are popular destinations on today's Strand. It hosts an annual Mardi Gras celebration and a very popular Christmas festival known as Dickens on The Strand.

Galveston Sacred Heart of Jesus Catholic Church, 1900

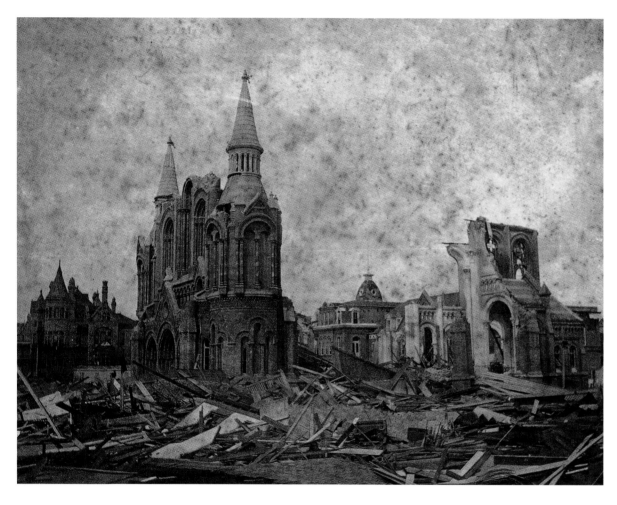

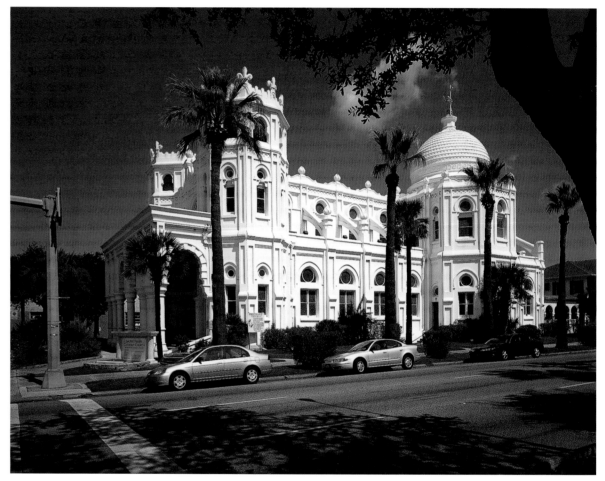

This elegant church by architect Nicholas Clayton was just one of the casualties of the hurricane of 1900. The storm made no distinction between woodsheds and houses of prayer. Sacred Heart of Jesus Catholic Church was just across the street from the Gresham Home (now Bishop's Palace), which came away with much less damage and was, in fact, sturdy enough to protect many homeless people from the storm's fury.

Brother Peter Jiménez designed the Moorish-style church built to replace the first Sacred Heart Church. Two other churches provided the inspiration for its design: one in Toledo, Spain, and the other, the Immaculate Conception Church, in New Orleans, Louisiana. Clayton, the architect of the original church on the site, had a hand in the design of the new church, working on its distinctive dome. The church is such a pure shade of white that to expose it properly, I had to underexpose the sky and the landscape around it.

Galveston The Wharf District, circa 1920s

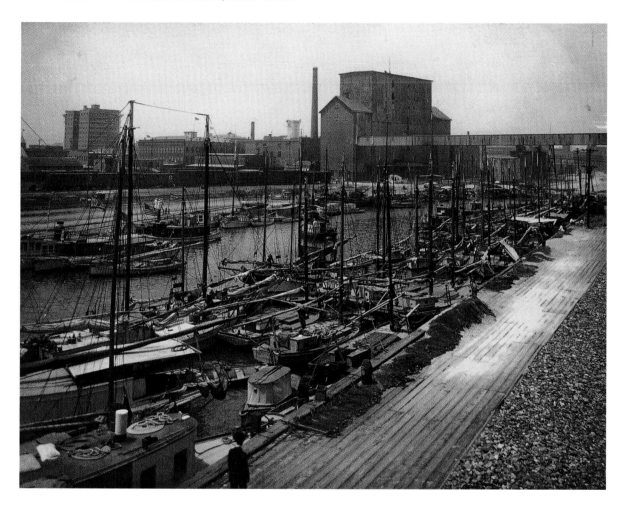

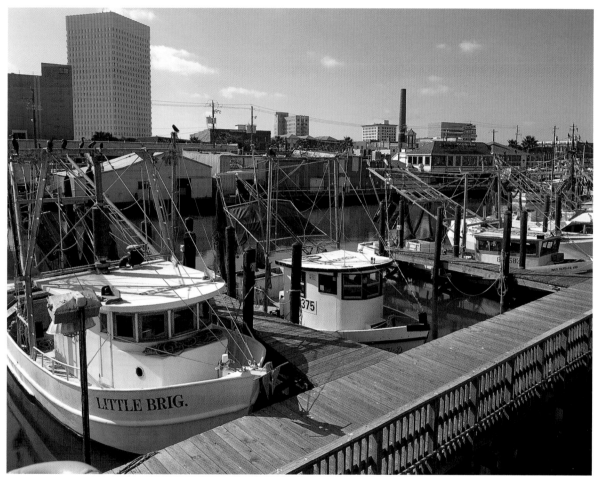

This beautiful photograph depicts the western end of the Galveston wharf district in the early 1920s. The Galveston Wharf and Cotton Compress Company was founded in 1854, but seamen had long recognized that Galveston Island and its harbor would make an ideal port. Pirate Jean Laffite reportedly used it from 1818 to 1821 as his base of operations. Stephen F. Austin once described Galveston as the "best natural harbor the colony of Texas has to offer," and his growing settlement utilized it as a common port. The devastating hurricane of 1900 brought national interest to the region and called attention to the city's precarious position close to the sea. The wharves were repaired at a cost of $382,673 and reopened within two weeks.

In searching for the location of this photograph, I had gone up and down a road paralleling the harbor's edge, searching in vain for an area that looked even remotely like the one in the vintage photograph. After giving up hopes of finding it, I drove to the wharf area and parked near the tall ship Elissa to get a good look at it. As I walked down a boardwalk in the marina nearby, I noticed a raised walkway to my left that went to the Ocean Star Offshore Drilling Rig and Museum. Turning around, I saw a smokestack that looked like the one in the vintage photo and realized I had unwittingly placed myself in almost the exact location. After getting permission from the museum to shoot from its boardwalk, I came back the next morning and took this photograph.

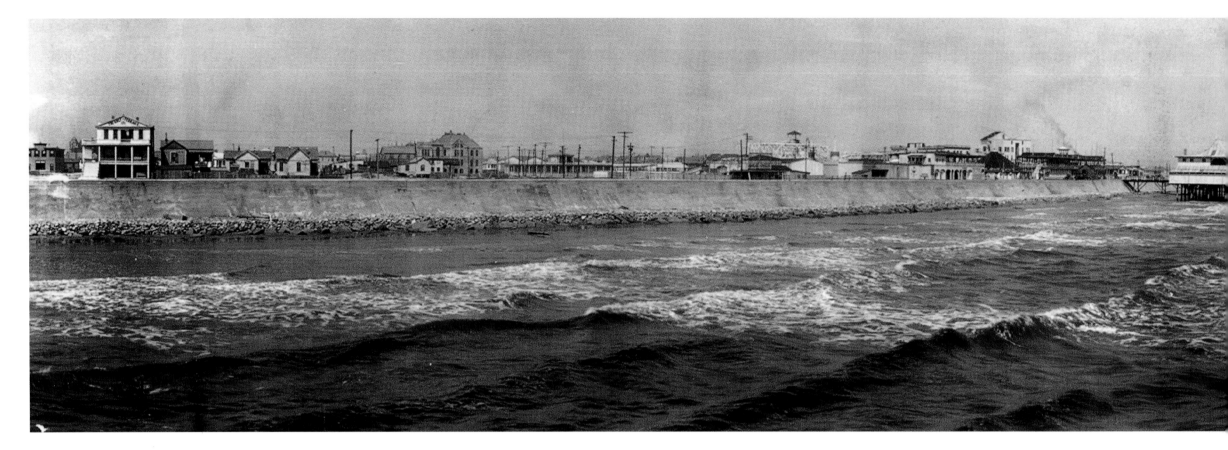

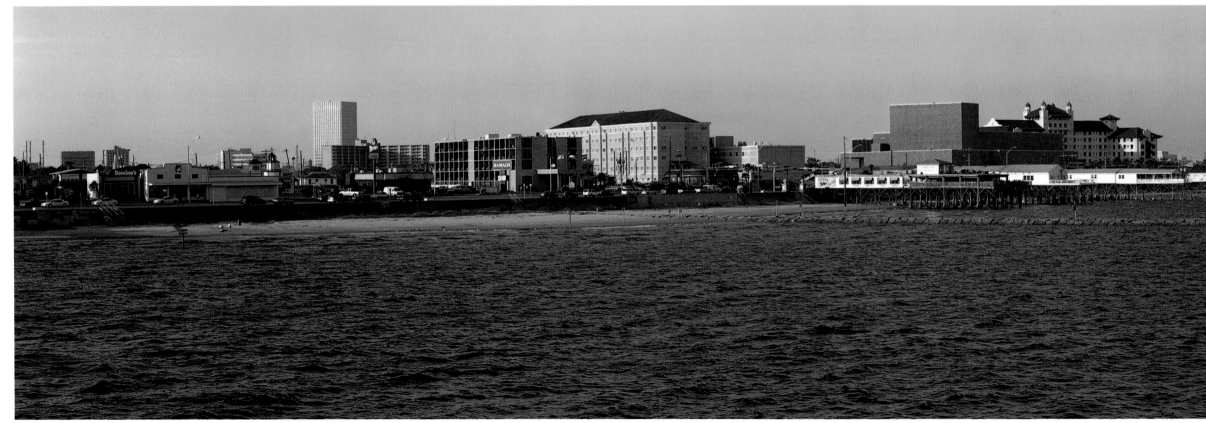

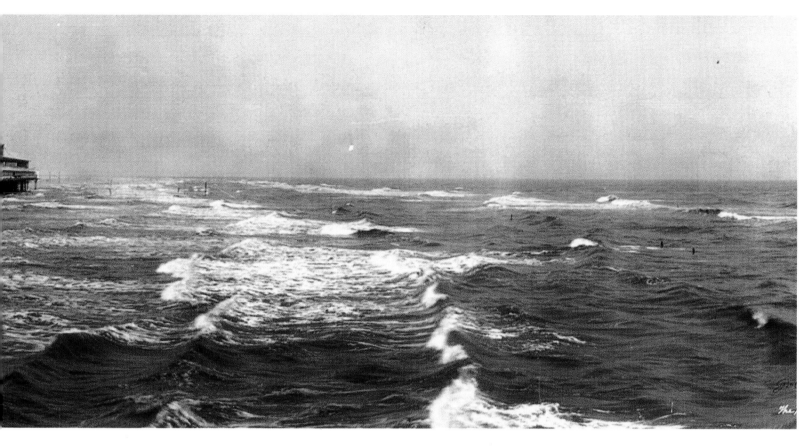

This panorama showing the Galveston Seawall and Seawall Boulevard was made in 1910. Ten years earlier, a devastating hurricane sent an 8-foot-high storm surge through the city of Galveston. At that time, it was the state's largest city with 36,000 residents. This hurricane killed 6,000 to 8,000 people and is still considered to be the worst natural disaster in U.S. history. In the wake of the devastation, the city enlisted engineer Henry Robert to design a seawall that would stand 17 feet above mean sea level. Robert not only designed the wall, but he raised the city's elevation by pumping dredged sand underneath all of its buildings. In 1915, another strong hurricane slammed into Galveston, providing the first test of the city's new seawall. This time, only eight people perished.

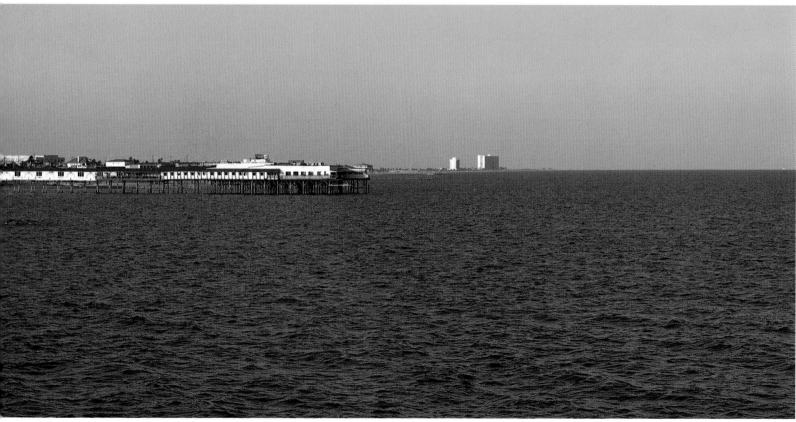

Today, the seawall stretches west for more than 10 miles from near the island's eastern edge. A wide sidewalk along its top is popular among runners, joggers, and skateboarders. A number of different piers with restaurants, hotels, bathhouses, and shops have come and gone over the years, victims of various storms. I made this panorama from the pier supporting the Flagship Hotel.

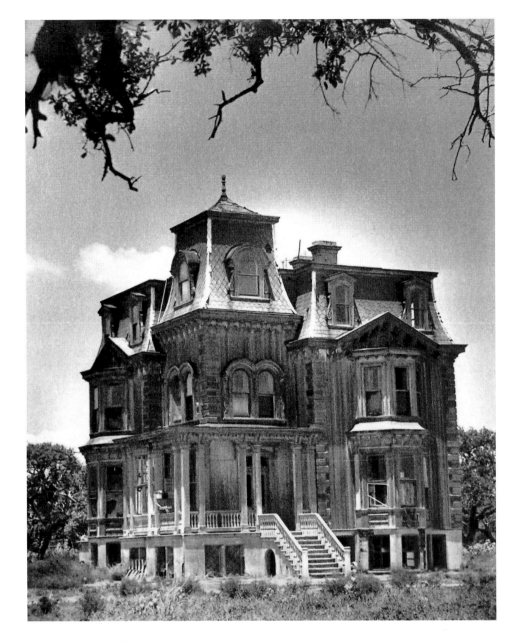

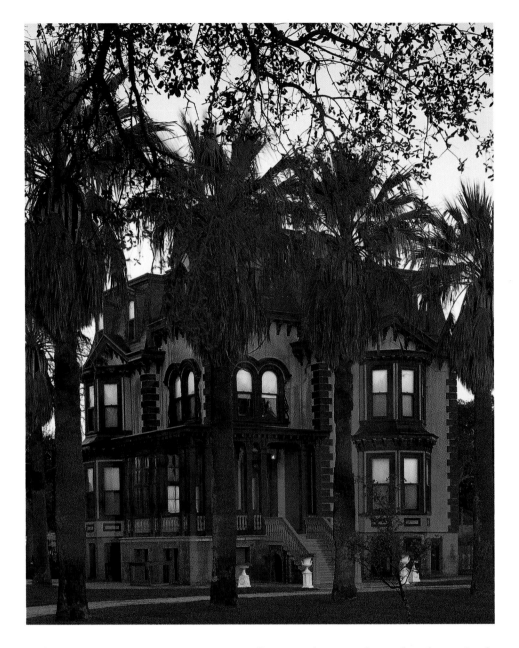

George Ware Fulton, a successful rancher and businessman, founded the town of Fulton in 1866. By 1885, the town had a population of 175, a beef-canning plant, a bone-fertilizer factory, a post office, a school, and several churches. George Fulton built this three-story house and lived in it from 1877 to 1893. At the time, it featured some of the latest technological conveniences, including modern plumbing, central heat, and a gas lighting system. It was one of the very few houses to embody virtually all of the major characteristics of the Second Empire style, and its classic design, unusual construction, and technologically advanced systems make it one of the most significant residences of this style in the Southwest.

Fulton Mansion State Historic Structure lies on Fulton Beach Road and remained in private hands until 1976, when the state purchased the 2.3-acre site. The house was added to the National Register of Historic Places in 1975 and was restored in 1983. The Texas Parks and Wildlife Department now maintains it as a museum.

Corpus Christi 1900

One Shoreline Plaza

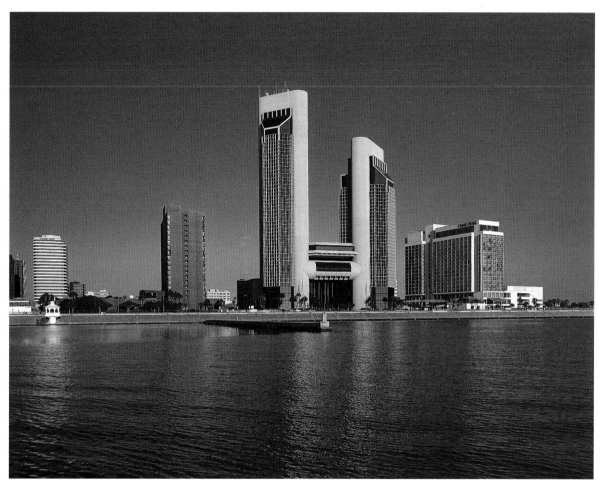

Corpus Christi's rise to becoming a major port in the United States began almost 500 years ago. The Spanish explorer Alonzo Álvarez de Pineda was the first to visit the area in 1519. Other explorers came and went, and attempts to establish a permanent settlement failed until Colonel Henry Lawrence Kinney set up a trading post on the west shore of Corpus Christi Bay in 1839. By the mid-1840s, the settlement became known as Corpus Christi ("Body of Christ"). In the 1850s, trade through the city increased when steamships began making regular stops. During the early years of the Civil War, Corpus Christi served as an important crossroads for Confederate commerce. After the war, the cattle industry boomed and Corpus Christi became a major shipping point for the beef industry. The railroads came to the area in the 1870s, and by the end of the century, the city had its first paved streets, a street railway line, and a public water system.

For decades, the Corpus Christi Bayfront District had no buildings taller than 10 stories. In the early 1980s, two large hotels were built near the north end of the seawall that rivaled some of the skyscrapers downtown. Then, in the late 1980s, One Shoreline Plaza was built. The high-rise consisted of two towers, 22 and 28 stories respectively, connected by a nine-story atrium. The new office building, designed by Morgan Spear and Associates, featured spectacular views of the Bayfront attractions. What set Shoreline Plaza apart, however, was the fact that it was built right on the water, and had architectural features specifically designed to protect it against hurricanes, such as deep-set windows with concrete latticework to deflect winds and storm debris.

Corpus Christi Central Wharf, early 1900s

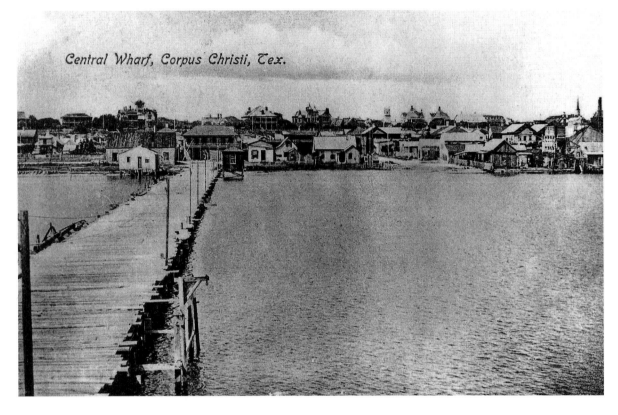

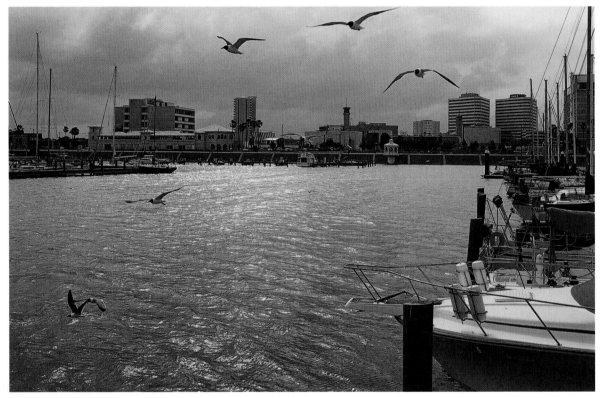

Corpus Christi's Central Wharf was built in 1853. According to Murphy Givens of the Corpus Christi Caller Times, it was the scene of more maritime commerce than any other dock or wharf in the harbor for more than 50 years. Many ships docked and unloaded their cargo at Central Wharf, which was an extension of Laguna Street (now Sartain). In 1916, a hurricane struck near Corpus Christi and destroyed most of the Central Wharf and much of the Bayfront. Unfortunately, it took a much stronger hurricane only three years later to provide the impetus for an ambitious project that would include the construction of a breakwater and seawall to protect the city from future storms.

The Corpus Christi "T-heads" are the center of activities on the bayfront. Three streets—People's Street, Lawrence Street, and Cooper's Alley were extended into the bay to provide protective marinas called "T-heads," and "L-heads," referring to the shape of the extensions. Sightseeing cruises, bay fishing, and water sport rentals are some of the more popular activities in the area. Shrimpers sell fresh shrimp right off their boats at the People's Street T-head, and the 80-year-old Corpus Christi Yacht Club is headquartered on the Cooper's Alley L-head. This view, looking toward Sartain Street, the original location of Central Wharf, is from the tip of the Lawrence Street T-head.

Corpus Christi North Beach, 1934

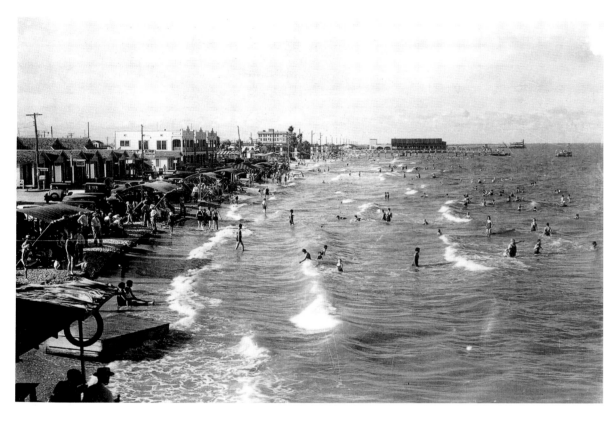

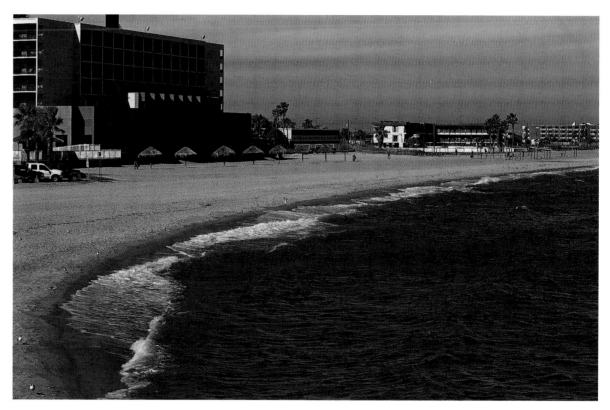

This view of North Beach from the 1930s highlights its former popularity. Its official name is Corpus Christi Beach, but many longtime residents know it as "North Beach," because of its location on the north side of the ship channel. When Padre Island National Seashore was opened to the public in 1970, people flocked to its wide, sandy beaches and large waves. Ultimately North Beach, with its narrow beaches and coarser sand, could not compete with Padre Island.

Corpus Christi Beach is much less crowded than some of the more popular beaches in the area and it's convenient to Corpus Christi's restaurants, hotels, and tourist attractions. The U.S.S. Lexington Museum (a decommissioned aircraft carrier) and the Texas State Aquarium are nearby. Corpus Christi Beach is a good family beach with restrooms, rinse-off showers, cabanas, and picnic tables. Because of the excellent wind and wave conditions, it's also popular for kiteboarding and boardsailing.

Corpus Christi Bascule Bridge, circa 1940s

Harbor Bridge

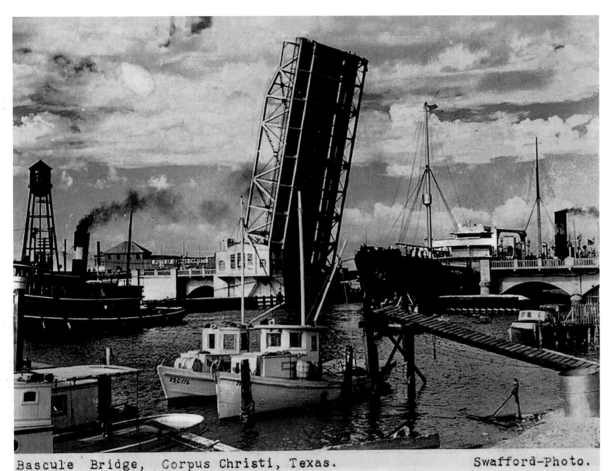

Bascule Bridge, Corpus Christi, Texas. Swafford-Photo.

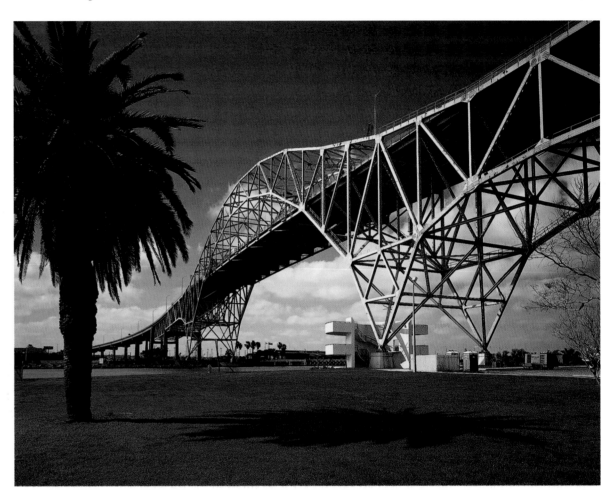

In 1926, the Wisconsin Bridge and Iron Company built the Bascule Bridge at the entrance to the Port of Corpus Christi for $400,000. The counterbalanced bridge, named after the French word for seesaw, was painted black and coated with grease to protect it from the ravages of salt and sand. The bridge allowed Corpus Christi residents to cross the harbor to get to North Beach and points beyond. Although it only took one minute for the twin 100-horsepower engines to raise the bridge, its operators raised it well before the ships arrived in case the bridge mechanism failed and captains needed time to reverse their ships' engines. This resulted in waits of up to half an hour, holding up automobile traffic and provoking tempers, pointing to the need for a new bridge.

An elegant, shiny new bridge across the harbor was just what the flourishing city of Corpus Christi needed by the time the Harbor Bridge was completed in 1959. The sleek feat of engineering stretches 235 feet over the water below and affords stunning views in all directions. The bustling port, the emerald waters of Corpus Christi Bay, the picturesque Bayfront District, and North Beach, the city's original playground, may all be seen from the Harbor Bridge. Docked beneath the bridge is the U.S.S. Lexington, a vintage wartime aircraft carrier, now a floating naval museum.

Corpus Christi View from Driscoll Hotel, circa 1940s

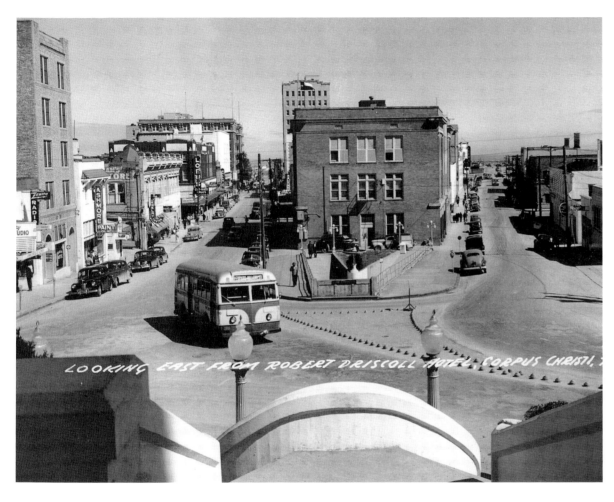

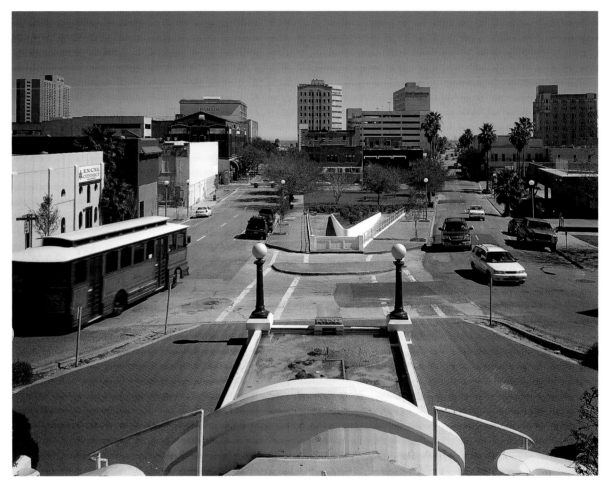

This photograph was taken from a staircase on the bluff in front of the former Driscoll Hotel. The Robert Driscoll Hotel opened on May 25, 1942, and was the hotel of choice in Corpus Christi for such movie stars as Tyrone Power, Mary Pickford, and John Wayne. Driscoll had been a leader in the drive to get Corpus Christi a deepwater port in the early 1920s. Clara Driscoll, who built the hotel and named it for her brother after his death in 1929, lived in a penthouse on the 20th floor until her death in 1945. Her will stipulated that the Driscoll fortune was to be used to create the Driscoll Foundation, which would operate a children's hospital. Clara Driscoll's legacy also includes her successful efforts to rescue the Alamo from certain ruin in the early 1900s. The Driscoll Hotel was closed in 1970. It was later remodeled and is used today as an office and banking complex.

The white structure in the left middle of this photo is the Lovenskiold Building, the oldest standing commercial building in Corpus Christi. It has served as a post office, library, telegraph office, and drugstore since it was built in 1891. The original cast-iron-and-brick finish of the structure was plastered over at some point in its past. It is believed to be the only known cast-iron building in Corpus Christi. The words "Bingham's Drug Store," one of its past incarnations, are still visible painted on the back.

Indianola 1873

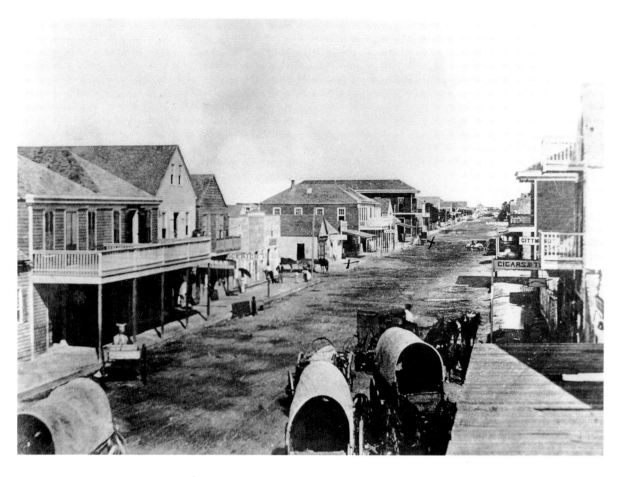

In 1846, Sam Addison White and William M. Cook established a port in Matagorda Bay on the middle Texas coast and named it Indian Point. Carl, Prussian prince of Solms-Braunfels, designated a nearby stretch of beach as a landing place for German immigrants in 1844. A post office was opened in September 1847 and stagecoach service commenced in January 1848. A year later, residents changed the town's name permanently to Indianola. The town grew rapidly, extending three miles down the beach to Powderhorn Bayou. For several years, Indianola was the second busiest port in Texas. Then, on September 16, 1875, a catastrophic hurricane nearly destroyed it. The storm devastated the low-lying city and killed many of its residents. The town battled back, determined to regain its prosperity and rebuild its flattened warehouses and docks. Only 11 years passed before another killer storm came and destroyed what was left of Indianola. This time the town never recovered. The few citizens who somehow survived left for good.

Today, only a few stones of the courthouse foundation remain and the outlines of a few shattered concrete cisterns may be seen poking through the sand. A few mobile homes and a bar serving locals and fishermen have popped up in recent years, as well as a beach campground with picnic tables. The state has erected a historical marker, but the most noticeable landmark is a solitary pink granite statue of René Robert Cavelier, Sieur de La Salle, the French explorer who was the first to leave a bootprint on the sands of Indianola more than 300 years ago.

Port Isabel Lighthouse, circa 1920s

Port Isabel Lighthouse State Historic Structure

Built in 1852 of brick brought in from New Orleans by schooner, the Point Isabel Lighthouse had a 16-mile range to guide ships into harbor and to the mouth of the Rio Grande. The lighthouse was instrumental in bringing commerce to southern Texas during the late 19th century. It was darkened during the Civil War when both Union and Confederate forces used it as a lookout, and again during World War I. The structure, built 82 feet above sea level, and the original beacon consisted of 21 reflectors and 15 lamps. The lighthouse was in and out of service many times between 1852 and 1905, when the U.S. government finally abandoned it.

On December 14, 1927, the U.S. government sold the lighthouse to J.S. Ford of Brownsville. The lighthouse received a state historical marker in 1936. In 1950, the lighthouse and its associated buildings were donated to the Texas State Parks Board, which remodeled the tower by replacing the iron platform with concrete and raising the glass dome to provide easier access for visitors. The Texas Parks and Wildlife Department performed additional repair work in 1970. In the early 1990s, the tower, with its mercury-vapor light, was marked on sea charts as an aid to navigation. Port Isabel Lighthouse State Historic Structure is on State Highway 100 in Port Isabel in southeastern Cameron County.

Point Isabel 1910

Queen Isabella Causeway

Up until 1928, when the city of Point Isabel (now Port Isabel) was incorporated, the town had been a sleepy little fishing village at the southern tip of Laguna Madre Bay, with several wooden fishing piers extending out into the bay. The town's 25-foot bluff made it an ideal spot for viewing both the Laguna Madre and the Gulf of Mexico, and so a lighthouse was built on it. The Queen Isabella Causeway, with a swing bridge across the ship channel between Port Isabel and South Padre Island, was completed in February 1954 at a cost of $2.2 million.

The bridge led to the development of South Padre Island, which continues to grow. The new Queen Isabella Causeway was constructed in 1974 and the original Queen Isabella Causeway became known as the "Old Fishing Pier." On September 15, 2001, a tugboat pulling four loaded barges hit the causeway and caused part of it to collapse, killing eight people. The causeway, the only link between Port Isabel and South Padre Island, was repaired in two months, in time for Thanksgiving. In the meantime, a ferry was used to get vehicles to the mainland while repairs were made to the bridge.

South Padre Island circa 1940s

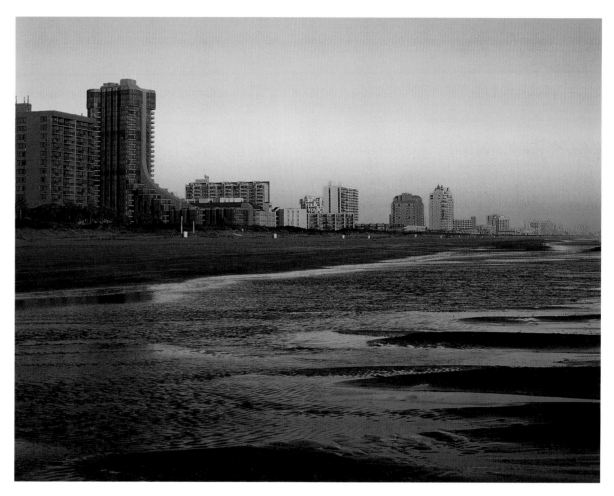

The town of South Padre Island is at the southernmost tip of the Island, a barrier island more than 100 miles long that runs parallel to the South Texas shoreline. It is flanked on the east by the Gulf of Mexico and on the west by the Laguna Madre. Until the 1950s, it was accessible only by ferry. The completion of the Queen Isabella Causeway, made the island much more accessible and greatly increased tourism. In 1967, Hurricane Beulah destroyed most of the town of South Padre Island, as well as much of nearby Port Isabel.

South Padre Island was rebuilt after Hurricane Beulah and today is a thriving tourist town in spring and summer. Most of its beautiful resorts were built during a building boom in the 1980s. Visitors come from all over the world, and it is one of the most popular spring break destinations for college students from across America. Most of its businesses are related to the tourist trade: hotels, restaurants, and souvenir shops. For those wishing to escape the tourist-heavy resort area, a 10-mile drive to the northern end of the island reveals a stretch of the island that is still fairly wild, with wide beaches, rolling sand dunes, and plentiful seashells.

ISBN-13: 978-1-56579-551-8; **ISBN-10:** 1-56579-551-2

Text & contemporary photography copyright:
Richard Reynolds, 2005. All rights reserved.

Foreword copyright: Roy Flukinger, 2005. All rights reserved.

Editors: Barrett Webb and Gretchen Hanisch

Design and production: Carol Pando

Design concept: Mark Mulvany

Published by:
Westcliffe Publishers, Inc.
P.O. Box 1261; Englewood, CO 80150
westcliffepublishers.com

Printed in China through World Print, Ltd.

Library of Congress Cataloging-in-Publication data:
Reynolds, Richard, 1950-
 Texas : then and now, text and contemporary rephotography / by Richard Reynolds ; foreword by Roy Flukinger.
 p. cm.
 ISBN-13: 978-1-56579-551-8
 ISBN-10: 1-56579-551-2
 1. Texas--Pictorial works. I. Title.
 F387.R4885 2005
 976.4'0022'2--dc22
 2005011131

ACKNOWLEDGMENTS

Thanks to the following people whose help was instrumental in finding the vintage photos in this book: Roy Flukinger, Linda Briscoe Myers, Grace McEvoy, Melleta R. Bell, Gaylan Corbin, Steven D. Williams, Betty Bustos, Patrick Lemelle, Jenny Spurrier, Patricia Perry, Joel Draut, Sue Canup, Christi Carl, Jane Soutner, Max Hill, Blanca E. Smith, John Anderson, Christina Davila, Lynne Russell, Pat Worthington, Paul H. Camfield, Carolyn DeBus, and Bettye Anderson. Thanks to Harold Fuchs and Betty Lancaster for use of their Alamo Plaza photo, and to the Texas State Historical Association for use of their invaluable resource *The Handbook of Texas Online*. Special thanks to my wife, Nancy, for lending her editing and research skills, accompanying me on trips, and providing general encouragement and guidance for this project.

ABOUT THE AUTHOR/ PHOTOGRAPHER

RICHARD REYNOLDS has photographed the Texas landscape for more than 35 years. From 1983 to 1990, he served as Chief Photographer for the State of Texas tourism office where he was able to discover the state's incredible diversity firsthand. In 1990, he opened a stock photography business specializing in Texas landscapes. His work has been published in thousands of newspapers, magazines, calendars, and books. An online gallery of Richard's landscape photography can be viewed at **richardreynoldsphotography.com**.

BIBLIOGRAPHY

Baker, T. Lindsay. *Building the Lone Star: An Illustrated Guide to Historic Sites.* College Station, TX: Texas A&M University Press, 1986.

Davis, John L. *Houston, A Historical Portrait.* Austin, TX: Encino Press, 1983.

Heines, Vivienne and Scott Williams. *Corpus Christi and the Texas Coastal Bend.* Guilford, CT: The Globe Pequot Press, 2001.

Kearney, Milo, ed. *Studies in Brownsville History.* Brownsville, TX: Pan American University at Brownsville, 1986.

McComb, David G. *Houston, A History.* Austin TX: University of Texas Press, 1981.

McDonald, William L. *Dallas Rediscovered: A Photographic Chronicle of Urban Expansion 1870-1925.* Dallas, TX: Dallas Historical Society, 1978.

Miller, Ray. *Ray Miller's Houston.* Houston TX: Cordovan Press, 1984.

Thompson, Jerry. *Laredo, A Pictorial History.* Norfolk/Virginia Beach, VA: The Donning Company, Publishers, 1986.

Texas State Historical Association *The Handbook of Texas Online.* http://www.tsha.utexas.edu/handbook/online.

Walraven, Bill. *Corpus Christi: The History of a Texas Seaport.* Woodland Hills, CA: Windsor Publications, Inc., 1982.

HISTORIC PHOTO CREDITS courtesy of. . .

PAGE # PHOTO CREDIT

A REDISCOVERY OF TEXAS PLACE
4 Houston Metropolitan Research Center, Houston Public Library
5 Tom Green Cty. Hist. Soc. Coll.; West Texas Collection, Angelo State Univ.
6 Harry Ransom Research Ctr. at UT-Austin, #10133
7 UT Inst. of Texan Cultures at San Antonio #075-1156

WEST TEXAS
8 Texas State Library & Archives Commission #1968/89 649(N381)
9 El Paso County Historical Society
10 El Paso County Historical Society
12 UT Inst. of Texan Cultures at San Antonio #071-0389
13 UT Inst. of Texan Cultures at San Antonio #071-0386
14 Texas State Library & Archives Commission #1968/89 655(N321)
15 UT Inst. of Texan Cultures at San Antonio #080-0133
16 El Paso County Historical Society
17 Harry Ransom Research Ctr. at UT-Austin #5483
18 Archives of the Big Bend, Bryan Wildenthal Memorial Library, Sul Ross State Univ., Alpine, Texas #CTA.1986.14.18
20 Center for American History, UT-Austin #401
21 Charles Livingston Coll, Archives of the Big Bend, Bryan Wildenthal Memorial Library, Sul Ross State Univ., Alpine, Texas #CLN986
22 Archives of the Big Bend, Bryan Wildenthal Memorial Library, Sul Ross State Univ., Alpine, Texas #N.10.b.1; P1978-284
23 Harry Ransom Research Ctr. at UT-Austin #4015-D
24 Archives of the Big Bend, Bryan Wildenthal Memorial Library, Sul Ross State Univ., Alpine, Texas #R.2.a.8FP
26 Harry Ransom Research Ctr. at UT-Austin #2714
27 Harry Ransom Research Ctr. at UT-Austin #4693
28 Harry Ransom Research Ctr. at UT-Austin #4653
29 Harry Ransom Research Ctr. at UT-Austin #4697
30 Harry Ransom Research Ctr. at UT-Austin #4664
32 Harry Ransom Research Ctr. at UT-Austin #4698

THE PANHANDLE
33 Panhandle Plains Historical Museum
34 Panhandle Plains Historical Museum
36 Panhandle Plains Historical Museum
37 Panhandle Plains Historical Museum
38 Panhandle Plains Historical Museum
39 Panhandle Plains Historical Museum
40 Panhandle Plains Historical Museum
41 Panhandle Plains Historical Museum
42 Panhandle Plains Historical Museum
43 Panhandle Plains Historical Museum
44 Panhandle Plains Historical Museum
45 Panhandle Plains Historical Museum
46 Panhandle Plains Historical Museum
48 Panhandle Plains Historical Museum
49 Panhandle Plains Historical Museum
50 Library of Congress, Prints and Photographs Division #6a10051
52 UT Inst. of Texan Cultures at San Antonio #073-0518
53 Southwest Collection/Special Collections Library Texas Tech University #690
54 Southwest Collection/Special Collections Library Texas Tech University #536
55 Tom Green Cty. Hist. Soc. Coll.; West Texas Collection, Angelo State Univ.
56 Tom Green Cty. Hist. Soc. Coll.; West Texas Collection, Angelo State Univ.
58 Tom Green Cty. Hist. Soc. Coll.; West Texas Collection, Angelo State Univ.

CENTRAL TEXAS
59 Texas State Library & Archives Commission #1968/89-899 (M669)
60 UT Inst. of Texan Cultures at San Antonio #078-0497
61 Texas Collection, Baylor University, Waco Texas
62 Library of Congress, Prints and Photographs Division #6a10093
64 UT Inst. of Texan Cultures at San Antonio #074-0019
65 Harry Ransom Research Ctr. at UT-Austin #10105
66 Harry Ransom Research Ctr. at UT-Austin #10116
67 Austin History Center, Austin Public Library #C00024A
68 Austin History Center, Austin Public Library #PICA07817
69 Austin History Center, Austin Public Library #C00558
70 Austin History Center, Austin Public Library #C01818
71 Austin History Center, Austin Public Library #C05429
72 UT Inst. of Texan Cultures at San Antonio #079-0033
73 Gillespie County Hist. Society #19xx.553.001
74 Gillespie County Hist. Society #1966.52.258
75 Gillespie County Hist. Society #19xx.698.003
76 Library of Congress, Prints and Photographs Division #ba10101
78 Texas State Library & Archives Commission #M405
79 Texas State Library & Archives Commission #1968/89 928 (M555)
80 Texas State Library & Archives Commission #1968/89 783 (M397)
81 Texas State Library & Archives Commission #1968/89 98 (M-391)

82 Texas State Library & Archives Commission #1968/89 147 (49-E)

EAST TEXAS
83 Texas/Dallas History and Archives Div./Dallas Public Library #PA76-1/31047
84 Texas/Dallas History and Archives Div./Dallas Public Library #PA81-00121
85 Texas/Dallas History and Archives Div./Dallas Public Library #PA76-1/1056
86 Texas/Dallas History and Archives Div./Dallas Public Library #PA78-2-1107
88 Texas/Dallas History and Archives Div./Dallas Public Library #PA19-59-109
89 Dallas Morning News
90 Dallas Morning News
91 Dallas Morning News
92 Dallas Morning News
94 Ft. Worth Star-Telegram Photo Coll., UT at Arlington Libraries #AR406-1-30-21
95 Genealogy History and Archives Unit Fort Worth Public Library
96 Genealogy History and Archives Unit Fort Worth Public Library
97 Texas State Library & Archives Commission #1968/89 339 (S-36)
98 Texas State Library & Archives Commission #1/28-10
99 UT Inst. of Texan Cultures at San Antonio #073-1690
100 Texas State Library & Archives Commission #1968/89 1003 (C-89)
101 Texas State Library & Archives Commission #1968/89 1147 (B107)
102 Texas State Library & Archives Commission #1968/89 1222 (M239)
103 Texas State Library & Archives Commission #1968/89 1231 (M214)
104 East Texas Research Ctr., Stephen F. Austin State University #P67a5
105 Texas State Library & Archives Commission #1984/219-12

SOUTH TEXAS
106 UT Inst. of Texan Cultures at San Antonio #083-0263
107 UT Inst. of Texan Cultures at San Antonio #093-0002; 075-1158
108 UT Inst. of Texan Cultures at San Antonio #075-1156
109 UT Inst. of Texan Cultures at San Antonio #L-2355-H
110 Courtesy of Harold Fuchs and Betty Lancaster
112 UT Inst. of Texan Cultures at San Antonio #082-0392
114 UT Inst. of Texan Cultures at San Antonio #084-0175
115 UT Inst. of Texan Cultures at San Antonio #082-0471

116 UT Inst. of Texan Cultures at San Antonio #080-0161
117 UT Inst. of Texan Cultures at San Antonio #074-1114
118 Webb County Heritage Foundation S.N. Johnson Collection
120 Texas State Library & Archives Commission #1968/89 1687 (N15)
121 Texas State Library & Archives Commission #1968/89 1456 (3734)
122 Ctr for American History, UT-Austin #03055
124 Ctr for American History, UT-Austin #02993
125 UT Inst. of Texan Cultures at San Antonio #073-0837
126 Texas State Library & Archives Commission #1968/89 398 (N31)
128 UT Inst. of Texan Cultures at San Antonio #073-0819

GULF COAST
130 Houston Metropolitan Research Center, Houston Public Library
131 Houston Metropolitan Research Center, Houston Public Library
132 Houston Metropolitan Research Center, Houston Public Library
134 Houston Metropolitan Research Center, Houston Public Library
135 Houston Metropolitan Research Center, Houston Public Library
136 Houston Metropolitan Research Center, Houston Public Library
137 Texas State Library & Archives Commission #1968/89 457
138 Library of Congress, Prints and Photographs Division #6a10083
140 Galveston County Historical Museum, #GCHM1990.004.004
141 Rosenberg Library, Galveston, Texas
142 Rosenberg Library, Galveston, Texas
143 Galveston County Historical Museum, #GCHM1990.004.027
144 Library of Congress, Prints and Photographs Division #6a10453
146 UT Inst. of Texan Cultures at San Antonio #079-0035
147 Corpus Christi Public Library
148 Corpus Christi Public Library
149 Dr. Fred'k McGregor Photo Coll. Corpus Christi Museum of Science and History
150 Corpus Christi Public Library
151 Texas State Library & Archives Commission #1968/89-459 (P9)
152 Texas State Library & Archives Commission #1924/2-1
153 Center for American History, UT-Austin #03159
154 Center for American History, UT-Austin #03171
155 Texas State Library & Archives Commission #1968/89 1493 (N41)

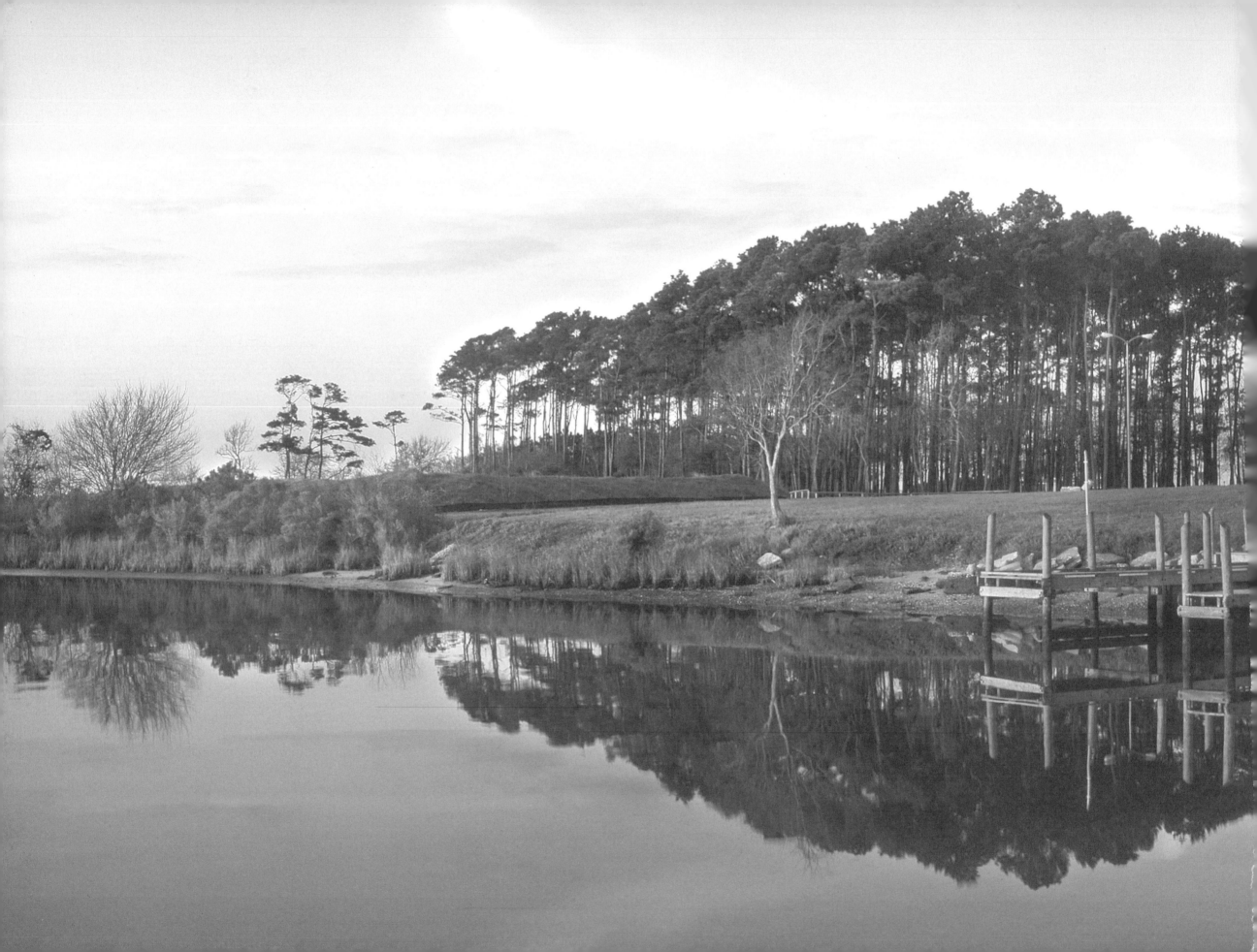